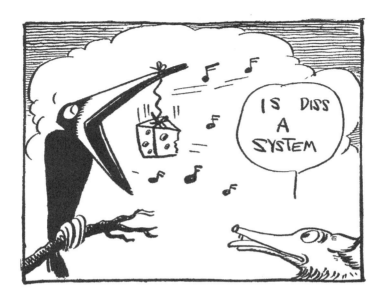

THE GOLDSTEIN-GOREN SERIES
IN AMERICAN JEWISH HISTORY

General editor: Hasia R. Diner

*We Remember with Reverence and Love: American Jews
and the Myth of Silence after the Holocaust, 1945–1962*

Hasia R. Diner

Is Diss a System? A Milt Gross Comic Reader

Edited by Ari Y. Kelman

IS DISS A SYSTEM?

A Milt Gross Comic Reader

EDITED BY

Ari Y. Kelman

NEW YORK UNIVERSITY PRESS

New York and London

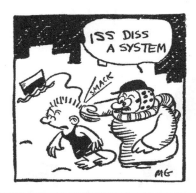

NEW YORK UNIVERSITY PRESS
New York and London
www.nyupress.org
© 2010 by New York University
All rights reserved

Library of Congress Cataloging-in-Publication Data
Gross, Milt, 1895-1953 [Selections. 2010]
Is diss a system? : a Milt Gross comic reader / edited by Ari Y. Kelman.
p. cm. — (The Goldstein-Goren series in American Jewish history)
Includes bibliographical references and index.
ISBN-13: 978-0-8147-4823-7 (cl : alk. paper)
ISBN-10: 0-8147-4823-6 (cl : alk. paper)
1. Comic books, strips, etc.—United States. 2. Jewish wit and humor,
Pictorial. 3. American wit and humor, Pictorial. 4. Caricatures and
cartoons—United States. 5. Gross, Milt, 1895-1953—Criticism
and interpretation. I. Kelman, Ari Y., 1971- II. Title.
PN6727.G76A6 2010 741.5′973—dc22 2009023998

New York University Press books are printed on acid-free paper, and their
binding materials are chosen for strength and durability. We strive to
use environmentally responsible suppliers and materials to the
greatest extent possible in publishing our books.

Book designed and typeset by Charles B. Hames

Manufactured in the United States of America

10 9 8 7 6 5 4 3 2 1

For L.P., who hipped me to
Gross some years ago.

And to E.P

Contents

[vi]

[vii]

Acknowledgments

This book began while I was working at the American Jewish Historical Society, where the executive director, David Solomon, not only supported the project but advocated for it as well. He mentioned it to Professor Hasia Diner, who encouraged me to pursue the project and see it to completion. Her comments have always been right on the money and she constantly challenged me to make this a more sophisticated, insightful book. Eddy Portnoy has been a great friend and incredible resource both with respect to things Yiddish and with respect to American comics. His patient readings and rereadings of the introduction helped the project dramatically. Sarah Bunin Benor has also been extremely helpful, offering key insights and suggestions along the way.

Simon Elliott at the Young Research Library at UCLA deserves special acknowledgment for being such a wonderful host during my weeks of research in the Milt Gross Papers, and for helping me follow up with Gross's family.

The four anonymous readers of NYU Press provided much needed criticism and guidance that I hope have succeeded in making this book stronger. My brilliant colleagues at the University of California, Davis, offer kind and strong support and have made Davis a great home. They are largely responsible for creating an environment of curiosity, rigor, and humane

working conditions. To Eric Zinner and Ciara McLaughlin, my editors at NYU Press, my most sincere thanks for their fond support and encouragement on this book. And finally, to Milt Gross himself, whose inventiveness, creativity, insight, and humor encouraged me to write a book I hope he would have liked.

Milt Gross . . . mangled all languages,
English, Yiddish, whatever.[1]
—IRVING HOWE

Wait—geeve a leesten. I hoid a good jukk
rigudding Cohen wit de lawyer! Off cuss
I couldn't tell it witt de dialect!
I'll hev to spick it plain!![2]
—MILT GROSS

1. Irving Howe, *The World of Our Fathers* (New York: Schocken Books, 1976), 404.
2. Milt Gross, *Dunt Esk!!* (New York: Dorian, 1927), 152.

Introduction GEEVE A LISTEN!

Ari Y. Kelman

Milt Gross had an ear for comedy. He could hear humor in the recessed corners of American poetry, in great myths, in historical tales, and in the airshafts of Bronx tenements. In classic slapstick style, Gross created a comic universe in which nobody could avoid a pratfall, a malapropism, or a well-placed anachronism that lowered the gods to human status and humans a bit lower still. Nothing escaped his comic ear or his sharp pen, both of which he showcased in an avalanche of cartoons and newspaper columns steeped in the sounds and culture of immigrant Jews.

Whether readers considered him a linguistic innovator or a peddler of derogatory stereotypes, Gross's popularity during the 1920s and 1930s indicates how widely his work resonated with American audiences. In his columns and cartoons, Gross captured the comedy of tensions between immigrant Jews and their American-born children during a period in which radio and movies began to speak, cartoons began to reach maturity, and ethnic comedy crested. His work from the late 1920s amplified these transitions and the attendant negotiations among sound, cartoons, humor, and ethnic identity in the United States.

From the late 1910s until the mid-1940s, Milt Gross turned his gift for hearing the humorous overtones of well-worn

[1]

stories and the comic undertones of daily immigrant life into a series of wildly popular cartoons and columns. Riding that wave of popularity, Gross collected his works and published them in books that captured the attention and appreciation of American audiences and critics and earned reviews in publications as diverse as the *New York Times*, the *New Republic*, and the *American Hebrew*. In Jewish-English dialect, Gross plumbed the outer limits of a new American immigrant language and found in it an almost endless supply of humor, ego-deflating parody, and fantastical characters with names like Count Screwloose of Tooloose, Looy dot dope, Mrs. Feitlebaum and her husband Mow-riss, their neighbor Mrs. Yifnif, Boitrem Mitzic, Hiawatta, Clippetra, Dave who owned an eponymous delicatessen, Phool Phan, Izzy Able, Joe Runt, Henry Peck, Iggy (a dog), and Otto and Blotto.

Many of these characters gave Gross a platform for perfecting his skill at writing in a Jewish-English patois in which people wondered about having their children "waxinated" or complained about riding the subway "pecked opp woister ivvin from soddinz in a teen box."[3] In his weekly columns and cartoons, Gross created a world where people regularly got caught standing around in their "Bivvy Dizz," and in which one character could explain to another that humans had been "suspended from monkehs," as they evolved from "pre-hysterical mounsters." More than a peddler of malapropisms or a trader in the remnant ethnic types from the vaudeville stage, Gross inherited both conventions, turning them upon themselves to offer a broader commentary about what Jewish ethnicity sounded like in the United States.

3. Milt Gross, *Nize Baby* (New York: Dorian, 1926), 77.

Yet, as Gross and his cast of characters became more popular and his audience grew, he moved away from dialect humor and toward a more easily accessible cartoon form that replaced the specificities of Jewish immigrant life and accent with urban life painted with a broader comic brush that relied more on sight than sound. In the most graphic example of this trend, in 1930 he published a novel that used no words at all, rendering its story instead over more than 150 hand-drawn plates. When he returned to the newspapers in the mid-1930s, his Yiddish accents nearly disappeared in favor of the broad slapstick humor of pratfalls, arrogant people being brought low, people falling down stairs, children besting adults, and people getting hit by hammers or anvils, falling off cliffs, or otherwise on the verge of encountering pain, both physical and emotional, all for the delight of his audience. The strips he produced during this period included the beloved "Count Screwloose," "That's My Pop!" and "Dave's Delicatessen," and they relied on an almost endless supply of sight gags, formulaic jokes, and illustrated punch lines. These cartoon strips represent his most popular legacy, but they do not capture his most sophisticated, insightful, or critical work.

Is Diss a System presents the earlier work on which Gross built his career in order to attend to his brand of humor that cut closer to the immigrant bone. Collected from the five books he published between 1926 and 1928, this volume presents Gross's versions of family dramas, historical figures, Greek myths, and classic poetry retold and reprocessed through the filter of immigrant Jewish life. Gross's cartoons and columns also offer a running commentary on the aural culture of the United States in the 1920s, where accent and elocution figured in national debates about immigration and education as much

as they did in the emergent popular-cultural forms of radio and "talking pictures." A critical voice in a much larger conversation about the sound of America at the end of the 1920s, Gross exploited the relationship between ethnic humor and ethnic identity to amplify its comical, cultural, and critical undertones.

THE DEVELOPMENT OF A STYLE

Born in 1895 to Jewish immigrant parents from the Russian Empire, Gross grew up in between Yiddish and variants of immigrant and American English. Although he used those differences to fuel his writing, his first jobs focused on illustrating. He began his career as a copy boy in the *New York American* before arranging a job during the 1910s in the art department of the William Randolph Hearst–owned daily, the *New York Journal*. There, he worked as an apprentice to Tad Dorgan, a popular and influential illustrator who worked primarily on the sports page. In addition to providing illustrations to accompany news items, Dorgan also developed a widely popular comic strip and his own regular column. As Dorgan's assistant, Gross contributed illustrations to the sports page, but more importantly, he studied how Dorgan combined his work as a writer, illustrator, cartoonist, and humorist. Alongside Dorgan, Gross developed his first few short-lived cartoons, including, "Phool Phan Phables," "Izzy Human," "Amateur Night," and "Sportograms." In form and content, these early cartoons show Gross developing his craft by copying both Dorgan's style of illustration and his approach to the interplay between image and text.

When Gross had occasion to work outside the sports pages, he continued to develop his sense of humor and style, and he

expanded the kinds of items he contributed under Dorgan. Gross began to draw on stories and situations from other parts of the newspaper. Never one to pass up a pratfall, Gross focused his attention on illustrating the most humorous, off-beat, and occasionally off-color news items he could find. And, given that he worked for a Hearst newspaper, funny human-interest stories proved easy to come by. Often, Gross culled headlines, added illustrations, and created a kind of one-panel cartoon that blended real news with his fanciful imagination. Typically, they sounded something like this: "The Humane Society got after Senator Snifter last night for leaving his gin where the cats could get at it." Or this: "Mortimer Mitzic screamingly promised never again to use the vacuum cleaner to remove the snow from the sidewalk."[4] Encouraged by the humor and outrageousness of some of the stories that made it to press, Gross blended fictional and actual news stories, sometimes making it difficult to tell the difference.

In 1917, Gross enlisted in the army to serve in World War I. He did not see combat and instead spent much of his time at Camp Gordon, in Georgia, where he continued cartooning. As an enlisted man, Gross published cartoons in the *New York Globe and Commercial Advertiser*, and as an artist and storyteller, his work began to mature, moving from illustrations of news items toward drawings that captured a more integrated relationship between image and narration. During this time, Gross continued working almost exclusively in one-panel comics that commented on and mocked the daily trials of life in the army. These comics, which he signed "Private Milt Gross," usually focused on a fictional character named Sidney

4. *The Evening Journal*, Sunday, September 13, 1914.

Sapp and followed him as he found ways to shirk work or avoid getting up too early. In this way, Gross predicted Irving Berlin's famous account of life in the army, "Oh! How I Hate to Get Up in the Morning," which Berlin wrote for an army fund-raising revue in 1918.[5]

At this stage of his career, Gross avoided ethnic accents and comedy, focusing instead on the cartoon form and on telling jokes for the widest possible audience. Upon his release from the army, Gross began working in animation, and contributed to no less than twelve animated films for the legendary animator John R. Bray. He also continued developing his skills as a cartoonist in middle-brow, family-focused cartoons like "Hitz and Mrs" and "Mr. Henry Peck and His Family Affairs," both of which used the broad palette of family conflict for their humor. Though hardly innovative, his work proved popular enough to keep Gross employed and allowed him to continue developing his talents as an artist and a humorist. More importantly, his early strips gave him occasion to begin moving away from single-panel cartoons and to experiment with the longer, multipanel form, a development that paralleled the changes in cartooning at that time.[6]

While working out his skills on tame fare, Gross returned to the illustrated news story in a column called "Gross Exaggera-

5. Berlin's chorus goes, "Oh! how I hate to get up in the morning / Oh! How I'd love to remain in bed / For the hardest blow of all, is to hear the bugler call / You've got to get up, you've got to get up, you've got to get up this morning / Some day I'm going to murder the bugler / Some day they're going to find him dead / I'll amputate his reveille, and step upon it heavily / And spend the rest of my life in bed." Published 1918, by Waterson, Berlin, and Snyder (New York).

6. Bill Blackbeard and Martin Williams, ed., *The Smithsonian Collection of Newspaper Comics* (Washington, DC: Smithsonian Institution Press, 1977); Ivan Brunetti, *An Anthology of Graphic Fiction, Cartoons, and True Stories* (New Haven, CT: Yale University Press, 2006); Ian Gordon, *Comic Strips and Consumer Culture, 1890–1945* (Washington, DC: Smithsonian Institution Press, 1998); Jerry Robinson, *The Comics: An Illustrated History of Comic Strip Art* (New York: Putnam, 1974).

tions," which ran in the Pulitzer-owned *New York World* and found a national audience through syndication. It began as a collection of humorous news headlines, which Gross illustrated with small, cartoonish sketches. Soon, however, the column developed away from the illustrated news story format and came to rely more and more on Gross's imagination for content. Through the column, Gross cultivated a handful of main characters around a loosely constructed narrative about the lives and relationships of residents in a New York tenement.

In this reinvented column, Gross stretched out creatively and allowed his keen ear for accents and interactions to guide his pen, rather than forcing the narrow frame of the illustrated news story to dictate his narrative. Moving away from the traditional vaudeville-style setup-and-punchline humor that tended to dominate panel-based cartoons, Gross explored the more subtle humor embedded in the intricacies of social situations and the art of aural caricature. This new form became almost immediately audible in characters like Mrs. Feitlebaum and her husband Morris, whom Gross rendered onomatopoetically as "Mow-riss." Sharing space in Gross's imagination, Mrs. Goldfarb, Mrs. Klepner, and Mrs. Yifnif developed into full-blown characters, supported by a cast of obstreperous children and wise-cracking siblings, with a little neighborhood gossip thrown in for good measure.

THE SOUNDS OF IMMIGRANTS

Each of these elements drew directly on the experience of Jewish immigrant life in America's urban centers. If surnames like Goldfarb and Feitlebaum did not evoke Jewish immigrants powerfully enough, the names of his characters, including

Mow-riss and the children Looy and Isidore, also echoed popular choices of "American-sounding" names for Jewish immigrants. More generally, Gross peppered his columns with other aspects of immigrant life like pushcart vendors and parents who worried about their children running in the streets instead of going to school. Characters worried about money and made much hay of going to the movies or the doctor. The conversations Gross imagined among the building's residents echoed the immigrant experience of life in crowded tenements, where airshafts became virtual news feeds, a fact of tenement life made popular by Gertrude Berg in her role as the matriarch of the Goldbergs, the eponymous family of the popular radio (and television) program. In fact, "Gross Exaggerations" appeared under the title "Down the Dumbwaiter" in at least one publication.[7] The close proximity of families living in a tenement building meant that neighbors often knew a little too much about one another, a situation that, in turn, fueled the gossip that kept good neighbors close and interesting neighbors even closer.

Gross's focus on Jewish immigrant families gave him plenty of material to work with as he caricatured stern fathers, wise-cracking children, and gossipy mothers with equal flair, drawing heavily on the familial tensions that often developed along the generational lines of immigrant life. Looy dot dope constantly taunted his father in youthful American English, while Mrs. Feitlebaum and Mrs. Yifnif traded stories about the oddities and incongruities of life in America. Upstairs, Mrs.

7. Though the Milt Gross papers do not contain any references to a column of this name, a reviewer of *Nize Baby* claimed this column as the predecessor of the book. "Gross Exaggerations," in all likelihood, included a series that Gross called "Down the Dumbwaiter," to which the reviewer referred, but it was not the title of the column itself. See Robert Littell, "Nize Baby," *New Republic*, June 9, 1926, 93–94.

Goldfarb became a voice of the concerns of many immigrant parents as she tried almost anything just to get her baby to eat. To that end, she retold popular stories like "Jack witt de binn stuck" or the "ferry-tail from Elledin witt de wanderful lemp" in order to distract her child from the task at hand. In exchange for listening and eating, Mrs. Goldfarb rewarded her baby and her readers with closing comments like, "nize baby itt opp all de farina." Or oatmeal, or cereal, or whatever else was on the menu.

Mrs. Goldfarb provided a ready vehicle for retelling accented versions of popular stories, and though Gross created her character, he did not create her type. The immigrant mother concerned with feeding her children emerged from an anxiety over the nourishment and care of immigrant children and turned into a practice that writer Alfred Kazin called "the veneration of food in Brownsville families."[8] Gross's attention to details like these infused his cartoons and his characters with the experiences of immigrant families in order to cultivate a cast of characters through which he could speak slapstick.

By 1926, "Gross Exaggerations" had become popular enough for Gross to collect his columns and publish them as his first book. Borrowing from Mrs. Goldfarb's complimentary refrain, he called the collection *Nize Baby*. The book proved so successful that it spawned interest from radio and film and made Gross a national celebrity. In 1927, a Hollywood studio began production of a live-action adaptation that made it into preproduction before falling off the studio's docket, ironically

8. Kazin, quoted in Hasia Diner, *Hungering for America: Italian, Irish, and Jewish Foodways in the Age of Migration* (Cambridge, MA: Harvard University Press, 2001), 192. See Diner, pp. 191–93, for a fuller discussion of this particular phenomenon.

because, in all likelihood, of the coming of sound to film.[9] Later, in 1929, New York radio station WPCH hosted writer Himan Brown reading chapters of the book on the air.[10] The book's success and popularity encouraged Gross to continue mining the rich vein of Jewish accents and American literature. In 1926, Gross followed the publication of *Nize Baby* with his version of Henry Wadsworth Longfellow's "Hiawatha," which he published in a richly illustrated book of its own "witt no odder poems." Gross extended his aural updating of Longfellow in a rendition of "wott it rilly happened to Paul Rewere," took on Edgar Allan Poe in a version of "The Raven," and published his own account of "De Night in de Front from Chreesmas," in December 1926. His dialect version of Clement Clark Moore's original again proved so popular that Gross published it under its own cover the following year.

Because Gross was now something of a literary celebrity, his treatments of literary classics began to attract wider and wider attention from other quarters. Soon, *Cosmopolitan* magazine hired him to retell stories of "famous fimmales" in the accent he had helped make famous. With a circulation of well over one million readers, *Cosmopolitan* presented Gross with a new audience, and he did not disappoint, continuing to push the limits of dialect humor and parody through retellings of historical events. "Laty Godiwa," "Clipettra," and "Loocritchia Borgia" all received the Gross treatment, as did the "hize hages," the story of "How It Got Bomped Huff Julius Sizzer," "How it Got Inwanted Tenksgeeving Day," and other tales from American history like the "Bustun Tipotty" and "Bonker

9. *New York Times*, August 26, 1928, 98.
10. Himan Brown also worked for Gertrude Berg, during *The Goldbergs'* early years, and went on to be a successful radio writer and producer.

Heel." He added some other stories, collected them under the title *Famous Fimmales witt Odder Ewents from Heestory*, and published the volume in 1928.

Importantly, and despite the density of his specific references to Jewish immigrant life and vocabulary, Gross relied almost exclusively on English, saving "nu" and "mozzletoff" for rare occasions. What marks Gross's style as Jewish, then, was not his vocabulary but his accent and, even more tellingly, his syntax. Gross wrote almost entirely in English *words* but in Yiddish *grammar*. Gross presented phrases like "wott it rilly happened" and "geeve a leesten" as literal translations from Yiddish that would be intelligible in English but remained marked as Yiddish in their construction. "Sotch a excitement wot is going on by you in the monnink, Mrs. Feitlebaum" is an almost exact grammatical translation from the Yiddish *"aza geruder vos geyt on bay aykh in der fri, Mrs. Feitlebaum."*

In this way, Gross fabricated a kind of unique English-Jewish speech for a general, largely non-Jewish audience. By relying on English vocabulary, Gross could still be understood, no matter how foreign his sentence structure. But the Jewish immigrants whose experiences informed Gross's characters and among whom he had grown up generally did not speak this way. Typically, the patois of Jewish immigrants featured far more Yiddish than English, interpolating English words or phrases when necessary or convenient. And American-born children who attended American schools did not adapt the syntax and grammar of their parents in as wholesale a manner as Gross presented it. Thus, Gross's particular brand of dialect ought not be read as documentary of Jewish immigrant speech but as itself a kind of audible fiction.

James Loeffler has argued that Gross provided a kind of linguistic bridge between Jewish novelists Abraham Cahan and Philip Roth, for the ways in which he rendered Yiddish syntax without Yiddish vocabulary.[11] Cahan, known best in his capacity as the editor of the Yiddish-language daily newspaper the *Forward*, and Roth, one of the United States's most celebrated twentieth-century authors, represent different points on the spectrum of Yiddish and English usage. Gross, Loeffler argued, supplied the "missing link" between the two because he did not interpolate English words into Yiddish, as Cahan did, nor did he employ Yiddish words in a largely English text, as did Roth. Rather, argues Loeffler, Gross used "Yinglish," a "third language" that mediated the movement in American Jewish literature from Yiddish to English. Working in neither language exclusively, Gross evoked Yiddish through an English vocabulary, allowing English vocabulary to sound Yiddish when set to the cadences of Yiddish grammar. The construction of this immigrant dialect as something different than the combinations of Yiddish and English that appear in Henry Roth's *Call It Sleep* or Abraham Cahn's *The Rise of David Levinsky* indicate that Gross concerned himself less with dramatizing immigrant life than with playing with its representation.

In fact, as he finished *Famous Fimmales*, Gross contributed a series of articles for *Smart Set* magazine, an imprint of *McClure's* intended for younger readers, that articulated just that. This assignment represented a significant departure for Gross. Though he wrote them shortly after *Famous Fimmales*, they featured an accent more hard-boiled street than immigrant tenement.

11. James Loeffler, "Neither the King's English nor the Rebbetzin's Yiddish," in Marc Shell, ed., *American Babel: Literatures of the United States from Abnaki to Zuni*, *Harvard English Studies 20* (Cambridge, MA: Harvard University Press, 2002).

Once upon a time there lived up in the Ritzy section of the
Bronx, which is like sitting in a box seat in Loew's Theater, a
dame named Connie. Now this Connie belonged in the category
of cats, who spend all their time faking and four-flushing
and dishing dirt and promoting scraps between friends and
panning people behind their backs and then smiling to their
faces which she didn't mean at all, but she figured it fooled
them, and it did.[12]

Though accented differently, this story highlights Gross's gift
for mimicry. Reading this alongside his Jewish-dialect work
highlights two important facts. First, it reveals his talent for
echoing the content and form of popular genres like pulp
detective stories. Second, it reveals his inner English and the
fact that he, in all likelihood, did not speak with the accented
tongue of his immigrant parents. Gross put on the dialect of
his parents as he put on the English of Longfellow or Poe.
Thus, to read his work as an artifact of an immigrant would
be to misapprehend the sophisticated interplay between
English and Yiddish languages, and between American and
immigrant cultures, that circulated so freely in his work from
the 1920s.

Moreover, the style of his presentation during this period,
which relied so heavily on text and only secondarily on illus-
tration, derived directly from his apprenticeship under Tad
Dorgan, where news stories dictated the illustrations, not the
other way around. His early training emphasized stories over
illustrations, and as his style developed, it did so in conver-
sation not only with emerging forms of cartooning but also
in conversation with other venues of popular culture, like
newspapers, pulp novels, and magazines. Gross's style ampli-
fied and echoed these various influences, and attending more

12. "Just a Good Girl Scout," *Smart Set*, July 1929.

directly to questions of dialect will further clarify the sound of Gross's voice in and between English and Yiddish.

GROSS DIALECT

Gross's work is best approached by reading it aloud, and his ability to render ethnic dialects sets his work solidly apart from that of his contemporaries. Thus, reading it silently, to oneself, proves rather difficult, if not impossible. This is especially true for an audience some eighty years removed from the echoes of the accents that Gross captured in his writing. Turning a written text into an aural experience may seem awkward at first, but with practice, sounding out Gross's accent becomes both easier and more pleasurable.

Though told in deep dialect, Gross's parodies, like all parodies, capitalized on his audience's familiarity with the material being parodied. Gross, like his audience, had to know these poems and stories in order for his jokes to "work," and his ability to render them both familiar and strange yielded productive and humorous tensions. "Hiawatta" is funniest if one knows "Hiawatha," and his parody of Poe is funny because it evokes the original rhythms and rhymes of "The Raven."

Wance oppon a meednight drirry	Once upon a midnight dreary
While I rad a Tebloid chirry —	While I read a tabloid, cheery —
"Pitches Hinnan gatting lirry —	"Peaches Heenan[13] getting leery —
Odder Peectures on Page Furr"	Other pictures on page four"
Gredually came a whecking,	Gradually came a whacking
Tutt I: "Feitlebaum is smecking,	Thought I, "Feitlebaum is smacking
Witt a razor strep shellacking	With a razor strap shellacking

13. Frances Belle "Peaches" Heenan was the nickname of the fifteen-year-old child bride who sued her fifty-two-year-old husband, Edward West "Daddy" Browning, for a divorce in 1927. The salacious details of their stormy marriage, made public by their separation trial, became one of the most talked-about scandals of the year.

Goot for noting Isidore!	Good for nothing Isidore!
Smecks heem where de pents is lecking	Smacks him where his pants is lacking
In de rirr from Isidore	In the rear from Isidore
Wheech hez happened huft befurr!"	Which has happened oft before!"

Whether drawing on jokes from his other work—in this case, incorporating Mr. Feitlebaum and Isidore from *Nize Baby*—or accessing common experiences of Jewish immigrant life, Gross's dialect humor always played on two simultaneous tensions. The first, as with all parodies, highlighted the relationship between a parody and the original that it copied. The second emerged in the ongoing tension between English and Yiddish in Gross's work, which characterized his unique version of Jewish dialect.

In fact, with parody generally, the similarities between an original and its parody generate far more humor than do the differences, and the same principle is at work in Gross's dialect. Some of his malapropisms, like "speedometer"/"thermometer," or "pan"/"pen," seemed rather pedestrian for ethnic humor of the 1920s. But Gross excelled in his ability to reintroduce Yiddish words into English malapropisms in order to amplify their humor, as in his use of "shvitzbud" for "switchboard." In Yiddish, a "shvitzbud" is a steam bath, which, for immigrant Jews, would have referred to a public bath, many of which dotted the Lower East Side. The accent might have been funny to general readers, but the humor deepened if one understood the interplay of Yiddish and English in the immigrant context. Similarly, Gross also used his accent to fuel a sly sense of humor and light social commentary, as in his reference to a "Teefany ritz-watch," which played the fanciness of the

Tiffany name off the substitution of "ritz" for "wrist," turning the phrase into both a malapropism and a double entendre. Unlike his Yiddish-speaking contemporaries who faithfully translated works of English literature in order to make a claim on the possibility of integrating American and immigrant sensibilities, Gross amplified the cultural contradictions of immigrant life. Writing in a distinct version of Jewish-American dialect gave him access to a range of humorous overtones often absent from more faithful translations. When Gross published his version of Longfellow's epic poem "The Song of Hiawatha," he couldn't help but make the Great Plains sound like a tenement.

> On de shurrs from Geetchy Goony
> Stoot a tipee witt a weegwom
> Frontage feefty fitt it mashered
> Hopen fireplaze—izzy payments.

Through a subtle class joke about "izzy payments," Gross amplified the ways in which immigrant Jews could never sound like Native Americans and implied that their residence in the United States still relied on an installment plan.

Gross was not the first American Jewish writer to translate "Hiawatha." In 1910, prolific Yiddish translator and playwright Yehoash published his "Lid fun Hayavata," which Alan Trachtenberg called a "bridge into America" for Jewish immigrants. Trachtenberg claimed that the translation "recalls a fleeting radiant moment when becoming American in Yiddish, by creating an Indian mediation for a Yiddish-American identity, seemed a plausible prospect."[14] But, if Yehoash's version

14. Alan Trachtenberg, *Shades of Hiawatha: Staging Indians, Making Americans, 1880–1930* (New York: Hill and Wang, 2005), 169.

promised a "bridge into America," then Gross's version supplied the tools for tunneling under that very prospect.

By making a teepee sound like a tenement, Gross indicated that he did not share Yehoash's hopes that literature could help make immigrant Jews sound more American, or that translation could ever work alchemically to turn immigrants into Americans. Instead, Gross did just the opposite. In Jewish-English dialect, Gross mocked both Longfellow's original and Yehoash's Yiddish attempt to stage American identities in Yiddish. For Gross, the poem did not present a way to translate oneself into a new identity, but rather a vehicle for both amplifying and undermining the absurdity of such a process.

Nowhere is this sensibility more audible than in his version of Clement Clark Moore's "Visit from St. Nicholas," which Gross first wrote for his newspaper column in 1926 and then published as "De Night in de Front from Chreesmas" the following year.

> Twas de night befurr Chreesmas und hall troo de house
> Not a critchure was slipping—not ivvin de souze,
> Wot he leeved in de basement high-het like a Tsenator,
> Tree gasses whooeezit—dot's right—it's de jenitor!

Mimicking the rhymes of Moore's original, Gross turned his focus on the absurdities of tenement life, complete with a drunken, top hat–wearing janitor. Similarly, when Santa Claus does make an appearance, Gross could not resist the opportunity to comment.

> It stoot dere a ront jost so high teel de durr-knob
> De faze fool from wheeskers und smoking a curncobb,
> From de had to de hills sotch a werry shutt deestance

I naver befurr saw in hall mine axeestence
De nose it was beeg like de beegest from peeckles
I weesh I should hev sotch a nose fool from neeckles.

Comparing Claus's nose to a pickle anticipated the seasonal American Jewish tension, known as the "December Dilemma," wherein many American Jewish families experience alienation in the face of abundant and attractive Christmas decorations and sales. Unable or unwilling to participate in Christmas like his non-Jewish colleagues and the majority of his audience, but also unable to ignore it, Gross reworked the classic holiday poem in Jewish dialect and recast the "American folk icon whose legend at once celebrated the myths of the Gilded Age and critiqued its realities" in terms of a short figure with a nose like a particularly Jewish snack.[15] Like an immigrant ancestor of Irving Berlin's "White Christmas," Gross's "Chreesmas" drew out the dissonance between Jewish sentiment and the holiday season.

Gross deployed dialect to amplify these larger cultural contradictions, and he attended most consciously and carefully to the issue of accent, which, for Jewish immigrants and their children, became a particularly fraught site for trying on and trying out American identities. American Jewish literature from the early twentieth century contains numerous accounts of men shaving their beards and women adopting more contemporary fashions in their attempts to Americanize. Likewise, changing one's name from Yankl to Jack or Soreh to Sadie represented a similar strategy, as did adopting American eating habits and participating more broadly in the American culture

15. Penne Restad, *Christmas in America: A History* (New York: Oxford University Press, 1996), 143.

of consumption.[16] And certainly, for children of immigrants or people who immigrated as children, attending American public schools provided an institutionalized venue for learning American culture and behavior. But, for all the cosmetic and ideological changes that immigrant Jews could assume, one of the most difficult to shed and most revealing was the accent.

In print, as Hana Wirth-Nesher argued, "the bulk of Jewish American literature was written by immigrants or the children of immigrants for whom Yiddish was their mother tongue, and English an acquired language and their passport to acculturation."[17] Wirth-Nesher argued further that "[f]or immigrant writers, English language acquisition often became a passion," appearing as a frequent theme in their work.[18] Abraham Cahan's David Levinsky recalled with some shame that studying Talmud as a youngster left "a trace . . . [w]hich still persists in my intonation even when I talk of cloaks and bank accounts and in English."[19] Likewise, the protagonist of Samuel Ornitz's novel, *Haunch, Paunch, and Jowl*, recalled the precariousness of the relationship between Yiddish and English in Jewish neighborhoods. "Yiddish, the lingo of greenhorns, was held in contempt by the Ludlow Streeters who felt mightily their Americanism."[20] Writing in a memoir, Alfred Kazin recalled his horror at the possibility that his accent would betray him

16. Andrew Heinze, *Adapting to Abundance* (New York: Columbia University Press, 1992); Jenna Weisman Joselit, *The Wonders of America: Reinventing Jewish Culture, 1880–1950* (New York: Hill and Wang, 1994).

17. Hana Wirth-Nesher, *Call It English: The Languages of Jewish American Literature* (Princeton, NJ: Princeton University Press, 2006), 9.

18. Ibid., 9.

19. Abraham Cahan, *The Rise of David Levinsky* (New York: Harper and Brothers, 1917), 28.

20. Samuel Ornitz, *Allrightnicks Row: Haunch, Paunch, and Jowl, the Making of a Professional Jew* (New York: Markus Wiener Publishing, 1986 [1923]), 14.

in school and on the street. "Our families and teachers seemed tacitly agreed that we were somehow to be a little ashamed of what we were," he recalled. "It was rather that a 'refined,' 'correct,' 'nice' English was required of us at school that we did not naturally speak, and that our teachers could never be quite sure we would keep. This English was peculiarly the ladder of advancement."[21] Similarly, Mary Antin, whose autobiography, *The Promised Land*, tells a classic tale of Americanization, recalled her reaction to successfully learning American elocution. "When at last I could say 'village' and 'water' in rapid alternation, without misplacing the two initials, that memorable word was sweet on my lips."[22] Although eventually she claimed that she could think and write without an accent, her speech remained marked.

These writers either fictionalized or recalled a sense that accent meant obstacle. But Gross reveled in the presentation of that accent in loud, idiosyncratic spelling that called attention to precisely the difficulties that these authors, among others, tried to transcend. Any page of Gross will reveal something that looks and sounds like this account of a trip to the doctor:

> First Floor—So I went by a abominal spashaleest wot he should geeve me a torrow exzemination. Hm!—you should see a exzemination, Mrs. Feitlebaum. De hott, wid de longs, witt de hears, wid de heyes, witt de trutt witt de . . .
> Second Floor—So wot was de henswer?
> First Floor—De henswer is wot I'm cerrying too motch access wait witt supurpleous flash.

21. Alfred Kazin, *A Walker in the City* (New York: Harcourt Brace, 1951).
22. Mary Antin, *The Promised Land* (New York: Houghton Mifflin, 1912), 166. Quoted in Wirth-Nesher, *Call It English: The Languages of Jewish American Literature*, 58.

Written in deeply accented, at times almost unintelligible English, Gross's stories and poems amplified precisely what so many Jewish immigrants found to be most embarrassing. Their embarrassment personalized what had become part of a broad, politicized public sentiment against immigrants and immigration that culminated in the passage of the 1924 Johnson-Reed immigration bill, which effectively shut the door on immigrants from Central and Eastern Europe and the Far East.[23] While American nativism and "one hundred percent Americanism" contributed to a politically unpleasant environment for immigrants, the cultural realm proved far more welcoming. Jewish entertainers like Al Jolson and Sophie Tucker became national celebrities, Jewish men owned most of Hollywood's major studios, and Jewish songwriters churned out hits on Tin Pan Alley.

In terms of language, Americans began expressing a kind of pride in "American English" that drew specifically upon the contributions of jazz-age slang and immigrant groups. In 1925, the introductory editorial to the new journal *American Speech* articulated this sensibility:

> Something of the daring and independent seems at last to be on the way of achievement. The rule of the grammar and the spelling book and the dictionary are not over. "Better English" weeks still support the old regime, to abandon which, entirely, indeed, in America would mean anarchy. But a wealth of fresh words and phrases, products of new conditions of life, are being made to enrich an older language.[24]

23. One of the best accounts of this movement in American history is John Higham, *Strangers in the Land: Patterns of American Nativism, 1860–1925* (New Brunswick, NJ: Rutgers University Press, 1955).

24. George H. McKnight, "Conservatism in American Speech," *American Speech* 1, no. 1 (October 1925): 16.

By amplifying his own version of Jewish immigrant dialect, Gross tried to avoid the anxieties of his Jewish literary counterparts and situate himself instead among the new producers of American slang. The punch lines of his cartoons like "banana oil" (meaning "nonsense"), "dunt esk," and "is diss a system," became national catch phrases. Reviewers and critics praised Gross's innovative style and his contributions to contemporary language. The *New York Times'* review of *Dunt Esk!* went so far as to imagine it as a kind of New York–ish Rosetta Stone for future researchers. "The book also will probably be diligently sought by future etymologists for the light it will throw on the sources of those dialectic changes in the English language which are even now puzzling transient visitors in New York."[25] Other reviewers in mainstream American publications praised his book as a "masterpiece of correct dialect" and noted that Gross's accents "are all the more ludicrous for being phonetically faithful."[26] George Phillip Krapp, one of the first linguists to study American dialects, offered his approval of Gross's innovative application of dialect. "It takes a kind of inventive genius to write a language as astonishing, and withal as persuasive, as that which Milt Gross puts into the mouths of the Feitlebaums and their neighbors. Here language has become a highly ingenious game, played for its own sake."[27] Likewise, in *American Humor,* a massive study of American culture, Constance Rourke praised Gross's Mrs. Feitlebaum, whose "linguistic accomplishments outstrip those of any other exponent of

25. "Theory and Practice of Nonsense," *New York Times,* 16 January, 1927, BR7.
26. Ernest Bates, "American Folk-Lore," *Saturday Review of Literature,* July 10, 1926, 913–14. Robert Littell, "Nize Baby," *New Republic,* June 9, 1926, 93–94.
27. George Phillip Krapp, "The Psychology of Dialect Writing," in Juanita V. Williamson and Virginia M. Burke, eds., *A Various Language: Perspectives on American Dialects* (New York: Holt, Rinehart, and Winston, 1971), 25.

the early dialect tracts."[28] And H. L. Menken advocated adding Gross to Funk and Wagnalls's list of the "ten most fecund makers of the American slang then current."[29]

Gross's welcome in the Jewish press proved somewhat less warm. The *Jewish Daily Forward*, the most popular Yiddish newspaper of the time, only mentioned Gross in passing, and then, only on the newspaper's weekly English page, a feature aimed at attracting younger readers. One example used "Nize Baby: Et Up All de Cabbage," as the title of a joke reprinted there, indicating Gross's popularity but not his worthiness of a full book review or column.[30] In the Yiddish parts of the paper, authors and linguists weighed the significance of Harkavy's English-Hebrew-Yiddish dictionary and what it meant for the future of Yiddish as a "language without children." But none mentioned Gross and his popular uses of Yiddish dialect and accent in English. For the headier columnists and linguists of the Yiddish press, Gross did not quite count, either as literature or as a serious enough work of linguistics to warrant attention.

Der Tog, the second most popular Yiddish newspaper, likewise found Gross to be part of the popular-cultural environment but not deserving of a whole article or review of either of his first two books. Tellingly, the only direct references to Gross appeared, as in the *Forward*, on the newspaper's English page. This time, however, they appeared in Lillian Eichler's regular column dedicated to the study of proper English. In June 1926, she offered Gross as an ideal example of how the "foreign born" ought not to speak:

28. Constance Rourke and Irving Stone, *American Humor: A Study of the National Character* (Garden City, NY: Doubleday Anchor Books, 1931), 290.

29. H. L. Mencken, *The American Language: An Inquiry into the Development of English in the United States*, 4th ed. (New York: Knopf, 1939), 560.

30. *The Jewish Daily Forward*, Sunday, July 11, 1926, E3.

Milt Gross with his "Nize Baby" is unquestionably influencing the New York accent, for wherever one goes—in the subway, on the street, even at parties and dinners—one hears inevitably the amusing unusual patter made popular by the gay columnist. But however we may chuckle with Milt Gross and his comic characters—and their still more comical pronunciation—we realize the importance of good speech.[31]

The article continued to outline ten suggestions for the "elimination of the foreign accent." (Breathe deeply while speaking, avoid harsh, guttural tones, try not to be conscious of your accent, practice reading aloud.) Although Eichler did not approve of Gross's English, her reference to him illustrated his popularity, even as he set a perfect example of the "hybrid, mutilated English" that one ought to strive to overcome. Notably, Eichler omitted mention of Gross's Jewishness.

The Yiddish press nodded to Gross, but only as evidence of a broader American popular culture rather than as a representative voice from within their communities. Similarly, in the English Jewish press, Gross received some attention, but mostly as a humorist and not as a Jewish writer. The *American Hebrew*, an English newspaper that catered primarily to the English-speaking and typically better-established German Jewish communities, mentioned Gross a handful of times, and even reviewed his *Hiawatta*, but focused its comments on Gross's use of "lengwidge" that would have caused Longfellow to "drop dead again." "His sublime impudence," one article explained, "is such that it never occurs to Milt Gross of 'Nize Baby' fame to apologize to any one. His business is merely to make people laugh."[32] Ironically, as in the Yiddish press, the

31. Lillian Eichler. "The Importance of Correct Speech," *Der tog*, June 20, 1926.
32. "The World of Books," *American Hebrew*, December 3, 1926, 198.

American Hebrew omitted Gross's Jewishness, focusing instead on his sense of humor and "comic illustrations."

But Gross's accent proved too loud to simply ignore. Working along the comic lines of parody and language, Gross repeatedly called attention to the Jewishness of his dialect and refused to let his writings self-consciously deny their immigrant roots. He parodied classic literature in ways that confused sound and substance, and he made his biggest contributions not only in American Jewish literature but also in the emergent conversation about American English, a formulation that owed less to strict standards than to porous boundaries. Yet, the growth of the Gross dialect did not only occur on paper. Rather, Gross worked in dialogue with American vaudeville and its history of dialect-driven humor, as well as in the context of radio and the early days of talking motion pictures.

ACCENT AND AURAL CULTURE IN THE 1920S

Writing in newspapers and working so deeply in dialect, Gross used the medium of print but his work made its greatest impact on American aural culture. During the 1920s, American aural culture underwent some significant changes; "American English" began embracing the innovations of immigrant groups and jazz-age slang, radios became practically ubiquitous, and even motion pictures learned to speak. In some ways, new media extended the reach and scope of older performance styles, as stock character types migrated from the vaudeville stage to radio and film. Many of the ethnic stereotypes that defined vaudeville performance persisted, and Gross certainly benefited from their ongoing popularity. But he approached this phenomenon by turning the sounds of Jewish immigrants

into a different kind of performance that thrived on the aural culture of the late 1920s.

Although he worked in print media, his idiosyncratic spelling and Yiddish syntax made it almost impossible to read his work silently. His columns and books did not lend themselves to quiet, solitary, disciplined reading; they practically beg to be read aloud. One critic from 1927 observed, "If you are able to read the peculiar dialect of Milt Gross aloud (it cannot be read any other way), you will enjoy his 'De night in front from Chreesmas.'" Another reviewer, citing Gross's successful use of dialect, concluded almost precisely the opposite but acknowledged the urge to read Gross aloud. Gross's books, he wrote, "have the high merit of being almost impossible to read aloud, unless one is born on Grand Street," referring to one of the main thoroughfares of New York's Jewish East Side.[33] Inverting the sound of a "proper" accent meant succumbing to Gross's version of American English. For that critic, knowing Gross's accent seemed to be a way into reading his work, while for Gross more generally, reading provided an opportunity to learn the accent.

Gross urged his readers not to read quietly but to perform his work aloud, even when reading to themselves. And in so doing, he placed Jewish dialect in the mouths of non-Jewish readers, challenging them to approach immigrant English with as much concern for an alien accent as his fictional characters and his real-life peers did in their approach to English. By encouraging his readers to speak like Jewish immigrants, Gross inverted the anxieties Jewish immigrants felt about their accents, foisting those anxieties on his non-Jewish or nonimmigrant readers.

33. Robert Littell, "Nize Baby," *New Republic*, June 9, 1926, 93–94.

In this way, Gross evoked the American tradition of ethnic and racial performance of vaudeville, but with a twist. Vaudeville caught on in the early 1880s, roughly coincident with the surge in immigration from Europe, and it developed as cheap entertainment for the growing urban masses. Alongside musical performances and novelty acts like those of musicians or dancers, vaudeville shows often featured highly stylized performances of different ethnic types. By one historian's account, "Irish acts predominated, blackface ran a close second and Dutch, or German, dialect made an important third."[34] Each ethnic type had its tell-tale props: Irish could be recognized by their cape coats and lace falls, African Americans by blackface, and Jews by long black coats, shabby pants, and pointy beards. But more than that, even, their accents revealed their ethnicities.

In fact, in his history of vaudeville, Douglas Gilbert differentiated between "dialect" comics and the "extraordinary burlesque" of other performers.[35] Even with respect to blackface, he differentiated between "negro impersonators," who used dialect, and "blackface performers," who did not.[36] Another historian argued that the dialect comedians of vaudeville, who often came from the ethnic communities they parodied on stage, created the ethnic types they parodied not by representing them faithfully but by creating syntheses of immigrant life that drew on both the differences between ethnic groups and the similarities among working-class members of this new mass-entertainment audience. Performers captured this dynamic in their dialect. "Their language . . . was neither

34. Douglas Gilbert, *American Vaudeville, Its Life and Time* (New York: McGraw Hill, 1940), 62.
35. Douglas Gilbert, *American Vaudeville, Its Life and Time*, 73.
36. Ibid., 80.

a fabrication nor the actual patter of city streets. It combined elements of popular culture—Tin Pan Alley—and elements of everyday speech."[37] Thus, vaudeville performers worked at the intersection of the thin lines that divided mass culture from real speech and one ethnic group from another, where language played a central role.

This history of vaudeville meant that New York audiences of the 1920s could tell the difference between the different ethnic caricatures just by listening to them. Though it began on stage, dialect became an audible art. In fact, the most popular "talking books" of the 1910s featured people performing ethnic characters like Russell Hunting's Irish "Casey," Frank Kennedy's "Schultz," Cal Stewart's hillbilly "Uncle Josh" character, or George Graham's "Colored Preacher."[38] The most popular of these spoken word recordings from the 1910s featured vaudevillian Joe Hayman's rendition of "Cohen on the Telephone," in which Cohen, in Jewish dialect, attempted to call a repairman to his home.[39] With the advent of radio in the 1920s, a similar process took place as accent and dialect performers led the way in the new aural medium. The first two programs to find national audiences during the late 1920s featured dialect comedy in the form of the blackface-based *Amos 'n' Andy*, and the Jewish dialect humor of Gertrude Berg's *The Goldbergs*, both of which aired on NBC.

37. Kerry Soper, "From Swarthy Ape to Sympathetic Everyman and Subversive Trickster: The Development of Irish Caricature and American Comic Strips between 1890 and 1920," *Journal of American Studies* 39, no. 2 (2005): 106

38. Jason Camlot, "Early Talking Book: Spoken Recordings and Recitation Anthologies," *Book History* 6 (2003): 159.

39. Joe Hayman, "Cohen on the Telephone," Columbia A-1516 (1914). The success of Hayman's "Cohen" recording spawned a whole host of mimics, including Monroe Silver, who recorded no fewer than seven different variations on the theme. See Michael Corenthal, *Cohen on the Telephone: A History of Jewish Recorded Humor and Popular Music, 1892–1942* (Madison, WI: Yesterday's Memories, 1984).

Not everybody embraced the persistent popularity of dialect humor, however. Radio's elite attempted to enforce a standard for proper American diction, but formal English pronunciation found itself losing the struggle over broadcast English. Radio historian Michelle Hilmes noted, "A breezy, slang-filled style of speech soon became the preferred radio mode, and networks and other bastions of 'correct English' fought a losing battle to preserve the finer points of diction and pronunciation."[40]

Even with the development of phonography and radio, audiences, apparently, still wanted to hear the same ethnic humor that they heard from the vaudeville stage. As with the example of Gross's poetry parodies, the similarities between actual speech and performed dialect became the source of a performance's humor. As one scholar has argued with respect to blackface, "while minstrel show audiences may have been predisposed to believe some rather absurd things about real blacks, even those audiences would have had to have been aware of the differences between Standard American English and Black English Vernacular in order to comprehend some of the verbal subtleties embedded" in blackface entertainment.[41] Recognizing difference required recognizing similarity. The humor of malapropism, which provided the motor for much ethnic comedy, required listeners to know the difference between, for example, a "tournament" and a "tourniquet." But Gross upped the ante on the audibility of this kind of humor, spelling almost everything phonetically and forcing his audience to recite rather than read quietly.

40. Michelle Hilmes, *Radio Voices: American Broadcasting, 1922–1952* (Minneapolis: University of Minnesota Press, 1997), 19.
41. William J. Mahar, "Black English in Early Blackface Minstrelsy: A New Interpretation of the Sources of Minstrel Show Dialect," *American Quarterly* 37, no. 2 (Summer 1985): 264.

By capitalizing on vaudeville recitation as a new mode of speech, Gross's version of reading provided yet another venue for inverting proper reading practices as taught in schools. Jason Camlot has written about Victorian recitation books that "functioned as elocution manuals and public-speaking primers for educated upper and upper-middle-class males who would be pursuing careers that might involve public speaking."[42] For Camlot, these books represented one aspect of a culture of recitation that included reading and reciting, alongside "talking books," as models of proper diction. In an American context, Joan Shelley Rubin has identified the three "prevailing purposes" in school-based recitation as "patriotism, the cultivation of moral sense and the desire to equip the young with memorized works that could provide 'comfort, guidance and sympathy' throughout life."[43] If recitation books and poetry recitals intended to reinforce proper behavior through proper diction, then Gross's writings aimed squarely at destabilizing those practices.

Ironically, the power of Gross's parody lay, in fact, in how closely it resembled recitation books. Jason Camlot found that by the end of the nineteenth century, many of these books began to include examples of dialect humor alongside Shakespeare or Poe.[44] *Dunt Esk!!* followed this model, beginning with Gross's version of "The Courtship of Miles Standish" before turning to follow the Feitlebaums at home and on vacation, retelling a Horatio Alger story and a version of Rip Van

42. Jason Camlot, "Early Talking Books: Spoken Recordings and Recitation Anthologies," 160.

43. Joan Shelley Rubin, "Listen, My Children: Modes and Functions of Poetry Reading in American Schools, 1880–1950," in Karen Halttunen and Lewis Perry, eds., *Moral Problems in American Life: New Perspectives on Cultural History* (Ithaca, NY: Cornell University Press, 1998), 261.

44. Camlot, "Early Talking Books," 160.

Winkle, and concluding with his version of "The Raven." Like recitation books, *Nize Baby* and *Dunt Esk!* present quite a varied array of texts. But unlike recitation books, the accent they intend to induce hardly sounded Victorian and did not necessarily provoke either patriotism or sympathy in those who read them aloud.

Gross wrote recitation books that encouraged American readers to speak like immigrant Jews. So, when Herman Mankiewicz reviewed *Nize Baby* for the *New York Times*, he misread it as a work of fiction, rather than a full parody of reading and elocution. Although he praised the book as "one of the most distinctive and promising contributions to American humor of recent years," he criticized Gross for failing to develop his characters as works of fiction typically did. "The exploits of the floors become tiresome and strained in the telling. There is an inherent artificiality to the characters, their dialect and their doings, that is un-annoying when they are presented briefly and with complete concentration upon their most entertaining values; repeated and repeated and repeated, their very earlier strengths and joys become nuisances."[45] Despite his praise, Mankiewicz seems to have read the book wrong. *Nize Baby* does not read well when approached like a standard work of fiction. It reads better aloud.

In practice, Gross's books functioned more like recitation collections or anthologies of scripts than like narratives. Moreover, the density of his dialect encouraged readers to approach his writings as aural artifacts rather than as the written word. Working within the aural culture of the 1920s, Gross absorbed the tradition of vaudeville only to reinterpret it, in print, for the

45. Herman J. Mankiewicz. "Nize Baby! Itt Opp All de Wheatinna!" *New York Times*, 11 April, 1926, BR7.

radio age. Likewise, as a product of public schools, he inverted the practice of elocution that his Jewish immigrant counterparts found so fraught, in order to make his audience imitate Jewish immigrants. Working almost exclusively within the audible milieu of Yiddish-accented English, and drawing on his urban experience, Gross sketched comical caricatures of neighborhood types and parodied beloved works of American literature. In contrast to Gilbert Seldes's characterization of "Krazy Kat" as an exemplar of "work which America can pride itself on having produced" for its evocation of classic narrative qualities, Gross's work in the 1920s flipped those qualities on their heads and regurgitated them in a manufactured Yiddish accent that left American culture and Americans sounding far stranger than even Krazy Kat creator George Herriman could have imagined.[46] Gross seemed less interested in evoking classic narratives than he did in poking fun at them and making them speak English set to Yiddish rhythms, which made even the most American figures and forms sound unimaginably strange.

THE SOUND OF STEREOTYPES

As an inheritor of the vaudeville-driven dialect-comedy tradition, Gross worked on the border between cartoons and text, where he rendered the sounds and sights of his Jewish immigrant characters. However, working within a primarily urban milieu, in a form that both traded on and traded in a broad ethnic audience, Gross included other ethnicities in his work, sometimes relying on and sometimes inverting stereotypical depictions of other minority groups. Yet, Gross's depictions differed significantly from other cartoon

46. Gilbert Seldes, *The Seven Lively Arts* (New York: Harper and Brothers, 1924), 242.

or silent film caricatures of ethnic types, and they did not render Jews according to conventions of anti-Semitic iconography. Nowhere are there references to the Jewish "cleverness" or facility with finances that typically appeared in vaudeville sketches about Jews. In his cartoons, Gross distributed sausage-shaped noses, push-broom mustaches, curly hair, and aprons indiscriminately, leaving his ear and those of his readers to pick up his ethnic cues.

As John Appel and Louise Mayo have illustrated, images of Jews in American popular culture date back to the mid-nineteenth century.[47] Appel noted that the earliest American image of a Jewish character spoke with "the accents of his British counterparts," and dated from 1834.[48] Appel argued further that "Jewish caricatures with non-British pedigree[s]" arrived with the 1877 debut of *Puck,* a weekly journal of American humor and satire.[49] *Puck's* success quickly gave birth to two other satire journals: *Judge* in 1881 and *Life* in 1883. According to Appell, *Puck* tended to depict Jews as "Wandering Jews, Shylocks and Fagins" but often also focused its satiric eye on anti-Semites in the United States and abroad.[50] Likewise, *Life* traded in depictions of Jews as "greasy parasites, scheming for the public dollar."[51]

To oppose to these images and others, Harry Hershfield created Abe Kabibble, the protagonist of his long-running cartoon, *Abie the Agent,* which made its debut in 1914. Hershfield's

47. Louise Mayo, *The Ambivalent Image: Nineteenth-Century America's Perception of the Jew* (Madison, NJ: Farleigh Dickinson University Press, 1988). And see John J. Appel, "Jews in American Caricature: 1820–1914," *American Jewish History* 71, no. 1 (Sept. 1981).
48. Appel, "Jews in American Caricature: 1820–1914," 109.
49. Ibid., 110.
50. Ibid., 113.
51. Ibid., 116.

strip preceded Gross by nearly a decade and revolved around a Jewish businessman who spoke with a light accent. In 1916, Hershfield explained that he disliked images of Jews that were "not at all complimentary to the Jewish people and not at all justified" and that he hoped to present Abe as "a clean-cut, well-dressed specimen of Jewish humor."[52] Therefore, in almost every respect, Hershfield presented Abe as an aspiring middle-class American. He owned his own company, wore a suit, and spewed patriotic sentiments that only occasionally included Yiddish words. In other words, "Abe must be recognizable as a Jew without giving validation to stereotypes."[53] Hershfield represented Abe's Jewishness primarily through his name and his accent, both of which would probably have resonated with urban audiences who could have recognized Abe as a Jew. However, Herschfield carefully crafted his cartoon so as to present his Jewish protagonist in as respectable a light as possible.

If Hershfield approached his work as an opportunity to depict Jews in a positive manner, Gross approached his writing and cartooning with a completely different set of concerns. Gross underplayed the power of his representations, opting instead for a more interactive approach to reading cartoons. He relied less on the characters to be "positive" or "negative" in their presence and found more power in playing with the ways his audience approached reading cartoons to begin with. Unlike Hershfield, Gross did not let the power of his depictions do the talking but instead made his audience try to speak

52. Hershfield, quoted in Richard Moss, "Racial Anxiety on the Comics Page: Harry Hershfield's 'Abie the Agent,' 1914–1940," *Journal of Popular Culture* 40, no. 1 (2007): 91.
53. Ibid, 95.

for his characters. Whereas Hershfield tried to make his Abe Kabibble counteract public impressions of Jews, Gross invited his audience do their own impressions.

Though no traditional anti-Semitic themes appeared in his work, Gross did not seem to think twice about depicting his version of tenement life in an unromantic or unsentimental light. Mrs. Feitlebaum brimmed with malapropisms, and Mr. Feitlebaum beat young Isidore for nearly falling into every popular-cultural trap imaginable, from playing craps to making a "bumfire" in the yard to becoming a "cooke-snuffer." Meanwhile, Looy dot dope routinely landed himself in trouble everywhere a young Jewish boy could go—at school, at work, at summer camp—all the while threatening to run away from home.

Although he infused his narratives with Jewish immigrant experience, he did not include much in the way of traditional markers of Jewish life. In fact, beyond their names and accents, little remained to identify his characters as Jews, unless one knew how and where to listen. His characters did not do anything identifiably Jewish at all. They did not participate in either Jewish communal or Jewish religious life. They did not read Jewish newspapers in any language, nor did they belong to Jewish benevolent societies, synagogues, or think about Jewish holidays. As with his knack for the Yiddish malapropism, Gross let his insider's knowledge of immigrant life signify the Jewish identities of his characters, and left their accents to speak louder than their actions.

But if readers knew what to listen for, they could not have missed Gross's Jewish overtones. When Looy dot dope decided to go into show business, he took a decidedly Jewish approach.

In his journal, Looy noted, "Precticed memmy sung for wodeweel hect. Seng so: Ma-aa-aa-meeeeeeeeeee. . . . Nenny gutt follows me in houze. Hold man redder peeved."[54] In a nod to Al Jolson's proclivity for "mammy songs," Looy hoped that his journey to success would follow a similar sound-track. In another example, when the Feitlebaums went out to eat at a Chinese restaurant, they became agitated when they found themselves unwittingly eating pork, in violation of Jewish dietary law.

Although Gross marked Jews by accent but not sight, he marked Asian Americans and African Americans with stereo-typical illustrations but not accent. In the same restaurant scene, Looy put on a stereotypical Chinese accent but ended up being mocked by the waiter, who responded in proper English:

> Looy: We Melican people wantee tie-ee on
> nosey-bagee-savee??
> Waiter: I dare say—!!!
> Looy: Ooops!!!—Wise guy, huh—Gotta watch dem blokes—
> cagey mob dey are! Probbly got de plans of West Point
> tatooed on his left kidney!!! Well, watcha gonna have—hey—
> lay off, pop—dat ain't no straw—ha ha ha—ats a hot one
> tryin to zip tea troo a chopstick—Ems chopstics, ye eat witt
> em!
> Mr. Feitelbaum: Hm—Is dees a fect. A foist cless Chinaman you
> bicoming, ha, dope??? So—um—hm—wot kind from a crazy
> beel from fare is dees—ha?? You got maybe sour crimm witt
> boiled potatis???[55]

While the scene illustrated the changing power dynamics in immigrant families, where children often knew more about the

54. Gross, *Dunt Esk!!*, 125
55. Ibid., 139.

local culture than did their parents, in this case, both Looy's insensitivity and Mr. Feitlebaum's request for a typical Jewish dish reinforced the Feitlebaums' identification as foreign, not the waiter's. In the accompanying image, Gross drew the Feitlebaums as stereotypically "Chinese," and rendered their accented speech in (probably fake) Chinese characters. In this way, Gross parodied the same sensibility that distinguished him from his literary counterparts and reinforced his sentiment that attempting to pass only makes one look more like someone attempting to pass. The Feitlebaums could not fool anyone.

Gross treated African Americans similarly. In "Chreesmas," Gross called the African American elevator operator "Onkle Tom" and drew him in a stereotypical manner but gave him no lines. Elsewhere, Gross turned the screws on racial caricature and drew the Feitlebaums in blackface, even as he still had them speaking in Jewish dialect, to ensure that they always appeared as the subject and object of his humor. The blackface drawing had almost no direct connection to the text, which, ironically, had Mr. Feitlebaum asking a "hinterlocutor" to ask Looy to loan him two dollars. But, as in the scene in the Chinese restaurant, the sound of their Jewish accent revealed his characters' ethnicity, regardless of what they looked like.

Employing accent to distinguish among various "white ethnic" Italian, Jewish, Irish, and "Dutch" (German) characters proved a popular strategy in American vaudeville during the late nineteenth century. These strategies translated to American newspapers through the vehicle of cartoons whose authors often shared the same ethnic identity as their characters. George McManus's *Bringing Up Father* revolved around the class ambitions and ambiguities of an Irish family. Likewise,

Rudolph Dirks, a German American immigrant, created the *Katzenjammer Kids,* and African American cartoonists Henry Brown and Wilbert Holloway created "Bungleton Green" and "Sunny Boy Sam."[56] Yet, as Kerry Soper argued, more important than correlating the ethnicity of cartoon characters to the ethnicity of their creators is observing the ways in which the strips themselves straddle the various worlds of immigrants in which ethnicity became only one area of conflict, alongside gender, class, family structures, and so on. Importantly, as with *Bringing Up Father, Happy Hooligan,* and other cartoons featuring ethnic characters, the majority of the strips' humor did not stem from racist or stereotyped depictions of immigrant minorities but from jokes leveled at the cultural elite.[57] Gross approached his work with a similar attitude.

Although many cartoonists deployed stereotypical images of their ethnic characters, most of them turned their keenest satirical sense away from their protagonists and toward the arrogance, self-importance, and seeming impenetrability of mainstream, white American society. Gross captured this sensibility in the character of Mrs. Noftolis and her precious son, "Boitrem." Mrs. Noftolis still lived in the tenement but

56. John D. Stevens, "Reflections in a Dark Mirror: Comic Strips in Black Newspapers," *Journal of Popular Culture* 10, no. 1 (Summer 1976). Also, there is an online "Tribute to Pioneering Cartoonists of Color" at http://www.clstoons.com/paoc/paocopen.htm (accessed November 1, 2008).

57. Recent scholarship on the phenomenon of African Americans in cartoons has produced two significant books, one that catalogues representations of African Americans in comics and another that traces the history of African American characters in animated films. See Christopher Lehman, *The Colored Cartoon: Black Representation in American Animated Short Films, 1907–1954* (Amherst: University of Massachusetts Press, 2007); Fredrik Stromberg, *Black Images in the Comics* (Seattle, WA: Fantagraphics Books, 2003). Similarly, Nicolas Kanellos has written a wonderful article about cartoons and parody poetry in Spanish-language newspapers roughly coincident with Gross, see Nicolas Kanellos, "Cronistas and Satire in Early Twentieth-Century Hispanic Newspapers," *MELUS* 23, no. 1 (Spring 1998).

put on the airs of one who imagined herself superior to other immigrants. For Gross, class aspirations sound as silly as linguistic ones. When explaining why she spent the summer at the beach, Mrs. Noftolis offered up the kind of explanation that revealed her immigrant status. "Hm of cuss mine husb—I minn, Doctor Noftolis inseested like annytink we should go for de sommer to Europe, but I motch refer presumed de sisshore for a wariety." Despite her pretensions to middle-class leisure, she still sounded and vacationed like an immigrant.

Though his attention to the sounds of American English and his gift for dialect won him fans among American humorists and critics, his unflagging commitment to making his Jewish characters the butt of his jokes did not necessarily win the hearts of all of his Jewish readers. None other than Gertrude Berg, the writer, producer, and star of *The Goldbergs*, admitted that she dedicated much of her work to opposing Gross's depictions of Jewish life. *Time* magazine even credited Berg's start in radio to a direct response to Himan Brown's radio readings of Gross. "Then she heard one of Milt Gross's dialect stories over the air. Thereupon inspiration welled up, and the next day she started in on *The Goldbergs*."[58]

The irony of Berg's opposition couldn't be more audible, as both Gross and Berg used the sounds of Jewish dialect to signal their characters' ethnic identities. Working on radio, Berg had to rely on the signature accents of Jewish dialect comedians that preceded her in order to ensure that her audience would rec-

58. "The Inescapable Goldbergs," *Time Magazine*, June 23, 1941. See also Lorraine Thomas, "The Rise of Molly Goldberg." *Radio Guide*, November 17, 1939, 13, Gertrude Berg Papers, Syracuse University Special Collections Research Center, Published Material, Box 2, p. 43. Quoted in Glenn D. Smith, Jr., *Something on My Own: Gertrude Berg and American Broadcasting, 1929–1956* (Syracuse, NY: Syracuse University Press, 2007), 30.

ognize her characterizations of Jews. This exchange from *The Goldbergs* could easily have been transposed into *Nize Baby*:

> Jake: Vell, Mollie, now I can really fill mineself a beezness man.
> Mollie: Foist now foist.
> Jake: Yes, foist now!
> Mollie: How's dat?
> Jake: Vell, de Mollie Cloik and Suit Company has disteblished far itself credit vit vone of de finest seelk houses in de country.
> Mollie: Ay, ay, ay, is dat so?⁵⁹

Berg explained her use of dialect in her autobiography. "The script was written in dialect. I was trying to be authentic. I made the children Americans and the parents immigrants; the dialect, I thought, gave me the effect."⁶⁰ Though no less comical or crude than Gross's use of dialect, Berg explained her rationale in terms of "authenticity" rather than parody.

In 1934, Berg explained her distaste for Gross in greater detail:

> [My grandmother Czerna] used to agree with me that an awful lot of rot was written about the Jews; that the broken dialect and smutty wise-cracks of the Jewish comedians wasn't all the way they talked really; and the gushing sugar-coated sentimentalities of many of the "good willers" were just as far away from the Jews I knew. I wanted to show them as they really are—as I, a young Jewish girl, knew them. That was my effort from those very early sketches I tried writing for the air.⁶¹

59. "Jake Establishes Credit," *The Rise of the Goldbergs*. Episode 18. Original airdate: March 13, 1930. The Gertrude Berg Papers. Syracuse University Special Collections Research Center.

60. Gertrude Berg with Cherney Berg, *Molly and Me* (New York: McGraw Hill, 1961), 178.

61. Bernard Postal, "The Story of Gertrude Berg, Author and Actor," *Jewish Toronto Canada*, October 4, 1934, 22. Gertrude Berg Papers, General Scrapbook 8, 1934. Syracuse University Special Collections Research Center. Quoted in Glenn Smith, Jr., *Something on My Own*, 31.

Reverting again to a claim of "authenticity," Berg tried to distance herself from both "good willers" like Hershfield and "smutty" comedians like Gross. Critic Donald Weber explained further that Berg probably found Gross's work offensive for "how the mangled Yiddish-English dialect of his characters rendered immigrant family life as unsavory, an endless screaming match between children and their helpless parents." Perhaps Berg found Gross too crass for her Americanized taste because of the ways in which he accented their immigrant roots too sharply for comfort. Berg, who prided her program on its "sentimental, harmonious vision of ethnic life," imagined that her accent somehow captured the sounds of American Jews with a respect she found lacking in Gross.[62] Later, Sam Levinson would join Berg among the loudest voices to oppose the Jewish "dialect comedian" for his or her less than flattering depictions of Jewish characters.[63]

Yet, this kind of ethnic concern for popular-cultural representations did not limit itself to Jews, indicating just how seriously ethnic minorities took popular-cultural representations. When the successful Irish comedy duo, the Russell Brothers, set about opening a new show in 1907, "ninety-one Irish societies (known collectively as the United Irish Societies) formed a special committee to investigate images of the Irish as presented on stage. Called the Society for the Prevention of Ridiculous and Perversive Misrepresentation of the Irish Character, the committee found the Russell Brothers

62. Donald Weber, "The Jewish American World of Gertrude Berg: The Goldbergs on Radio and Television, 1930–1950," in Joyce Antler, ed., *Talking Back: Images of Jewish Women in American Popular Culture* (Hanover, NH: University Press of New England, 1998), 99.

63. Sam Levinson, "The Dialect Comedian Should Vanish," *Commentary*, August 1952.

and their 'Irish Servant Girls' routine to be particularly offensive."[64] Instead of addressing the Russell Brothers themselves, the committee set about speaking with booking agencies and theater managers, but the brothers proved too popular and went on stage anyhow. Not to be discouraged, the committee stormed a performance, throwing trash and vegetables in protest.[65] Similar in sentiment but not in practice, African American communities strenuously objected to the showing of Cecil B. DeMille's 1915 racist epic *Birth of a Nation*.[66] Then, in 1931, the Pittsburgh *Courier*, an African American newspaper, organized a campaign against the radio program *Amos 'n' Andy*, which featured two white "clowns [wh]o continue nightly [to] exhibit the undesirabl[e] type of Negro . . . thereby exploiting the race."[67] The *Courier* generated a petition that garnered some 740,000 signatures, but ultimately, the campaign did not succeed in silencing the program.

Ironically, *Amos 'n' Andy*, along with *The Goldbergs*, helped establish the financial and popular viability of radio as a mass entertainment medium. More ironically still, and despite her own opposition to Gross's characterizations of Jews, Gertrude Berg benefited from a situation in which African American dialect humor helped propel radio forward and her career with it. Yet the apparently high stakes of ethnic self-representation nevertheless motivated Berg to criticize Gross directly.

64. Geraldine Mascio, "Ethnic Humor and the Demise of the Russell Brothers," *Journal of Popular Culture* 26, no. 1 (Summer 1992): 85.

65. Robert W. Snyder, *The Voice of the City: Vaudeville and Popular Culture in New York* (New York: Oxford University Press, 1989), 110.

66. Anna Everett, *Returning the Gaze: A Genealogy of Black Film Criticism* (Durham, NC: Duke University Press, 2001), 59–106.

67. Quoted in Arnold Shankman, "Black Pride and Protest: The *Amos 'n' Andy* Crusade of 1931," *Journal of Popular Culture* 12, no. 2 (Fall 1978): 236.

Indirectly, scholars of Jewish humor have largely reinforced Berg's opposition to Gross by omitting him from accounts of Jewish humor, even as American critics like H. L. Mencken and Constance Rourke embraced him as an American humorist. Just as Berg preferred a more refined version of American Jewish life, so too a handful of scholars have promoted a more refined version of "Jewish humor." Study after study of "Jewish humor" has omitted Gross and has focused instead on more cerebral qualities of Jewish humor like self-deprecation, intellectual jousting, and existential coping.[68] William Novak and Moshe Waldoks, editors of the *Big Book of Jewish Humor,* offer one of the most influential articulations of "Jewish humor" since Freud. Providing a negative definition, they write, "It is not, for example, escapist. It is not slapstick. It is not physical. It is generally not cruel, and does not attack the weak or infirm. At the same time, it is also not polite or gentle."[69] Gross appears to violate every one of these qualities. Gross's cartoons and chapters offered a kind of audible slapstick that echoed with the humor and horror of the style, and his idiosyncratic renderings of misspelled English words appeared about as physical as dialect could. Gross mocked Isidore's stupidity and his incessantly stuffed nose (which receives its own impenetrable dialect) and often turned jokes on their tellers. To their credit, Novak and

68. The literature on "Jewish humor" is substantial. To name just a few works here: Arthur Asa Berger, *The Genius of the Jewish Joke* (Northvale, NJ: Jason Aronson, 1997); Sarah Blacher Cohen, *Jewish Wry: Essays on Jewish Humor* (Bloomington: Indiana University Press, 1987); Christie Davies, *Ethnic Humor around the World: A Comparative Analysis* (Bloomington: Indiana University Press, 1990); William Novak and Moshe Waldoks, *The Big Book of Jewish Humor,* 1st ed. (New York: Harper & Row, 1981); Jacob Richman, *Jewish Wit and Wisdom: Examples of Jewish Anecdotes, Folk Tales, Bon Mots, Magic, Riddles, and Enigmas since the Canonization of the Bible* (New York: Pardes, 1952); Avner Ziv and Anat Zajdman, *Semites and Stereotypes: Characteristics of Jewish Humor* (Westport, CT.: Greenwood Press, 1993).

69. Novak and Waldoks, *The Big Book of Jewish Humor,* xx.

Waldoks included Gross in their anthology, but tellingly, they reproduced his version of "Ferry Tale from Romplesealskin," instead of his depictions of Jewish life in the tenements. Despite his popularity during the 1920s, Gross has fallen through cracks in the story of Jewish humor and landed in between the folksy Yiddish tales of Sholom Aleichem and the erudite antic parodies of the Marx Brothers. The omission of Gross from many conversations about Jewish humor has revealed a Berg-like bias against Jewish characters who sound or appear "too Jewish" in their affect or accent. Preferring the bookish to the bawdy and the cerebral to the crass, scholars of Jewish humor have, perhaps unwittingly, sustained Berg's bias while deliberately ignoring the sounds of Jewish humor that they may not have wanted to hear.

HE DONE WRONG

By the end of the 1920s, Gross, it seems, grew tired of his own voice. With syndication in full swing and interest in cartoons expanding, he turned his attention to crafting cartoons as zany as those that built his career, but absent the accent. In this way, Gross followed other Jewish performers who built their careers on New York's vaudeville stages, where a little Yiddish went a long way. Faced with the possibility of a national audience on either radio or film, performers like Eddy Cantor and Milton Berle tempered their Jewish content and portrayed instead more generalized "urban ethnic" types that continued to look and sound Jewish, but only if one knew what to look and listen for.[70] Despite this change in approach, Gross

70. For a good account of how this happened in television, see Susan Murray, "Ethnic Masculinity and Early Television's Vaudeo Star," *Cinema Journal* 42, no. 1 (Fall 2002).

retained more than just his sense of humor, and throughout the 1930s he launched a series of silly salvos aimed squarely at the emerging conventions of the cartoon genre, before returning to his roots in the 1940s.

In a complete reversal of the strategy and style that built his career during the 1920s, Gross began the 1930s in silence. He published *He Done Her Wrong*—a story told entirely in pictures. According to the book's subtitle, it was to be the "Great American Novel. . . . And not a word in it—no Music, neither," and it told an appropriately epic story of a lumberjack who loses his love interest to a robber baron and his adventures to get her back. The story follows the main character from Alaska to New York, through countless dangerous encounters with crooked businessmen, wild animals, forests, and cities.

Ever the parodist, Gross drew his novel with another in his sights. Specifically, he aimed to skewer Lynd Ward's critically acclaimed 1929 wordless novel *Gods' Man*. Ward, an artist rather than a cartoonist, undertook a serious attempt at a wordless novel that featured a story about existential struggle rendered in 139 beautifully crafted woodcuts. Responding the following year, Gross upped the ante by offering a pointed metacommentary on Ward's success by making his own protagonist a lumberjack—a woodcutter. Simply aping Ward's success and style would have been too easy for Gross.

A *New York Times* review of *He Done Her Wrong* praised Gross's eye for mimicry and his ability to satirize the conventions of pulp fiction. "Melodrama is easy to parody," wrote the reviewer, "but Milt Gross does it with a difference. For in heaping up the balderdash he exhibits as wild a fancy, as prodigal an imagination as one could wish. . . . Obsession could go no further; the manias of DeQuincey and Baudelaire are mild

hobbies in comparison. . . . In parodying the picture novel Mr. Gross sets us laughing at the American myth of the Superman."[71] Hidden in his exuberance for "heaping balderdash" lay the light touch of critique. Although he clearly enjoyed working without words and crafting a much longer narrative than he had to date, Gross never lost sight of his initial target: the woodcut novel and its pretensions at literary and graphic grandeur. By skewering the form, the content, and the intent, Gross offered his own inflated vision of the "Great American Novel" that proved as silly and as broad as the very notion itself.

In terms of Gross's development as an artist and a storyteller, *He Done Her Wrong* represented a dramatic departure from his newspaper work in three distinct ways. First, it represented a book-length treatment of a single story. Unlike *Nize Baby* and *Dunt Esk!*, which presented collections of short pieces, *He Done Her Wrong* follows a single, if at times meandering, storyline. Second, *He Done Her Wrong* abandoned the heavily textual emphasis of Gross's work up until that point. When "Gross Exaggerations" appeared in the newspaper or was adapted for either of his first two books, his illustrations provided commentary on the prose. *He Done Her Wrong* completely reversed this relationship, privileging the pictures to the total exclusion of any and all text, save a few street signs that appear in the book. Following from this, the third significant difference emerged in the ways in which the books could be read. The humor of *Famous Fimmales* or *Hiawatta* lay in their approximation of Jewish immigrant dialect, and in order to be fully appreciated, they had to be read aloud within the context of

71. "'The Heights That Crown' and Other Recent Fiction," *New York Times*, 30 November, 1930, BR5.

American aural culture of the late 1920s. In contrast, *He Done Her Wrong* begged to be read in total silence.

Having taken the pretense out of picture novels, Gross turned his attention to his cartoon counterparts, who had begun to take themselves too seriously for his taste. Cartoons generally had evolved a long way since their beginnings in the late nineteenth century. Simple joke-driven multipanel comics like Gross's "Banana Oil," in which some bluffer always gets his comeuppance in the final frame, had begun to give way to longer, serialized forms. Comic strip writers, eager to expand the form, found success in more graphically "realistic" adventure comics like "Buck Rogers," "Prince Valiant," and "Tarzan," whose stories, told in four-panel segments, frequently extended over months and even years. Ever critical of this kind of self-serious fare, Gross struck out in precisely the opposite direction with two of his most popular features: "Count Screwloose" and "Dave's Delicatessen."[72]

Both cartoons chronicled the quasi-predictable doings of their respective title characters. "Count Screwloose" told of the adventures of the Count as he escaped from the aptly named Nuttycrest Asylum. Occasionally, other characters like the Count's father, the walrus-whiskered Colonel, and his best friend, General Piggott, would appear to move the story along. But generally, the Count would escape on his own only to find things on the outside to be more horrifying and bizarre than on the inside, and the strip's final panel always found him scampering back over the wall, asking his dog, Iggy, to "keep an eye on me." "Dave's Delicatessen" focused on the trials and

72. For an account of this period in the development of cartoons, see Gordon, *Comic Strips and Consumer Culture, 1890–1945*; Alfred M. Lee, *The Daily Newspaper in America* (New York: Macmillan, 1937); William Henry Young, "Images of Order: American Comic Strips during the Depression, 1929–1938" (PhD thesis, Emory, 1969).

tribulations of a small-time deli owner, his wise-cracking dog, and a team of twelve trouble-making, bowler-wearing stiffs.

For Gross, successful parody meant taking aim at both content and form. So, as cartoons began taking themselves more seriously through epic-length tales of danger and heroism, Gross mimicked and mocked these conventions and the self-seriousness of his counterparts. In the middle of 1934, Count Screwloose and his father, the Colonel, began appearing in "Dave's Delicatessen." At first, they appeared as special guests, weary from the daily grind of supporting their own strip and hoping to find a well-deserved respite at Dave's. While on "vacation," they fell in with a film crew and got involved with the making of a movie that took them, comically, to Africa. Meanwhile, the space that normally featured "Count Screwloose" began hosting "Count Screwloose's Penguin Paradise," a daffy strip intended to hold Screwloose's place until his "return." Screwloose's sojourn lasted a few months while the Penguins filled in, until Count Screwloose replaced "Dave's" altogether, and a new cartoon—"That's My Pop!"—took over where the Count had been.

"That's My Pop!" became both a successful strip and a popular catch phrase. The strip focused on a well-intended but ill-fated father and his attempts to impress his son. In each strip, the father invariably landed himself in some kind of trouble, to which his son naively and proudly responded, "That's My Pop!" The strip became so popular that it made an appearance in the 1936 Warner Brothers Merrie Melodies cartoon "I Love to Singa." The animated cartoon approximated the plot of *The Jazz Singer*, telling the story of "Owl Jolson," who gets thrown out of his parents' nest for singing jazz over his father's objec-

tions. Upon being tossed from his nest, he points a wing at his father and says, "That's mein pop." The popularity of the strip also encouraged a commission of Gross to write a guide to New York in honor of the 1939 New York World's Fair, using "That's My Pop!" as a vehicle. And, eventually, Gross turned the strip into a short-lived radio program for CBS. Ironically, stripped of the visual form and bound by the conventions of the sitcom genre, Gross's humor, which worked so poignantly when read aloud in conjunction with the printed page, did not translate well into radio.

Encouraged by the success of his columns in the 1930s, Gross moved to Beverly Hills in 1938 to begin a brief stint in MGM's animation department. After only two animated shorts featuring Count Screwloose, Gross left MGM to focus on other pursuits.[73] He contributed the background designs for band leader Spike Jones's "Musical Depreciation Revue," and later, he created the set for the play-within-a-play in the 1944 Bing Crosby vehicle, *Here Come the Waves*. Later in the decade, Gross published his own short-lived series of comic books called the *Milt Gross Funnies*. In general, however, following his move to Beverly Hills, Gross seemed to focus less on cartooning and more on landscape painting, which he showed at a few galleries in and around Los Angeles.

But in 1944, he returned to his roots for what would be a final column for the *New York American* called "Dear Dollink." Written in classic Gross dialect, the column featured fictional letters from a Jewish mother to her son, "Frankie," a GI. By this time, Jews accounted for some five hundred thousand American

73. "Wanted, No Master" and "Jitterbug Follies" are the two cartoons that Gross animated while at MGM. Apparently, he left after a disagreement with Fred Quimby.

GIs, and the "Jewish mother" had become a recognizable Jewish character, thanks, in large part, to Gertrude Berg.[74] "Dear Dollink" looked and sounded like "Gross Exaggerations," relying primarily on Gross's older Jewish dialect writing and featuring illustrations that embellished the text rather than helping to tell the story. As in the past, Gross did little to render his characters Jewish beyond having them speak with prominent accents and bear typically Jewish names like Mrs. Yifnif, Uncle Pincus, Shoiley, and Goity Glick.

Although Gross did not have his characters involved in Jewish religious practices or organized Jewish communal life, his readers clearly understood the column's Jewish accent, and they took the opportunity to share their appreciation for the column and to identify with Gross as Jews. One such letter, written by some soldiers stationed on "South West Pacific Island X" in October 1944, thanked Gross for his column and highlighted the authors' Jewishness as well as their connection to Brooklyn—and Gross, by association (or accent):

> I am writing this letter not only for myself but for twenty or more fellows who like myself hail from God's country (BROOKLYN [caps in original]). . . . Keep them coming Milt, they're just what the chaplain ordered.
>
> Signed: your GI Landsman
>
> Pvt. Irving Sayes Yussel Albert Pvt. Sid (Buggsy) Goldstein James (Aloyissous) Farrell.
>
> PS There is one thing about the Island that reminds me of the old burlesque days in New York. That being the native women wear nothing but a smile. "Noo noo, so don't esk." Also Ah Morel Builter.[75]

74. Joyce Antler, *You Never Call, You Never Write: A History of the Jewish Mother* (New York: Oxford University Press, 2007).

75. Letter, Irving Sayes to Milt Gross. October 4, 1944. Milt Gross Collection, Box 1: File 1. UCLA Special Collections. Young Library.

Gross returned the favor the following January when he incorporated Sayes and his friends in his column:

> From liddle Oiving Sayes wo he's now in de Sout Pacific—you remember him, dollink, from Brooklyn—we got such a dollink letter. Him witt de whole platoom, Joey Alpert, witt Sidney Goldstein, witt Jimmy Farrell, so dey all sending you regards, wot it makes Oiving yet jokes dot de letter wot it sent hom Benny Kaplan, dot he was in tree raids. So it shouldn't worry de family, on account it was tree times raided by dem de M.P.'s crap games. Also he writes, wot it reminds dem dere de natives from the female category, werry much like in de Boilesque Theatre de Runaway. Imedgine, Babies tucking yet from Boilesque Runaways![76]

For these readers, Jewish dialect became a point of identification with Gross. Whether mobilizing the shared experiences of tenement life or of military service, Gross employed a handful of ethnic clues that enunciated Jewish ethnicity. Even as these shared experiences shifted from New York to the South Pacific and from mothers' concerns for feeding their children to concerns for their general safety, Gross maintained his keen ability to articulate an audible sense of Jewishness that continued to resonate with readers.

Gross's work during the 1930s and 1940s represented a departure in style but a continuity of substance, as he continued to use his cartoons and columns to parody popular conventions. *He Done Her Wrong* could be read as a silent version of his treatments of Poe and Longfellow, and Count Screwloose can be understood as Tarzan's comic doppelgänger. In each of these examples, Gross's parodies worked because they capitalized on the similarities between the original and its comic

76. "Dear Dollink," Jan. 29, 1945. Box 10. Milt Gross Collection. UCLA Special Collections. Young Library.

copy. Importantly, Gross employed the same sensibility when working with Jewish accents as well, providing a comically amplified version of Jewish immigrant speech that included very little Yiddish vocabulary. Following the conventions of vaudeville that demanded a wide, multiethnic audience, Gross pursued his audience throughout his career, mocking popular forms and speaking from a deeply accented tradition, even when he used pictures instead of words.

THE SOUND OF SLAPSTICK

Milt Gross died of a heart attack on his way back from vacation in Hawaii in 1953, the same year that television became America's medium. Gross, whose work spanned radio, comic books, cartoon strips, newspaper and magazine articles, musical revues, Hollywood films, art galleries, animated films, and books, captured in caricature the silliness of America during the interwar period. With a sharp pen and an even sharper ear, Gross took every opportunity to take the air out of American arrogance, to highlight the humor of hubris, and to lampoon the logic of American popular culture. Gross's work spanned the period in which American mass media moved from print to sound, from vaudeville to radio, from silent pictures to talkies. He saw cartoons evolve from a sideshow to the front page and from dime store shelves to feature films. Despite these changes and his ability to adapt to them, he sustained a singular focus on the significance and sounds of parody.

As a parodist, Gross understood that the humor lay not in difference but in similarity. Thus, his reworkings of myth and history, his silent treatment of the "picture novel," and his mockery of the adventure strip illustrate his talent not only for comedy but also for mimicry. Ironically, the emphasis on mim-

icry, particularly with respect to speech, drove Jewish immigrants to try to shed their accent and sound like "real Americans." As evidenced by some of his other writing, Gross could do this, too, but opted instead to amplify Jewish dialect and forced his readers to do the same.

By mimicking the rhythms and accents of Jewish immigrant speech, Gross mocked conventions of popular culture and Jewish life. He depicted a version of American Jewish life that Gertrude Berg, at least, did not find entertaining, but that non-Jewish American critics lauded as innovative and insightful. Likewise, he articulated a deeply dialect-based sense of humor that most scholars of Jewish humor have not found funny enough despite fans like Mencken and Roarke. Nevertheless, Gross wrote and drew himself into a unique place in the history of American comics and American Jewish culture. His versions of classic American literature and his parodies of life in immigrant quarters amplified the impossibilities of Americanization, forcing his readers to sound like immigrant Jews. His ear for double entendre and malapropism upped the ante on dialect humor and spoke subtly of the experience of working-class Jewish immigrants.

Unlike Al Herschfield or Gertrude Berg, who sought to present respectable depictions of American Jews, and in a departure from stereotypical depictions of Jews in magazines like *Puck* and *Judge*, Gross offered an unmistakably Jewish cast of characters that did not play on stereotypes at all. Eschewing the very notion of the stereotype, Gross offered up unvarnished caricatures of Jewish life, told in a fabricated, dense version of Jewish dialect. In this way, he differed from many of his cartooning counterparts who had more ambivalent relationships with graphic portrayals of ethnic types. He denied the impor-

tance of stereotypes but held fast to the resonance of dialect humor, urging his audience to approach his work as a series of texts for recitation, not just reading. By making his audience read aloud, he altered the power of the image, changing the way people read cartoons and drawing his audience into their frame.

Writing within the aural culture of the late 1920s and 1930s, Gross drew on the traditions of vaudeville to make his columns and cartoons speak. In this way, he capitalized on technological and cultural changes by offering a kind of media-based synesthesia, in which audiences approached cartoons with their ears and voices, not just with their eyes. He wrote columns to be read aloud and inverted the performance of vaudeville-based dialect accents. He developed characters steeped in the culture of Jewish immigrants but found himself on the margins of Jewish life. And, when comics became too serious, he turned that form on its head as well. In these ways, his open invitation to "geeve a leesten" comes off as more than an old Jewish dialect joke. For Gross, to "geeve a leesten" meant to attend to the sounds of his cartoons, but not to let them speak for themselves.

Nize Baby (1926) (excerpts)

By 1926, "Gross Exaggerations" had become so successful that
Gross collected some of his more popular columns and pub-
lished them under the title *Nize Baby*. Like his columns, the
book focuses on the families of a four-story New York tene-
ment—the Feitlebaums, the Yifnifs, and the Goldfarbs. Despite
the recurring characters and themes, each chapter basically
stands on its own.

The transitions among the three stories are often clumsy,
and changes in story are indicated by a change of "floor"
instead of something more elegant or fluid. Gross intended
that the move from floor to floor would function as a kind of
audible snapshot of what the tenement would have sounded
like if heard from the airshaft. Read separately, each chap-
ter might seem a little choppy, but taken together, the book
reveals a kind of internal rhythm and allows the characters to
take shape.

Structurally and narratively, the conversations between
Mrs. Feitlebaum (first floor) and Mrs. Yifnif (second floor) that
typically open each chapter are basically vaudeville skits that
revolve around a misunderstanding of some kind that can
usually be traced to Mrs. Feitlebaum's accent. For example,
Mrs. Feitlebaum mistakes "peels" for "pills" in one case and

"pen" for "pan" in another. The humor is light and somewhat predictable and it rests solidly on the character's accents.

Upstairs, Mr. Feitlebaum spends most of his time disciplining his son, Isidore, for every imaginable reason: drawing pictures of the teacher, playing craps, ruining his clothes, going swimming, etc. Often, these scenes read like a list of fears that immigrant parents had about their children's futures, including Gross's ironic self-reference, "a cotooneest you'll grow opp maybe, ha!"

On the fourth floor, Mrs. Goldfarb focused primarily on getting her baby to eat a full meal. In order to distract her child during mealtime, she retold classic stories in Jewish dialect. She also gave birth to the book's title and one of Gross's first catch phrases, "nize baby."

Because Gross wrote each chapter as a stand-alone column, not as a fully developed narrative, there are a handful of inconsistencies. For example, in chapter 1, Mrs. Goldfarb speaks without an accent (p. 60), and later, a fifth floor makes a brief appearance (p. 124) before disappearing. But beyond those inconsistencies, this section offers a few highlights, including the first chapter, which includes some of Gross's best dialect work; chapter 11, which includes Mrs. Feitlebaum's trip to the "Toikish bett"; chapter 12, which discusses the Scopes Monkey Trial; and the retelling of the story of William Tell, from chapter 14.

NIZE BABY

MILT GROSS

NIZE BABY

BY

MILT GROSS

ILLUSTRATED
BY THE AUTHOR

NEW YORK

Nize Baby

I

BABY ATE OPP ALL DE PILLS—ISIDOR BECOMES A CHOLLY CHEPMAN

Second Floor—Did we hev excitement lest night in de houze Mrs. Feitlebaum!——Was almost by us a calumnity!

First Floor—What was?

Second Floor—Hm! What was, she esks!! I tut what we'll gonna hev to call a nembulence!

First Floor—Iy-yi-yi-yi-yi-yi-yi-yi!! WHAT WASS???

Second Floor—What was? Mine woister enemies shouldn't hev it! De baby ate opp all de pills!!

First Floor—Iy-yi-yi-yi-yi-yi-yi-yi! DE PILLS! He ate opp????

Second Floor—Yeh; de pills. I was stending, pilling pota-toes, und was falling on de floor de potato pills. Und he was cripping on de floor, so he ate opp all de pills!!!!

First Floor—De potato pills he ate!! Yi-yi-yi-yi-yi—— Und what did you did?

Second Floor—I ran queeck in de medicine chest, und I took out a box peels—und I gave him queeck a pill he should take. Und now he's filling motch better.

Third Floor—So, Isidor!!! Benenas you swipe from de push-car'; ha? (SMACK!) A Cholly Chepman you'll grow opp, maybe, ha? (SMACK!!) I'll give you. (SMACK!) Do I (SMACK!) swipe? (SMACK!!) Does de momma (SMACK!!!) swipe? (SMACK!!!) From who you loin dis? (SMACK!)

Fourth Floor—Well, she's forty if she's a day—and you ough-ta see her mornings—her and her permanent wave! Huh—she musta got it carryin' wash baskets around on her head.

What, me worry? ME? I ain't givin' her a thought, Mrs. Klepner,
I assure you. Huh! Far be it from me to talk behind people's
backs. Whatever's on my mind I come out with—you know that,
Mrs. Klepner—but if I was that woman's husband——Although
he's no bargain, either. Didn't we trip over him in the vestibule
the other night?—— And they owe the whole town—— Sh! Here
comes the ice man. Tell him you didn't see me. (SLAM.)

Courtyard—(Enter bum, singing).
'Ave you 'eard of Kitty Ketchum,
 (*Takes hat off.*)
Victim of a rich man's gime—
 (*Looks up hopefully.*)
'Ow she ran awaye to Lun'non?
 (*Holds hat up.*)
Isn't it a bloomin' shime! ! !
 (*Nothing drops into hat.*)

Nize Baby (1926)

'Ere is 'im wiv all'is money,
(*Waves hat.*)
Goes wiv 'er as is so poor,
(*Windows shut.*)
Keepin' 'er from 'er rely-shuns!

.

OY ELI—EL-I-EEEEEE! EL-I-EEEEE——
(*Windows open, shower of nickels, dimes, quar—pennies. Two salamis and one old suit fall down.*)
Second Floor—Oohoo! OOHOO! ! Wachtable Man! ! ! OO-HOO! Wachtable man! YOOHOO! What you got?
Basement—I gotta . . honions . . stringa binz . . . speenich
. . grappa frootz . . . pineopples preena pep . . . cucumbs . . .
swede potates . . . musharooms . . stroomberries . . . cabbages.
. . . You lika maybe nice carrotz . . collyflows . . . aggplantz . . .
radeesh . . . sporragoos? Nice-a plooms . . . pitches . . . bananz.
Second Floor—Hm! Never mind. I teenk, what I'll cook batter epricots mitt stoot proonz.

II

PRASIDENT COOLIDGE RIDES ON IRON HUSS—ISIDOR STAPS WIT NEW SHOES ON JALLYFISH

Second Floor—Was quiet by you in de houze lest ewening, Mrs. Feitlebaum. Where deed you was?
First Floor—To de moowies we want. Hm! Was playing a beaudyful peectcher—De Iron Huss.[1]
Second Floor—Dis is de one wot it's got in it Prasident Coolidge, no?

1. *The Iron Horse* (1924) was a popular full-length silent Western that told the human side of the story of the transcontinental railroad.

[62]

Nize Baby (1926)

First Floor—Und Ben Toipin's[2] a brodder we saw.

Second Floor—A BRODDER?

First Floor—Yeh, yeh, Ben Toipin's a brodder—Dick Toipin.[3] Ees he hendsome! Und Tom Meex[4]——

Second. Floor—I like badder Adolf Benjo[5]——

First Floor—Dot willian wot he plays wit Bibby Deniels[6] wit de mustash?

2. Ben Turpin (1869–1940) was a vaudeville and silent film performer, whose trademark brush mustache and crossed eyes made him a popular star of comedies.

3. Dick Turpin (1705–1739) was an English outlaw and bandit, and the inspiration of some legends. His story was captured in the 1925 silent film *Dick Turpin*, starring Tom Mix as the title character.

4. Tom Mix (1880–1940) was a popular actor and star of 335 films during his career. Mix specialized in the silent Western.

5. Adolph Menjou (1890–1963) was a popular movie actor during the late 1910s and early 1920s. His appearance in *A Woman of Paris* (1923) cemented his status as a debonair urbanite.

6. Bebe Daniels (1901–1971) was a silent film star who made hundreds of films during her career, which spanned the 1910s to the 1940s.

Nize Baby (1926)

Second Floor—Dot's de one wot she merried in Peris a marcus—no?

Third Floor—So, Isidor, wit de new shoes on a jallyfish you stapping, ha? (SMACK) For dees I'm giving you a heducation, ha? (SMACK!!)

Voice—Mowriss, not in de had!

Third Floor—SHARROP! I'll geeve heem (SMACK!!) dot he wouldn't know (SMACK!!) from where it came from (SMACK!!).

Second Floor—Sotch bad breeding wot mine Looy hed all his life, Mrs. Feitlebaum! Was tarrible!

First Floor—Und now is better?

Second Floor—Yeh, he hed lest week de tonsils cot out and now he breeds moch better, denks.

Fourth Floor—Hollo! Hollo! Hoperator! Hollo! Who's dere by de shvitzbud? Hollo! I vant Haudabon—hate—vun—ho—fife. Hate! HATE! Vun, two, tree, fur, fife, seex, saven, hate!

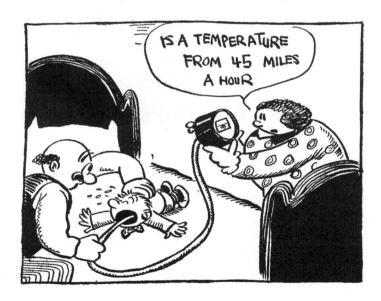

Nize Baby (1926)

HATE vun ho fife. Hollo! Dr. Elitzak? Rosh over queeck! De baby hez a hitch. A hitch! It hitches him and he scretches. It's maybe mizzles odder scollet fivver odder poison ivory. Vot——? How moch he's got fivver I couldn't tell. Ve broke lest veek de speedometer.

VI

LOOY, DOT DOPE, GEEVES A COT DE FEENGER

Second Floor–Hm! Did we had it a day yesterday, Mrs. Feitlebaum—I tut wot I'll gonna get population from de heart!

First Floor—Wot was? ?

Second Floor—Wot was? ? Mine son Looy dot dope—he ulmost cot off a hend! !

First Floor—Yi yi yi yi yi! How it happened?

Second Floor—How it heppened! ! He looks always for boggains—dot smot business men wot he is. So lest week it comes along a cruke from a bobber—und he sold it to him a pair of second-hand cleepers and he was tryink to feex it und it jumped out gredually de knife and it cot him de feenger!

First Floor—Yi yi yi! So wot was den?

Second Floor—I ren queeck wit him in de drog store he should put on it a deesinfecting—it shouldn't dewelop an inflection.

First Floor—Is locky wot he didn't cot a wain—

Second Floor—Mm, a wain! Dot's notting—a HOTTERY you should cot! !

First Floor—A Hottery? Woes dees?

Second Floor—Mm-m-m-m-mm—mine brodder cot once a hottery! ! ! Don't esk! Was so! He was sweemink in de wodder und he came out und be stepped on a clem-shell, it was

shop like a niddle! ! Und it went him right in de foot—Oy, was blidding someting tarrible. It's lucky what a polissman made him a tournament on de foot—so it stopped right away de blidding! !

Third Floor—So Isidor!!! (SMACK!!!) Crebs you shootink already—seven eleven—Ha?? (SMACK!!) A stout from a race trek

you'll grow opp maybe (SMACK!) a Joe mit Basestos[7]—you'll be HA?—(SMACK) From gembling (SMACK) comes chitting!! (SMACK) From chitting (SMACK) comes stilling (SMACK) From stilling (SMACK) comes moiderers (SMACK) From moiders (SMACK) comes—GO prectise queeck on de wiolin or I'll geeve you dot you'll wouldn't know from where it came from—.

VIII

BY IDILL COPPLE GOES ON SOTCH A LENGWIDGE— FAPLE FROM HARE WIT TUTTIS FOR NIZE BABY

Second Floor—You should hear a lengwidge wot its going on by dem pipple in de houze Mrs. Feitlebaum!!! A whole day long is notting but coising mitt fumigating!!!

First Floor—You mean de one wot she walks mitt de pong-eranium dog?

Second Floor—Yeh, yeh—de one wot she wore lest wik de assemble suit mitt de bidded bag!!

First Floor—By dem is going on a lengwidge?? I tut wot dey lookin to be sotch a idill copple!

Second Floor—Hm. Sotch a hanpacked poison I never seen it in mine life.

First Floor—Hm—und hes looking to be sotch a beeg-a-a-you know—one from dem-a-a-he-blodded red man! Und she's sotch a shreemp!!!

Second Floor—Oy, dot shreemp! Is someting terrible—Dot dope wot he is—he should geeve her once over de head wit someting it should flatter her out like a bockwhit cake—she should remain unconscience at list a heff-hour.

7. Joe and Asbestos. A comic strip by Kenneth Kling that focused on horse racing. Joe liked to bet on horses, and he got all of his tips from his stable boy, an African American named Asbestos.

Nize Baby (1926)

First Floor—Wot could it be de trobble bitwin dem——

Second Floor—I teenk wot its incompactability from de temper!

First Floor—Hm! Dot's already a seerious ting—It becomes prectically a piscological quashtion!

Second Floor—Sure!! Dot's wot dey stoddying now dees tings all de colleges mitt de anniversarys—dot cycle-analassist.

First Floor—So wot remained from de fight???

Second Floor—So she was complainink wot hes becomming lately werry infatuated——

First Floor—Hm, she's complainink yet!!! I weesh wot mine Mowriss would become a leedle more infatuated—Billive me—he could stand about five pounds more—Hes getting lately so skinny wot its notting left from him already——

Nize Baby (1926)

Third Floor—So Isidor (SMACK!) De clothes you deedn't change efter school, ha! ! You promised me (SMACK) wot you'll gonna (SMACK) change—und you deedn't (SMACK) change, HA! (SMACK) Wid de new suit you'll laying a whole day in de gutter, ha? (SMACK) To heng arond mitt de gengsters in de front from de pull-room—you need it new suits—ha! ! (SMACK! ! SMACK) For keecking stones in de stritt you need it new shoes, HA? (SMACK) You tink (SMACK) wot I'M getting (SMACK) de clothes (SMACK) for notting? (SMACK) You couldn't play a homonica wid de sweater—Ha (SMACK) A Ben Boinie[8] wid de huckestra you'll wouldn't be (SMACK.)

Fourth Floor—Oohoo! ! Nize baby! Itt opp all de farinna so momma'll gonna tell him about de Hare wit de Tuttis. Wance oppon a time de Hare wit de Tuttis decited wot dey'll gonna have a raze bitwinn dem! So de Hare, he could ron fest like a strick from lightnning—Und de Tuttis, he could only crip along gredually—(Nize baby, take annoder spoon farinna). So de Hare sad to heemself—Wot's de use I should run in de hurry— I'll take better a leedle nap—So while he was slipping de

Tuttis was cripping und cripping und cripping, and leedle by leedle he wan de raze! (Hm! sotch a dollink baby—He ate opp all de farinna! !)

8. Ben Bernie (1891–1943) was a popular American violinist and bandleader.

XI

DE HULL KRAUT GOES BY TOIKISH BETT—GOOT-
FOR-NOTTINK GRESSHOPPER IS DONN WIT OUT

Second Floor—Where did you was lest night, Mrs. Feitle-baum? We was looking for you de hull kraut.

First Floor—So who was?

Second Floor—Hm—was dere Meesus Horroweetz witt Meesus Shapeero witt Meesus Katz witt Meesus Keplen witt Meesus Mockoweetz witt Meesus Rooybin——

First Floor—So wot was?

Second Floor—A Toikish bett! ! Was lest night Ladies Night by de Toikish bett, so we went de whole kraut!

First Floor—So how was? ? ?

Second Floor—Hm! Don't esk——I feel so rejuveniled! ! It simulates de noives someting wonderful! Foist we came in so we became gredually ondrassed—ha! You should see shapes, Mrs. Feitlebaum! You would have a feet from leffing! So we set in de stim room. Hm—did we trenspire! ! So, so soon wot we came out from de stim we jomped in de pull. Did I get it a cheel! ! I tut wot mine teet wouldn't stop clattering! So hefter we came out from de pull itch one had it a message from a robber!

Third Floor—So Isidor—fire creckers you trowing in by de Chinee in de lundry, ha? (SMACK.) A craptical joker you become already, ha! (SMACK.) Wid a Chinee you gott to stott opp yet, ha? (SMACK.) You want maybe wot he should make from you (SMACK) a chop sooy wit de iron? (SMACK.) I need it, it should chase me yet a Tong witt de peestels may be, ha? (SMACK.)

Fourth Floor—Oohoo! Nize baby! Itt opp all de farinna so momma'll gonna tell you about de Gresshopper wid de Hant!

Nize Baby (1926)

Wance oppon a time was a gresshopper wid a hant. So in de sommer time, it was de busy sizzen, so a whole day lung de hant was woiking hod—geddering op eensects witt bogs witt all kind tings he should have to itt in de weenter time—— So de gresshopper was sotch a goot-for-nottink—a whole day lung was going on by him seenging wid jezz-time wid de Cholston dencing—hm! Did he was sewing de wild oats, dot loafer!

(Nize baby, take anodder spoon farinna—wait, momma'll wipe you off de cheen.)

So de hant he sad to de grasshopper—"Leesten grasshopper—it's not mine beezness should meex in, but I teenk wat you should batter push away aleedle bit someting for a rainy day."

So de gresshopper gave him a henswer: "Izzy comes, izzy goes! Ish ka bibble. Denks werry motch for de adwice! S'long! I got a date for a patting poddy!" So de hant sad: "Hm-mm-mm! He teenks wot he's smut! Hill find out!"

Nize Baby (1926)

So it came gredually de weenter. Hm! Was it cold wit frizzing wit rain wit hail wit snow wit slit! So de hant was seeting inside from de house comfintable wit planty to itt, wit stim hitt, witt a weectrola, witt a Mowriss chair. So while he was seeting it came gredually a knock on de door—so de bottler uppened opp de door—so dere was stending de gresshopper! ! Hm, was he don witt out! ! ! Sheevering witt frizzing witt hicicles henging from him—witt holes in de shoes—witt petches in de pants. So de hant sad: "Hm! It's YOU, ha? A penhandler you became already, ha? DEEDN'T I TOLD YOU? ?" So de gresshopper sad: "I jost walked in from Troy, N. Y. Could you spare plizze two beets for a cup cuffy?" So de hant sad: "What did you did in de sommer time, ha? ?" So de gresshopper sad: "Hm! Seenging witt dencing witt jezzing." So de hant sad: "A whole sommer you was seenging witt dencing witt jezzing—so now is de weenter. Go play wid a wiolin."

(Hm—sotch a dollink baby—ate opp all de farinna!)

XII

FROM CLEMS IT BECAME PIPPLE—FERRY TALE FROM CREFTY FOX WIT WAIN CROW FOR NIZE BABY

Second Floor—Sotch a foss wid a hogument wot dey making from de revolution in Tannessee, Mrs. Feitlebaum, you'll be soopriced.

First Floor—Wot is?

Second Floor—It stends here a hotticle in de paper wot a men claims wot averybody is suspended from a monkeh!

First Floor—So by us in de family is monkehs? ? ?

Nize Baby (1926)

Second Floor—Hm—not now is monkehs. He minns wot de hencestors was monkehs.

First Floor—So mine grenfodder was maybe a monkeh? ? ?

Second Floor—Hm—not ivvin de greatgrenfodder. Mine Looy wot he goes to Cissy N. Y. oxplained to me de whole teeng. Is so: it goes beck a long time—before ivvin de glazier peerod.

First Floor—So averybody was once a glazier too? ?

Second Floor—Hm—de glazier peerod—Was de hice age—foist was a hice age—den it comes gredually a—

First Floor—A coal wid a wood age maybe?

Second Floor—Foist was de hice age. Den, accurding wot mine Looy says it came gredually de stone hage——

First Floor—Hm—from dees we getting maybe de gull-stones, ha?

Second Floor—Hm—dey should worry in dem times from gull-stones. A whole day long was by dem busy fighting wid de pre-hysterical mounsters.

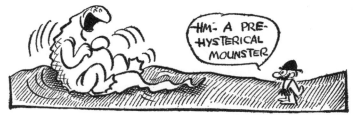

First Floor—So wot was?

Second Floor—It stots in in de begeeninck—Foist averybody was a feesh—was only clems wid hoysters wid shreemps wid soddeens, so gredually de feesh it stodded in to grow by dem fit wit laigs. So when it came de laigs de feesh could stend opp—so dees became a henimal.

First Floor—So wot was? ?

Nize Baby (1926)

Second Floor—So leedle by leedle de henimals dey stodded een to got smot so de smot ones became pipple!

First Floor—Yi yi yi—From clems it became feesh—from feesh it became henimals—from henimals it became pipple—Hm! de tings wot dey doing nowdays.

Third Floor—So, Isidor! ! (SMACK) in de front from de tsigar store you're esking pipple for cooypons already, ha? (SMACK.) A baggar you should grow opp, maybe, ha? (SMACK.) Penhendlers I nidd it yat in de family it's enoff wot you brodder is a peen-boy in a boiling-elly (SMACK.) To-morrow you'll want (SMACK) wot you should seeng maybe (SMACK) in a beck yod (SMACK).

Fourth Floor—Oohoo! Nize baby, itt opp all de bolly zoop, so momma'll gonna tell you a Ferry Tale abbout de Fox, witt de Crow, witt de Chizze . . . Wance oppon a time was seeting opp in a brench from a tree a crow. So she was kipping in de bick a piece from Swees-Chizze. So was wukking along a Fox wot he was sneefing witt de nose, so he smaltt gredually de chizze—und right away he begen skimming how he coult ketch it away from de crow de chizze—Hmmm! sotch a griddy critchure wot he was! ! !——(Nize baby—take anodder spoon bolly zoop)——

POT II

So dot crefty fox wot he was, he sad to de crow: "Goot monnink meesus crow! ! ! Hmmmm! ! ! Howbyootiful you looking! ! Wot a highschool complexion you got! ! ! Widout roodge yet! ! ! Mmmmmmm . . mmm! ! ! ! a ragular Glurria Svonson you toined out to be! ! !" (Of cuss he deedn't minn it, he was rilly appilling to her wanity.)

Nize Baby (1926)

So de crow, dot dope, she stodded in to blosh someting tar-rible, so de fox said: "Hm, sotch a face wid a feegure you got like a Winnus de Milo, it's a shame wot you couldn't seeng!" So de crow blushed. So de fox said: "Hm, I teenk maybe wot you're a leedle bit bashful. You like maybe you should be cuxxed, ha? Come on, geeve a try. I'll bat wot you could seeng ivvin bat-ter from Merry Godden.[9] Come, wubble a leedle sung." So de crow, dot dope, she uppened opp de bick she should seeng, so it fell don de chizze so de fox grebbed it queeck in de mout and he ran away—(Mmm . . . sotch a dollink baby, ate opp all de bolly zoop!) . . .

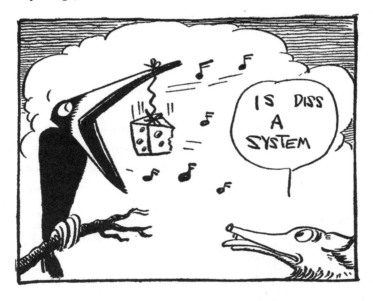

9. Mary Garden (1874–1967) was a well-known Scottish soprano who typified the operatic diva of the day.

Nize Baby (1926)

XIV

MRS. FEITLEBAUM TAKES DAILY DOESN T SHE SHOULD DIGEST DE MILL—TALE FROM FODDER WIT SON WIT DONKEH

Second Floor—Sotch a excitement wot its going on by you in de monnink, Mrs. Feitlebaum! Wot could be de cuzz?

First Floor—Hm—You deedn't hoid? I'm taking by a phunnagreph racket mine Daily Doesn't!

Second Floor—Wot is it de Daily Doesn't?

First Floor—Colicstennis! ! !

Second Floor—So wot is it colicstennis? ? ?

First Floor—Colicstennis is a neeckname wot dey geeving it Pheezical Sculpture.

Second Floor—Oh! You minn extracizes! ! ! So wid a weectrola you got to extracize?

First Floor—Hm—is jost a fat wot it deweloped to redooze de weight—so in de minn-time it also reserves de forum wid de feegure!

Second Floor—So from a fat, you gatting skinny?

First Floor—Hm—a FAT—a wogue—a style! Was so!—It stodded opp de whole trobble from de mills—I nutticed wot efter itch mill wot I hate, it boddered me so de bridding wot

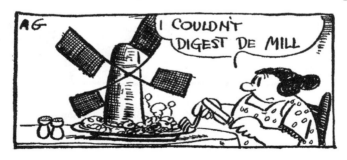

Nize Baby (1926)

when I ren oppstess wit donn-stess I tutt wot I'll gonna get population from de hott odder cute indigestion! ! !

Second Floor—Yi yi yi yi yi yi—So wot did you did?

First Floor—So I went by a abominal spashaleest, wot he should geeve me a torrow exzemination. Hm!—you should see a exzemination, Mrs. Feitlebaum. De hott, wid de longs, witt de hears, wid de heyes witt de trutt witt de——

Second Floor—So wot was de henswer—?

First Floor—De henswer is wot I'm cerrying too motch access wait witt supurpleous flash——

Second Floor—So wot'll gonna be? ?

First Floor—So he described wot I should take de extracizes. So efter diss he pushed me on a dite wot I shouldn't itt mitt, wot I shouldn't itt potatiss, wott I shouldn't itt pice witt pastries, wot I shouldn't itt corn on de cop, wot I should awoid tomatiss, witt grape froot witt peekles witt all kinds assiduous foots . . .

Third Floor—So Isidor! (SMACK) Mine doiby hat wot I was kipping it for naxt sizzon you tore opp already, ha? (SMACK)— A instructive nature you deweloping already, ha? (SMACK) You ain't got notting wot you should do, ha? (SMACK) why you don't knock batter de had in de wall, ha? (SMACK) Wit a straw hat you want maybe I should wukk arond naxt Chreestmas, ha?

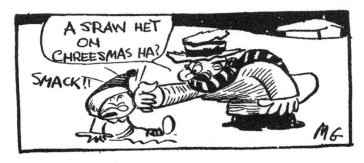

Nize Baby (1926)

(SMACK) To-morrow you'll want maybe wot you should chop opp a tableclutt wit a scissors, ha? (SMACK)

Fourth Floor—Oohoo, nize baby, itt opp all de stood feegs so momma'll gonna tell you a story wot its antitled, "De fodder wit de son, wit de donkeh." Wan day was wukking along a fodder wit a son wot dey was lidding wit a alter a donkeh to de mocket wot dey should sell him. So on de stritt wot dey was pessing was stending dere pipple. So de pipple sad, "Hm, sotch a fullishness. Why you're wukking when its dere a donkeh wot you could rite on him." (Nize baby, take anodder spoon stood feegs.) So de fodder wit de son sad, "Denks for de adwice." So dey jomped opp queeck on de donkeh und gave a yell—"Girryopp!"

POT II

So dey was riting along gredually so it pessed a hold lady wot she sad, "Hm, look wot it's taking two beeg broots adwentage from a domb henimal," so de fodder sad, "Wot's de metter, plizze?" So de hold lady sad, "Iss diss a system, you should rite on a poor leedle donkeh wot it's poffing witt penting witt shaking by him de knizz—wot he's becoming bendy lagged. I teenk wot I'll gonna nuttify de Society from Pretention from Croolty to Henimals!" So de fodder jomped off queeck from de donkeh so it rimmained on de top only de son wot he gave a yell, "Girryopp!"

POT III

So dey was motching along, so it pessed gredually a kraut pipple wot dey sad, "Hmm! ! Look a rispact from a son, wot he makes de old fodder should walk. Phooy! ! Goot for notting loafer, you got maybe flet feet odder falling hotches, ha?" So

[78]

de son he bloshed someting huffle. So he jomped uff queeck from de donkeh so it climbed opp de fodder so he gave a yell, "Girryopp!"

POT IV

So dey was motching along so it pessed anodder kraut pipple wot dey sad "Hm! Look a hod-hotted parent wot he's making a poor leedle boy he should walk. You want maybe he should

strain a hankle. Ha? ? PHOOY! ! !" So de fodder wid de son dey decited as a lest resource wot dey'll gonna carry de donkeh on a steeck. So dey pushed him opp queeck on de shoulders so de fodder sad, "Now, is HO K." So jost den dey was crussing a britch so dey treeped on a tweeg so it fell in de donkeh in de wodder wot he was dronned! ! ! So was a tuttle luss.

(Oohoo, sotch a dollink baby ate opp all de stood feegs! !)

XV

ISIDOR TAKES BETT IN REEVER—IT ITTS OPP
DE VULF ALL DE SHIP

Second Floor—Sotch a haxpeerence wot it happened by us lest night, Mrs. Feitlebaum—I'll rimamber it so long wot I'll leeve.

First Floor—Wot was? ?

Second Floor—Hm, don't esk. I fill wick in de knizz.

First Floor—So wot was? ? ?

Second Floor—De baby swallowed a pan! !

First Floor—Yi yi yi yi—a pan!—a frying pan, maybe—oder a deesh pan?

Second Floor—No!—a fountain pan!

First Floor—Yi yi yi yi yi—so wot'll gonna be?

Second Floor—So we took queeck a hex-ray wot it showed wot de pan is located insite from a vowel so de doctor explained - - - - - - - - bzz - - - - - bzzz - - - - - -bzzzzz.

First Floor—So in de minntime, wot'll be?

Second Floor—So in de minntime, we'll write wid a pen-zil . . .

Third Floor—So Isidor (SMACK) From de dock you're sweeming already in de doidy reever, ha? (SMACK) It should

Nize Baby (1926)

ron over you maybe a farry-butt udder a bodge, ha? (SMACK)
From a wuff you got to dife yet, wot you should maybe bomp
wid a pile de had, ha? (SMACK) Conclusion from de brain you
nidd it, ha? (SMACK) In de battob, (SMACK) is oompossible
(SMACK) de momma should drife you in (SMACK) wid a timm
husses (SMACK) bot in a doidy reever wot is full from dizzizez
you ronning queeck, ha? (SMACK.)

Fourth Floor—Oohoo, Nize baby, itt opp all de proon-jooze so
momma'll gonna tell you a story wot it's antitled "Volf! Volf!"—
Wance oppon a time was a boy, wot he had it a job he should
mind in a pesture a flock from ship. So vas dere a doidy volf wot
he used to snick opp und leedle by leedle he used to still foist
one ship, den gredually anodder ship, de naxt time a toid ship—
(Nize baby, take anodder spoon proon-jooze). So it was decited
wot dey'll gonna take a precussion, so was agridd when de boy
shall see de volf he shall geeve queeck a yell—"VOLF! VOLF!" So
would come ronning queeck de wood-cotters dey should chop
opp de volf wid de hexes. Hmm, dot doidy volf.

Nize Baby (1926)

POT II

So one day de boy was godding de ship so he tut wot he'll gonna play a joke. So he gave a yell, "VOLF! VOLF!" So it came ronning queeck all de wood-cotters out from bratt—poffing wit penting—So dey sad "Where is de Volf?" So de boy sad, "Hapril Fool" so de wood-cotters sad, "Is dees a system?" So dey want beck to de woots. So a copple minutes later de boy, dot dope, he gave again a yell—"VOLF! VOLF!" So de wood-cotters came queeck so dey sad, "Where is de volf?" So de boy sad, "False alorm!! I jost felt in de nude to make a leedle joke!" So de wood-cotters went away.

POT III

So one day all from a sodden it jomped opp de volf. Hm, did he stodded in to itt opp de ship, wid de lembs wid de rems wid de hews—yi yi yi yi! Was someting huffle! So de boy gave a yell "VOLF! VOLF!" so de wood-cotters gave him a henswer, "Hm, jokes you making, ha? Tell it to Swinny." So de boy stodded in to scrim on de top from de longs "VOLF! VOLF! Halp! Volf! It's itting opp de volf de ship!" So de wood-cotters gave him a henswer, "Benena Hoil!"[10] So in de minntime dot doidy volf he ate opp de whole flock from de ship!—(Oohoo, sotch a dollink baby! Ate opp all de proon-jooze!)

10. "Banana Oil" was Gross's first catch phrase, as well as the name of a cartoon strip that he drew. It means "baloney" or "that's hooey."

Nize Baby (1926)

XIX

Second Floor—Hm—sotch a narrow escape wott we hed lest night, Mrs. Feitlebaum. It's a locky ting wot we wasn't all sophixticated from gas!!!

First Floor—From gas!! Yi yi yi yi yi—Wot was??

Second Floor—Was so!!! Mine Looy, dot dope, wot he ain't got wot he should do, so he leestens a whole night to a goot-for-notting spikker on a supp-box wot he adwises all de pipple wot dey nidd frash hair—

First Floor—So from frash hair you became sophixticated??

Second Floor—Wait yat!! So we was all slipping in de bad, so dot dope he oppens it wite all de weendows wot it blew in a dreft wot it blew out de gas, wot if it wouldn't geeve us a alom de ket we would all be sophixticated.

First Floor—So how it gave a alom de ket?

Second Floor—Was so—Is sotch a goot for notting ket wot its by him avery Monday witt Toisday a litter from keetens!!!

11. The Green Hat was a 1924 novel about postwar London high society, written by Michael Arlen.

Nize Baby (1926)

So tsince lest spreeng was by him foist one litter den gredually a sacund litter den a toid litter—so jost lest wick was by him yat a new litter from keetens and wot he was opp a whole night so he smelled gradually de gas—so he gave a alom—it shouldn't be maybe sophixticated de litter.

First Floor—Hmm—is a locky ting wot you got in de houze sotch a litterary ket!

Third Floor—So Isidor (SMACK) Mine right hage you gave it in de front from de insurings agent, ha? (SMACK). A information brewery you became already, ha? (SMACK.) Wot nobody was hesking you, ha? (SMACK). Why you deedn't told him already (SMACK) wot I got maybe a blood pressure (SMACK) witt hoddeng from de hotteries wot mine grenfodder hed it, ha? (SMACK). In de school (SMACK) is by you notting but wrung henswers, ha? (SMACK) bot here you know it exectically, ha? (SMACK). To-morrow you'll ron maybe (SMACK) to de

Nize Baby (1926)

collaction from Fraternal Ravenue (SMACK) wot you'll geeve him de stateestics yat from mine hincome-tex, ha? (SMACK).

Fourth Floor—Oohoo ! Nize baby itt opp all de Crim from Whit, so momma'll gonna tell you a sturry from Weeliam Tell. Wance oppon a time was leeving in de Halps Montains in Tsweetzerland a man from de name from Weeliam Tell—wot he was a champeen hotcher witt de bow wit de harrow—mmm, sotch a moxman witt a shop-shooter wot he was—batter ivvin from Babe Root— (Nize baby, take anodder spoon Crim from Whit). So he hed it a leedle son wheech it was his chiff sauce from delight witt enjoinment—mm, sotch a switt boy witt a byootiful faze wot he had it like a Coopydoll—a ragular Leedle Lord Botterfly! !

POT TWO

So it was elected gredually a new King from de Helps Montains wot he was a minn critchure. So was hissued a hedict wot it was so——

HOCK YE! HOCK YE! GRITTINGS!

Be it nun! Hon odder hefter de Feeftint from Tseptamber, 1666—dees contry'll gonna be hunder new menagement. So I'll gonna hang opp mine hat on a steeck, so is pessed a statue on de statue books—wot itch one from de sobjects should slam in de front from de hat.

Werry trooly yours,
DE KING.

POT TREE

So all de sobjects was sheevering for de King so dey all stodded in slamming in de front from de hat so it came de toin from Weeliam he should slam too, so he deedn't slam, so de King's

[85]

Nize Baby (1926)

Wessels sad,—"Wot for you stending dere like a mummery, ha? Geeve queeck a slam de hat odder you'll sit in preeson for trizzon!"

So it was a werry tents mumment wot it was averyone kipping de bratt so de Wessels sad, "Noo?" so instat from a slam Weeliam pushed opp de tom to de nose, wot it made a haction wot it denutted "Rezzbarries!"

POT FUR

So dun't esk! De King was spitchless from hanger witt rage, so he sad, "Hm, it simms wot you not in occurd witt mine ideas, ha? MEESTER Tell! !"

So Weeliam henswered, "Dot's by you a idea? ?"

So de King sad, "Noo, so is not a idea, is jost a wheem! !"

So Weeliam sad, "So to-morrow you'll get maybe a wheem wot you should heng opp on a steeck de Bivvy Dizz[12]—wot we should wuk on de hends yat in de front from dem, ha? ! !"

So de King sad—"Hm! Queeps witt smotcrecks you pulling, ha? From a Bolshewickky nature yat! ! So for dees I'll gonna titch you a lasson wot it should stend in a plaze your son witt a hepple on de had—so you'll gonna shoot wit de bow witt de

12. BVDs. A brand
name of underwear.

Nize Baby (1926)

harrow de hepple. So go queeck batter to Cooney Highland you should make yat a leedle togget-prectice!"

So Weeliam sad, "You want wot I should shoot from mine boy a hepple off from de had witt a bow witt de harrow?? Dot's you idea from a hout-door sputt??"

So de King sad, "Hm! You gatting pale—ha?—So Gerrada-here queeck and you could tenk yat de locky stozz wot I don't making it maybe a grape, odder a goozebarry odder a—Kerraway sidd, yat!!!"

POT FIFE

So Weeliam greeted de teet, so he edwenced greemly to de spot, so he took out from de queever a harrow, so he pooled back de bow-streeng so it flew out gredually de harrow wot it went straight in de meedle from de cord from de hepple. So dot's de rizzon wot ontill dees day is by Lipshitz in de froot stend in itch hepple a hole!

(Hm—Sotch a dollink baby ate opp all de Crim from Whit!)

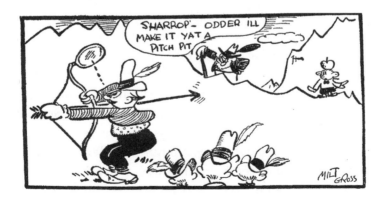

[87]

Nize Baby (1926)

XXII

LOOY, DOT DOPE, BRUK OFF A WHILL FROM
DE KEETY-CAR—STURRY FROM TOM TUM,
DOT TINNY-WINNY HUMAN BING

Second Floor—Hm! Sotch a dope witt a hignorant jenitor wot we got in de house, Mrs. Feitlebaum!

First Floor—Wot is?

Second Floor—Is so: I butt lest wick for de baby a keety-car so mine Looy, dot dope, wot he ain't got wot he should do,

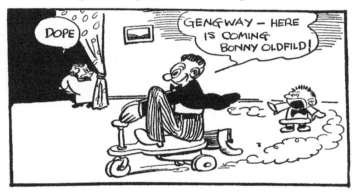

so he stots in to make wit de keety-car treeks wot he bruk it off a whill. So de baby was scrimming witt yalling so I went by de jenitor I should feex de car so I esk him a ceewilized quastion so I sad, "Do you got here plizze a ranch? ?" So he geeves me a henswer, "Wot kind from a ranch you want?" So I sad, "A monkeh ranch." So dot dope geeves me a henswer so he sad, "Hm—I hoid from maybe a cettle ranch odder a sheep ranch bot I deedn't hoid never from a monkeh ranch!"

Third Floor—So Isidor (SMACK) Bullets you putting on de trolleh trecks witt blenk cartilages, ha? (SMACK). A nexident you nidd it (SMACK) wot it should ron you over a feenger

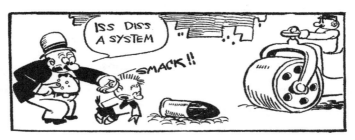

(SMACK) wot you should gat arrasted yat for jake-walking, ha? (SMACK). Bullets you got to explode (SMACK) wot it should shoot yat a innocent banister—maybe in de heye. (SMACK) Noises you want, ha? (SMACK) So why you don't go knock witt de had in de wall batter, ha? (SMACK.)

Fifth Floor—Hm—you should see how mine Joonior retcites, "It'll wouldn't gonna rain no more." Joonior, come here retcite for de doctor, "It'll wouldn't gonna rain no more."

(Sniff)—"It aid godda raid doe bore,
It aid godda raid doe bore (sniff-sniff)
How id the heck, kid I wash by deck
If it aid godda raid doe bore?" (sniff)

Hm, he's so smot, mine Joonior!

Fourth Floor—Oohoo, nize baby, dreenk out all de multed milk so momma'll gonna tell you a sturry from Tom Tum. Wance oppon a time was leeving a femily wot it was by dem a leedle boy wot he was sotch a tinny-winny meedget wot he was smuller ivvin from a feenger from a human bing. So dey gave heem a neeckname, "Tom Tum." So you should see a peeckneeck dey hed witt him. De momma she would say, "Hm—dot leedle goot-for-notting, a whole day making hendsprings undernitt from de battob, odder stilts he's making from de toopicks, dot leedle rescel!!" Und de papa he would say, "Bunfires you making insite from mine pipe, ha, you leedle

ront? Odder street-clinner you playing witt mine safety razor, ha? Go batter und crank opp mine watch for me! !" Und de seester would say, "Hm—in mine timble dot leedle loafer takes a batt, ha, wot it becomes rosty. Boo—Gerradahere, you leedle tremp or I'll lock you opp in a mouze-trep—wot'll itt you opp a mouze."

So halltogadder he was a conseederable sauce from prenks witt meeschif.

(Nize baby, take anodder zip multed milk.)

Nize Baby (1926)

So wan day de femily decited wot dey'll gonna go boggy-riting in de boggy. So de papa sad, "Hey, Shotty, come on geeve a halp here I should honest opp de huss!" So Tom sad, "Phooy! ! Tell momma she should batter powder opp de nose I should go sleigh-riting on it!" So de papa sad, "Hm—fon you making from you helders, ha? Jomp queeck in de boggy odder I'll geeve you witt a broom-straw a goot spenking. Hm,—you gatting pale, ha? So shake queeck a lag!" So Tom sad, "Ho K, I'm coming." So instat from riting in de boggy he sickritted himsalf in de hear from de huss so de papa gave a yall, "Gir-ryopp! !" So Tom gave a wheesper to de huss, "Whoa!" wot he deedn't bodge a hinch. So de papa sad, "Wot's dees? ? De huss is becoming maybe a leedle deft odder hod from hearing?" So he gave gredually anodder yell, "GIRRYOPP! ! !" So Tom gave a wheesper to de huss, "Beck opp," wot he becked opp straight in de staple. (Take anodder zip multed milk, dollink.)

De papa sad, "Hm—de huss got maybe de Hibby Jibbiz! !" So he gave queeck a yell, "WHOA!" So Tom gave a wheesper de huss, "Girryopp!" Wot he gredually ran away, witt de boggy witt all de pipple, wot dey all tombled out in a deetch.

Tom was junting marrily along on de huss so he came gred-ually to a pound in wheech it was a frock, wot he was sweem-ing witt jomping witt lipping arond. So Tom sad, "Hm! Look! a kengeroo! !" So de frock sad : "Hm, I'm nidder a kengeroo, nodder a frock. I'm a preencess! !" So Tom sad, "Put it here, Kirro, I'm Napoleon! !" So de Frock sad, "Cruss mine hot! !" So Tom sad, "How you gat like dees?"

Nize Baby (1926)

So de frock sad, "From a weecked hogre wot he henchented me! ! All de bogs witt de bittles witt de gresshoppers witt de feesh witt de henimals—so itch one is odder a preence odder a dook odder a dotchess odder a cont odder a hex-kaiser wot dot doidy hogre he cast a smell over oss." So Tom sad, "Hm! sonds like a ferry-tail to me, bot I'll inwestigate."

POT IV

So Tom snicked opp in de hogre's kestle. So he climbed opp on a beeg Swees-chizze wot he hit inside from one from de holes. So it came in de hogre wot he sad, "Hm, I'm a leedle hongry. I tink wot I'll greb a snag before I go to bad." So witt one golp he tswallowed opp de whole chizze. Wot Tom stotted in to jomp witt keeck wit ponch witt dence insite from de hogre. So de hogre gave a rur from pain—wot he was yelling witt scrimming witt rulling arond on de floor wot he had almost compulsions. So it came ronning queeck de wife wot she sad, "Hm! ! Walsh rebbitts you itting again! ! DEEDN'T I TOLD YOU? ? HA? ? ?" So de hogre was rulling so he rulled don a whole flight from stess und out from de door from de kestle wot it was uppen de drubbridge from de mutt so he fell gredually in de mutt wot he became unconscience. So Tom came queeck don wot he took off from de hogre de Savan-Ligg Boots wot he was wearing—so he ren queeck wot de hogre tried to ketch him so de hogre fell don wot he was keeled.

So de preencess presumed gredually her netcheral forum— so dey got married so witt de Savan-Ligg Boots Tom got a job es a Massanger Boy wot dey leeved heppily hever hefter.

(Hm—sotch a dollink baby—drenk out all de multed milk.)

Nize Baby (1926)

XXV

MINE JOONIOR TROWS A SPEETZ-BALL—FERRY TALE FROM ELLEDIN WITT DE WANDERFUL LEMP

Second Floor—Hm! Sotch a day witt hecteevity wot I hed it yasterday, Mrs. Feitlebaum!!—A whole monnink I was riding!!

First Floor—Hm!—witt a huttomobill you was riding?

Second Floor—No, wid a penzil, I was riding a ladder.

First Floor—Oh—you was cowrispounding! So witt who?

Second Floor—Witt de Preencipal from de school. Wait yat, I'll ridd you de ladder. Is so:—

> "Nowamber Seext, Ninetinn Twenteh-Fife.
> Preencipal, Pee Hess Feefty-Fife.

Dear Sar:

Mine Joonior hinforums me wot yasterday hefternoon in de school one from de pyoopills trew on heem a speetz-ball. So mine Joonior, wot he ain't, denks Gott, a cowitt, trew heem beck a speetz-ball wot de odder goot-for-notting docked so it flew gredually de speetz-ball de titcher in de faze."

First Floor—Yi yi yi yi yi——

Second Floor—Wait yat——

"So de titcher hordered heem wot he should go by de preencipal in de huffice. So while by de Preencipal in de huffice he hinforums me, wot de Asseestance Preencipal geeves heem herrands wot he should dileever to de werrious clesses massages. Is no?? So—I weesh wot if you nidd it dere a herrand-boy, you should pay heem at list seex dollars a wick—odder sand heem immiditly beck in de cless room.

> "Werry trooly by you,
> "MRS. YIFNIF."

[93]

Nize Baby (1926)

Third Floor—So Isidor (SMACK) de wills from de baby-ker-riage you taking huff already you should make a weggon, ha? (SMACK) A timmster odder a chuffer (SMACK) you'll wouldn't be, ha? (SMACK) bot de baby (SMACK) you want maybe wot de momma should kerry like a Hindian kerries on de beck a cabboose, ha? (SMACK). De shoes you werring it out ennehoe (SMACK) so you nidd yat weggons you should ron over some-body yat (SMACK) odder it should be a collegian, ha? (SMACK) wot I should gat yat a sommons from de Cut, ha? (SMACK). To-morrow (SMACK) you'll take maybe de strinks (SMACK) from mine wiolin (SMACK) you should make maybe for de radio a haireil, ha? (SMACK).

Fourth Floor—Oohoo, nize baby, zipp opp all de horange-jooze, so momma'll gonna tell you a ferry tale from Elledin Witt de Wanderful Lemp. Wance oppon a time was leeving in China a werry, werry poor weedow wot she hed it a son from de name from Elledin. So he was a goot-for-notting, wot de whole day he was playing Ma Jonk instat wot he should attent to de lundry. So it stodded in to complain de costomers wot dey sad so:—"Hm—de teeckets you meexing opp und de col-lars we sanding you wot you should iron dem, so instat you shoppening dem. Und de Bivvy Dizz you stotching opp yat! ! Is diss a system? ? ?"

(Nize baby, take anodder zip horange-jooze.)

POT II

So it went leedle by leedle to de dugs de beezness besites wot it uppened opp yat gredually a rifle acruss de stritt. So hall in hall—Elledin became don witt out.

So wan day he was seeting, wot he was playing a song on a mandarin, so it came along a men wot he sad he was a lung-

[94]

Nize Baby (1926)

lust huncle witt a beeg botter-und-agg men. (Of cuss, he deedn't rilly was; he was rilly a doidy crook from a megeecian witt a susser). So he gritted Elledin werry cudgelly wot he sad: "Mmmm mm, hollo, naffew dollink! ! Sotch a beeg hendsome shick you grew opp. How's de momma? C'mon, lat's we'll gonna knock over a bowl rize! !"

So Elledin went witt heem so dey arrifed gredually in a plaze so de huncle made a mysteerous notion witt de hends wot it uppened opp in de grond a hole. So de huncle sad: "Naffew dollink, go don stess so you'll see henging dere a lemp so you'll breeng me opp de lemp like a goot boy! !"

So Elledin was extrimmingly souprise witt dezzled witt bewilted, so he compiled gredually witt de requast so he fond de lemp so he stodded in he should come opp so de huncle sad:

"Gimme foist de lemp."

So Elledin sad: "Lat me foist I should come opp."

So de huncle reppitted: "Gimme foist de lemp! !"

So Elledin sad: "Lat me foist I should come opp! !"

So de huncle sad: "Gimme foist de lemp, you frash keed."

So Elledin sad: "In you hat! !"

So de huncle sad: "Hm! beck-tuk, witt smotcrecks, ha? ? Wait, I'll geeve you! ! You teenk wot I'm you huncle, ha? Dope! So I'm rilly Pincus de Megeecian! ! Hm, you gatting pale, ha? Wait yat! !" So he gave gredually a yell, "Huckuss Puckuss! ! !"—wot it closed opp de hole so he ren away. (Mmmm, dot doidy ting!)

POT TREE

So dun't esk! ! So it sizzed Elledin sotch a penic witt a fright wot he was sheevering witt shaking like a aspirin leaf. So in de

minntime he gave accidentically a rob witt de helbow de lemp so it appeared in de front from heem a Ginny wot he sad: "Yassar, wot you weesh, sar?"

So Elledin esked: "Who you?"

So de Ginny sad: "Any one wot he geeves a rob de lemp so wotever he weeshes so I foolfeel heem de weesh! ! Wot you'll gonna have! !"

So Elledin sad: "Hm—lat's see . . . Breeng me a cheecken chommain witt a plate boids nast zoop, witt yom dom, witt bemboo chutes, witt a pot from hoolong tea, und breeng batter a hextra pair chopsteecks! !"

Nize Baby (1926)

So efter dees he went gredually home wot he robbed a whole day lung de lemp wot he, witt de momma, hed it everyting wot dey weeshed. So he married gredually de Soltan's dudder. Und de, megeecian, dot crook, he hed to seet yat in preeson.

(Hm! sotch a dollink baby—zipped opp all de horange-jooze!)

XXIX

FERRY TALE FROM ROMPLESEALSKIN
FOR NIZE BABY WOT ATE OPP ALL
DE CREMBARRY SUSS

Second Floor—Hm! Sotch a seely tings wot dey preenting in de moofing peectchers, Mrs. Feitlebaum!!!

First Floor—Wot iss???

Second Floor—Hm! We was lest night, mine Mowriss witt me, by a moofing peectcher, so it stends dere a title on de scrinn wot it ridds, "Jake Goes to de Bad." So I'm waiting witt waiting he should put on alrady a pair pejamiss, he should go to slip, so instat from dees is exactically de counterary wot he commances a beezness witt bomming arond witt dreenking, witt gembling, witt night-clobs, wot he deedn't slapt ivvin a weenk, so on de top from dees it saz yat wot he was sewing dere wild hoats, wot he deedn't had nidder a niddle nodder a trad not ivvin a hoat in de hend de whole time!! Iss diss a system???!!

Third Floor—So Isidor (SMACK) De jenitor's bell you geeving a reeng und ronning away, alrady, ha? (SMACK.) A craptical jukker from fulse alomms you grew opp alrady, ha? (SMACK.) Wot it should stott opp yat witt de jenitor a feestfight, ha? (SMACK.) I should come in de huffice witt a bleck heye, maybe, in de front from de buss, ha? (SMACK.) Odder dees, odder

[97]

it should geeve oss yat de lendlor a prepossass (SMACK) we should seet witt de foinicha yat in de stritt, ha (SMACK)!

Fourth Floor—Oohoo, nize baby, itt opp all de crembarry suss so momma'll gonna tell you a ferry tale from Rompleseal-skin. Wance oppon a time was a werry, werry poor fommer wot he dicited wot he'll gonna go witt a weesit to de Keeng. So in horder he should make a imprassion on de Keeng wot he was a somebody so he cocknocted a skim witt a bloff wot he sad, he hed it a dudder, wot she could speen straw in a speening-whill it should come out gold. Of cuss, she didn't rilly could, it was jost a hux on de pot from de fommer. (Nize baby, take anodder spoon crembarry suss.)

POT II

So de Keeng was all agrog from excitamment wot it stodded in to hitch by heem de palm. (He was a werry griddy micer.) So

he lad her in a room wot it was full from straw, so he sad, "Noo, speen!" Und he locked de door and went away.

So de poor dudder was full from griff wot she deedn't know ivvin how to monopolate a speening-whill. So she was seeting witt tears in de heyes, so all from a sodden it stood in de front from her a leedle Dwuff, witt beeg wheeskers, wot he sad:

"Why you wipping, leedle goil?"

So she oxplained heem de rizzon, so he sad, "Hm! Und soppose wot I do dees for you, wot you'll gonna geeve me?"

So she sad: "Mine ganuine poil nacklaze from hunbreakable poils."

So he sad: "Is a boggain! !" So he set don, so in fife meenits he spon de whole straw wot it was a room full from 14 kerrot gold! !

POT TREE

So de naxt monnink de Keeng was extrimmingly jubilious, wot he robbed gliffully de hends. Bot instat he should be setisfite dot apparitious crichure, he lad her in de grend ballroom wot it was feeled witt straw, witt hay, witt hoats yat, so he sad: "Eef you'll gonna speen all dees stoff it should be gold so tomorrow, we'll gat gredually married wot you'll be de Quinn ... Eef not——Hm, you gatting pale, ha? So take hidd! ! ! !"

POT FUR

So it came agan de Dwuff wot he sad, "Steel cryink, ha? So eef I'll gonna do for you dees job ulso, so you'll promise me wot de foist baby wot you'll gonna have so I could take heem away? ?"

So she tut: "Hm, who knows wot'll gonna be? Could be ivvin maybe tweens, wot nidder one is foist, so he'll gat it in de nack, dot dope." So she sad: "Ho K, is agribble by me! !" So he set don, to speen, so de straw witt de hoats became solit gold.

POT FIFE

So she bicame gredually de Quinn wot she hed it a leedle baby—so wan day she was seeting so it came in all from a sodden de Dwuff wot he sad, "Ha, goot monnink, mine prout

[100]

byooty! ! You rimamber me, ha? ? De keed himsalf! ! Noo, so
punny opp! ! Come acruss witt de bret! ! !"

So she stodded in to cry und to plid witt heem und to cux
heem wot he took gredually compression on her, so he sad:

"I'll make you a preposition. In tree days time eef you'll gass
by me de name, so you could kip de baby!"

POT SEEX

So a hull night long she was wrecking de brains she should
tink from hodd names wot she put yat in de paper wot anny-
one wit a treek name so dey should sand it to de Quinn, so it
came de naxt day de Dwuff wot he sad:

"Noo, geeve a gass! !"

So she sad: "Meetchel? ?"

So he sad: "Nup! !"

"Fillix? ?"

"Nup! !"

"Chake? ?"

"Nup (ha ha) ! ! !"

"Hichabod? ?"

"Gatting warm, try agan!"

"Rastus? ?"

"Nup! !"

"Choolius? ?"

"N—n—nnn—"

"Helphonse? ?"

"Nup! !"

"Zik? ?"

"Nup! ! It sims wot you heving a hod time, ha? So I'll be beck
to-morrow und in de minntime you could lat me know where
I could gat chip a goot creeb for de baby, ulso you'll geeve me

Nize Baby (1926)

a leest deeference tings wot I could fidd heem (ha, ha). Goot night! !"

So de poor Quinn was at de weets-hend from dasparation, so jost den it came in a massanger wot he sad: "Hm! I was tooning in by de radio so it came in all from a sodden a strange wafe-lengt wot I hoid so a song in a werry piccooler woice wot it seng:

> "'To-day I brew, to-morrow I bake,
> Naxt day de Quinn's keed I shell take.
> Hm! I'm heppy! No one knows
> Wot mine name is Romplesealskin! ! !'"

So de Quinn was overjoined witt de noose, so it came in gredually de naxt day de Dwuff, so he sad: "Wal, Wal, goot monnink. I was looking on some fine boggains from baby kerriages! ! Ulso I saw werry chip some nize neeples! ! Is batter for de baby Grate Hay odder Grate Bee meelk? ? Heh, hah, hah! ! Nu, lat's gat don alrady to bress tecks! ! Geeve anodder gass! !"

So she sad: "Is you name maybe Mex?"

"Nup! !"

"Dave? ?"

"Nup! !"

So she sad: "Could be maybe—Romplesealskin? ?"

YI YI YI YI YI YI—deed he geeve a jomp witt a lipp witt a bond hout from de chair wot he stodded in to scrim witt shrick, "Is a jeep! ! Is a frameopp! ! ! A fake! ! ! It teeped you huff a weetch! ! A weetch! ! ! A WEETCH! ! ! ! ! !"

So he gave a stemp witt de foot so hod wot it stock in de grond.

So he trite he should pool himsalf hout so he gave sotch a pool de odder lag wot he turr himsalf in a heff! ! !

(Hm! Sotch a dollink baby, ate opp all de crembarry suss! !)

Nize Baby (1926)

XXXII

ISIDOR HAS HIS PEECTCHA TOOK (SMACK)

First Floor

Mrs. Feitlebaum—Looy, go geeve a henswer de bell wot it's reenging.

Looy—Awr, I'm bizzy!!

Mr. Feitlebaum—Hm—plestering don de hair on de hempty had is by heem a bizzyness, alrady!—Why you don't hire maybe a wallet wot he should sit by you a whole day on de top from de had, so'll be de night, so'll be exectically poifict by you de hair, ha? (opens door).

Voice—Feiginbaum live here?

Mr. Feitlebaum—So is wot?

Voice—Feiginbaum! Isidor Feiginbaum?

Mr. Feitlebaum—Yeh, yeh—wot is?

Voice—Zis your son?

Mrs. Feitlebaum—Yi yi yi, Mowriss, vot is? Isidor, come here!

Looy—Waddya suppose it is! He musta busted a window somewheres!

Mr. Feitlebaum—Yeh, dot's mine son.—So wots you beezness?

Voice—A dollar ana haff fer d'pitchers!!

Mr. Feitlebaum—A dollar witt a heff for de peetchas? He broke some plaze a peetcha??? Wot kind peetchas???

Voice—Fer d'pitchers de kid had took!! D'photograffs—Six-adem! Fitty cents apiece an' tree trown in free—A dollar ana haff fer d'pitchers!

[103]

Mr. Feitlebaum—Ah ha—aaaa-a! ! ! ! ! Peectchas you hed took, ha? Come on, meester, come out queeck from hunder de bad odder I'll dreg you hout by a hear. Peectchas you hed took, ha? (SMACK) Sotcha byootiful faze you got (SMACK) wot you nidd it yat seex from dem, ha? (SMACK) wot it shows yat de doit on de faze in itch one, ha? (SMACK.)

Mrs. Feitlebaum—Mowriss, not in de had!

Mr. Feitlebaum—SHARROP! !—A rugg's gellery I nidd it yat maybe in de pollar, ha? (SMACK) wot to-morrow'll come along maybe a sculpture (SMACK) wot dey'll gonna deelever me C. HO. D. seex statues maybe from dot goot-for-notting, ha? (SMACK.)

Looy—Ha, Ha—Civic Voitue! !—wid a tear drop in his nose! ! Ha—ha!

Isidor—Yeah! !—Who do you thik you're bakigg fud of—? ?

Mr. Feitlebaum—Und you, too, dope, sharrop, und gerrada-here queeck, odder I'll geeve you witt a humbralla, beeg as you are! ! Go batter, plester don some more de hair on de hempty had! ! !

Nize Baby (1926)

Voice—How aboutcha mister? ?

Mr. Feitlebaum—Hm! ! It sims wot you in a rosh, ha! ! ! ! Is waiting for you outside Prasident Coolitch you should take heem de peectcha riting on a iron huss, maybe ha? ? ? You'll oxcuse oss plizze wot we detraining you—So is here you hat und gerradahere gredually from mine houze witt de seex peectchas togadder in de bast from helt!

Isidor—Aw—ba—ba, aid you godda buy be the pitchers?

SMACK! ! ! ! !

Voice—Oh—Is zat so! ! ! Huh—wise guy, aincha?

Looy—Swell racket youre woikin there buddy. Y'know 'at kid's under age. Y'know 'at makes him a minor, y'know. Y'know wot 'at means, doncha? Hm—y'better watch yer step there feller! ! !

Voice—Ohhh—you're one of dem technical guys, eh? ? You're

wastin' yer time you are. Why aincha out chasing de ambulances? ?

Looy—Listen, buddy, don't go pullin' any wise cracks around——

Mrs. Feitlebaum—Looy—Looy! !—Lookout! ! Dun't stott opp witt heem, dot gooreela; wot he should come arond in de night witt a bonch gengsters yat! !

Voice—Nobody aint gonna hoit 'im, lady! !—Well, waddaya say, Mister? ?—Gonna pay fer d'pitchers? ?

Nize Baby (1926)

Mr. Feitlebaum—Was illacted Wodderman? ? ?—So like dees I'll gonna pay you de peectchas! ! !

Voice—Hm!—Swell deal! ! ! I'll take dis up wid de Legion——

Mr. Feitlebaum—Aha! ! Powlitics witt rilligion you dregging in, ha? ?

Voice—A fine game dis is toinin' out t'be. I could sooner tie on a bill an' go out pickin' woims wid de chickens an' make more jack! ! Huh! !—Swell gang of bohunks y'bunk up agenst— orders stuff an' den don't wanna come troo. . . —Y'know, I got me livin' t'make too, mister.

Mr. Feitlebaum—Aha! !—So why you deedn't sopplied me wid dees inflamation witt stateestics witt at list seextinn years ago—so itch year I could have for you bannifit tweens, wot dey should itch one come by you, you should make dem dey peec-tures, ha? Is no? ? ?

Voice—Awright, leave it go at dat. So long——

Mr. Feitlebaum—How motch you sad was de peect-chas? ?——

Voice—Huh! !——A dollar an a haff——

Mr. Feitlebaum—So jost you shouldn't weesh me hod lock, here is! !

Isidor—Hooray! ! Thaks Ba—ba. Ba—ba, kid I have a dickle for a ice-creab code? ?

<center>SMACK ! ! ! ! !</center>

Dunt Esk! (1927)

Gross extended the narrative form of *Nize Baby* in *Dunt Esk!*. It elaborated on the same characters and themes but with a few changes, including the migration of the Feitlebaums to the second floor and the Yifnifs to the first. Also, Looy dot dope, who belonged to the Yifnif family in the first book, somehow became a Feitlebaum.

Moreover, Looy dot dope, who appeared occasionally in *Nize Baby*, developed into a fuller character in this volume. His accent and attitude differ from those of his parents, and he provided the voice of a typical wise-cracking, Americanized son. Unlike his brother Isidore, who continued to receive his father's abuse, Looy dished out his own verbal version of mockery, often at his father's expense. And, in almost every chapter, Looy's frustration with his parents leads him to swear to run away from home and join the circus or the Foreign Legion or whatever.

Structurally, *Dunt Esk!* resembles its predecessor, but narratively and artistically, this book takes more risks. It also amplified typical immigrant experiences that emerge from trying to navigate the United States in a non-native accent. Rather than relying on vaudeville-type setups, Gross uses many of his columns to tell a complete story—about trouble

at school, or about Looy's career aspirations. Similarly, the discovery of Looy's journal allows Mrs. Feitlebaum to reflect on the differences between her generation and her son's. Also, in this book, Gross began to take additional liberties with his characters and illustrations, drawing them in blackface in one instance (p. 121) and as Chinese characters *speaking fake Chinese* in another (p. 136). Also of note are the stories about amateur night at the theater and the Feitlebaums' trip to the beach, which included references to a handful of famous New York and New Jersey resort towns.

Gross also began to experiment with illustrations. Whereas earlier, he relied on illustrations that served as visual punch lines, with this book, he began to use illustrations as part of the narrative. The best example of this is chapter 10, in which Mr. Feitlebaum tried to have his watch repaired. In the columns, Mr. Feitlebaum meets with different doormen indicating which way he ought to go, and Gross captured the subtleties of this exchange in a series of pointing fingers. So much of the story is captured in those fingers, and it represented a new approach to illustration and narrative that Gross developed more fully in his later cartoon strips.

Also of particular interest here are Gross's version of a Horatio Alger story, his retelling of Edgar Allan Poe's "The Raven," which he incorporated with stories from the tenement house, and a caricature of New York Mayor Jimmy Walker.

DUNT ESK!!

BY MILT GROSS

DUNT ESK!!

BY
MILT GROSS
Author of "NIZE BABY," "HIAWATTA," ETC.

ILLUSTRATED
BY THE AUTHOR

NEW YORK

Dunt Esk!!

II

Second Floor—So Isidor! (SMACK) Again you laft beck in de school, ha? (SMACK) Wot I butt you alrady a new soot you should be in it prumutted, ha? (SMACK.) Weesits I got to make alrady itch toim I should know gredually by de foist name de titcher, ha? (SMACK.) Notes I should hev to sand soon to de Preenciple he should oxcuse plizze (SMACK) mine Isidor's abcess from de keendergotten, maybe (SMACK) on account wot he hez to go by de bobber (SMACK). Weesits I got to make alrady.

Looy—Ha! Ha!—'at's a nifty! !—You tell 'im, Pop! We'll hafta buy 'im a set o' false teet an' a beard-cleaner for a graduation present! Wait till de nex' war starts an' we'll draft 'im outa school! Ha ha! !—De day he graduates—I'll git a job! ! HA HA! !—Well—dey can't all be smart in one family, y'know... No one ever hoid o' Gawge Washington's li'l brother! ! How about it, Stoopid—why doncha write a book on "My Four Years in 5-B"—huh?

Mrs. Feitlebaum—Looy—Looy—dun't distoibing de poppa. Put batter de baby a neeple in de mout, wot he's crying.

Looy—Izz 'at so! ! ! Wot am I around here? A noice? How about me tellin' 'im a couple bedtime stories, too, huh? Ha ha—'at's a hot one—Ha ha! !—"Nize Baby, zipp opp all de zweebach, so Looy'll gonna"——

Mr. Feitlebaum—Hmmm! ! — A movellous noice-mait it would be, de dope! So would be a whole time yelling de baby:

[113]

Dunt Esk! (1927)

"Savanillaven—creps! !" odder "Honkey donkey polly voo," odder de Preesoners Sung it would seeng from monnink till night, witt a "seex ball in de cunner," witt a "So's you hold man! !" Odder instat it should be by heem in de mout a bottle witt a neeple, so instat would be idder a tootpeeck odder a sigarette! !—Is no, Dope? ?

Looy—'RAY! !—Adda boy, Pop! Now give us the "Norwegian Ketchin' a Hen" for a encore!

Mr. Feitlebaum—MMMmmm—A rispact from a dope! !—Een hall mine life—deed you aver see a dope wot he should make a sansible rimock, yat? I'll geeve you witt a anchor, beeg as you are! !

Mrs. Feitlebaum—Noo—so come alrady we shouldn't be late we should see in de school de Preenciple. . . . Looy—so if'll cry de baby so you'll put heem de neeple in de mout.

Mr. Feitlebaum—Noo, so come on, goot-for-notting! Yi yi yiyi—mine bren new Penema het you making doidy witt feenger-spots, ha? (SMACK.) It should leff yat from me in de school averywan, ha?

Looy—Wait a minnit, pop—I'll fix ya up. Got the greatest invention in the woild t' clean Panama hats—lemme it. . . .

Dunt Esk! (1927)

Mr. Feitlebaum—Hm! A het-clinner it ulso bicame, de dope, ha——

Mrs. Feitlebaum—Loo-oo-y—Loooo-y, you'll watch ulso de lemb-stew so so soon wot it'll seemper de wodder so you'll push out gredually de gezz. Ulso if'll cry de baby——

Looy—Anyting elst? ? How about hangin' a coupla koitans, too? ? Here y'are, pop, here's ya hat—all nice an' clean—a little wet yet. Take it easy—adda boy—yer a real sheik at dat. . . .

Mr. Feitlebaum—Hm—so is gredually not so bed. Come on!

Isidor—Baba—Rastus Jodsid Browd's buther add father have to cobe to school too. Cad we call for theb add all go together? ?

(SMACK!)

SCENE TWO

Principal—I'm very sorry, Mr. Feitlebaum, but there is nothing that we can do. The child has been very deficient in his work all term. Now here is his composition on Columbus. It is misspelled; it lacks conception; it shows a total lack of knowledge of the subject; it is faulty in penmanship; the historical data is inaccurate. In short——

Isidor—That's the wud you wrote for be, Baba——

Mr. Feitlebaum—(SMACK.) Somebody's hesking you you should geeve a hopinion, goot-for-notting! !

Mrs. Feitlebaum—Mowriss—not in de head! !

Principal—Furthermore, Mr. Feitlebaum—we tried to advise you in time. Isidor's teacher sent letters repeatedly, which were ignored by you.

Mr. Feitlebaum — Wot? ? Latters you sant? ? ! !—To me—latters? ?

Isidor—I wadda leave the roob——

Dunt Esk! (1927)

Mr. Feitlebaum—Aha! !—Latters . . . So it dunns gredually a clue! Come hout here, meester, from hunder de dask (SMACK.) Tell me: why I deedn't gatting from de titcher de latters? ? Ha? (SMACK.) Geeve a henswer (SMACK.) Binn shooters you brutt in de school (SMACK.) Witt snizzing-powder, ha? (SMACK.) Choongom you choong in de clessroom, ha? (SMACK.) Good-condoct mocks you fudged in de conduct-book, ha? (SMACK—SMACK—SMACK.) Witt de titcher you fighting, ha? (SMACK.) Laft beck you got, ha? (SMACK.)

SCENE THREE

Looy—"So little Goldylocks" (Sh—pipe down, will ya, ya brat?)—"Goldylocks sez to de Dragon, (Nize baby, take another faceful bacon an' eggs.) 'My! ! wot a bigg tail ya got, Grandma! !'" (Clam up a minnit, will ya?) "So de fairy sez, 'Waddaya want: a diamond elephant wit a golden tail on a silver tray, OR a sapphire camel on platinum stilts?'" (Oh, boy, dis is moider! !—Wait a minnit. Hello, operator—Wadsworth 3125. . . . Hello, Jake's Poolroom? Hey, Jake—you got tree kids, aintcha? Well, waddaya do when dey—OH!—yes, yes—I should look under de—yeah—Well, how d'ya take dem tings off? Say, Jake, cantcha send yer wife around—huh? Oh, never mind—here comes me people! T'anks! ! Whew! !—here take 'im, mom——Oh, hello, Pop!)

Mrs. Feitlebaum—Looy, go way queeck befurr it sees you de poppa! !

Looy—Why—Wot's——

Mr. Feitlebaum—I'll geeve heem! ! Dot dope! ! I'll make heem for a creeple! ! Creptical juks he's making me yat——I'll——

Looy—Wot's wrong, huh? Wot? ?—Wot did I clean de hat witt? ? Witt peroxide of cawse. Sure, peroxide—It wot? ?—it

Dunt Esk! (1927)

bleached his hair? ? ? —Blond? ? ? Wot? ? Dey was razzin' 'im in de school? ? ? HA HA HA—Well, well, 'at's a good number—Bleached 'is hair—HA HA—Gentlemen Prefers Feitlebaums! ! 'At's rich—ha—ha—could I help it?' ? ? Why dincha borry some ink—an'——

(CRASH! ! ! ! ! !)

——'At's all—'at settles it. I'm troo—'at's de tanks y'git—mind babies fer 'em, clean hats fer 'em—I'm troo—I kin git a room—Isidor—Baba—will you cobe to our subber school—?

(SMACK! ! !)

Mrs. Feitlebaum—Mowriss, not in de head! !

Dunt Esk! (1927)

IV

LOOY, DOT DOPE, IS RIDING SOME MURR IN HIS DAIRY

Second Floor (Mrs. Feitlebaum)—Sotch hideas wot it's by de yonger genderation dese days, Meeses Yifnif! ! ! ! ! Is murr witt murr a sauce from bewilderness! ! ! !

First Floor—So wot is?

Second Floor—Hm, dun't esk! ! Mine Looy, dot dope, wot he ain't got wot he should do, so instat he should look arond maybe he should hoptain a job, so instat he kipps yat from de hidleness a racket, wot he rides itch day entrees in de dairy. Wait, so I'll gonna ridd you a fullishness. Geeve a leesten:

"Monday, Hapril feeft—illaven hay hem—Wukk opp witt hengover. Soot'll gonna nidd a dry-clinning. Culled opp Shoiley. Tsentral inforums me wot poddy hong op. Hoggument witt de hold man. Deed leedle shedow boxing. Wannt beck to bad. Tree pee hem—Hed brakfest. Culled opp Shoiley. Her hold man henswers phun. Hong opp queeck! ! ! Bruk in new pipe. Hold man flies huff from hendle. Stoot by scurrbudd. Won bat on Yenkizz—too bed wot I deedn't hed money on bat. Hesked hold man for two bocks. 'Sno use—I'll hev to gat room. Got de two bocks. Hev to hide hock teecket. Hope wot dey'll wouldn't mees wase. Collacted seex soots for tailor—hall de pockets hempty, toff lock. Tink wot I'll menege a price-fighter. Wrut spreeng pumm to Shoiley, so:

"'Spreeng whan averyting is grinn
Averyting wot is could be sinn,'
"(Hm, not so bed!)

Dunt Esk! (1927)

"'Trizz wit livves, wit gress, wit tweegs,
Dugs witt kets, witt ginny peegs,'
"(Ha ha! Dot's a hot one!)

"'Hall is grinn axcapt de rose,
Wheech is rad like you fodder's nose,'
"(Dees'll gonna hold heem!)
"Signed, LOOY W. LUNGFALLOW."

"T'ink wot I should maybe bicome a putt.

"Hapril seext—hate hay hem—Took a batt. Wan pee hem—Came hout from batt tob. Smooked new pipe. Hoggument witt de hold man. Stoot by scurr-budd. T'ink wot I'll gonna go on stage—could gat maybe izzy job—I should be asseestant to heepnoteest. Hold man geeves me two bocks I should go to dantist, und trow away pipe. Great ball game; hed wanderful sitts—not in de blitchers. Yenkizz ween! Shoiley culls opp. Her hold man rad pumm. Tink wot I'll batter go on rote witt coicus.

"Hapril savent—Hold man finds rain check from ball game. Dun't esk! ! ! Hate sopper by lunch weggon. Hemboiger not so goot. Chaf esks me should he breeng hesperrigus hout on tust, so I geeve him a henswer, 'No, breeng it hout on hussbeck.' Geng leffs. Beel by lonch weggon now $4.25. Sims wot I'll gonna hev to do someting. Tink wot I'll gonna look opp hot-dog conception in Coney Highland. Precticed in pull-room bitwin games. Boncer gats sore. Geeve heem hoggument. Wonder if it's anny biffsteak in de hice-box—I should put it on bleck heye. Humm—smooked pipe. Hold man raises rompus—usual hoggument. Heet de hay.

"Hapril hate—Late for hopening from ball game, meesed foist hinning—hed to stend in gotter in front from scurr-

Dunt Esk! (1927)

budd. Tink wot I'll gonna join navy, I should see de woild. Jenitor edwises me I should boil pipe in hoil so it'll gonna smoke switt like nott. Tink, wot I wouldn't join navy. Took a shafe. Ten pee hem—Humm from pull-room. Hold man raises tarrible rompus. Sims wot I boiled pipe in meeneral hoil wot he takes avery night a doze. . . . Ricovered pipe in hesh-barrel in yod. Heet de hay.

"Hapril nine—Rain. Hold man can't find humbrella. Wot I deed witt hock teecket? ? Simms wot I'll gonna nidd a priwatt sackrittarry. Steel raining. Gass I'll hev to cull opp pull-room I should nuttify dem I'll wouldn't be dere to-day. Rad mine mail. Final nuttice from Billiken Boys dues. Gass I'll look for job. Seex pee hem—Humm! Couldn't gat job—denks Gott! Came humm in texi. Hold man gots hibby-jibbiz, riffuses to pay shuffer. Makes me yat smot crecks! ! Inwites shuffer he should wait in de house till mine sacretary'll gonna breeng me de hinterest from mine stocks witt bounds. Shuffer saz: 'So wot'll gonna be?' So I geeve heem a henswer: 'Wait, I'll gonna smooke mine pipe I should feegure opp de metter.' Hold man punnys opp in jeefy. Beeg hoggument. Ulso breengs opp wot I chodged by de butcher biffsteak for de bleck heye. 'Sno use— I'll hev to gat room.

"Hapril tant—Hon houts witt hold man—no murr hogguments—I dun't spicking to heem—he dun't spicking to me— fine witt ho kay.

"Wrut hold man nutt he should land me two bocks. Riccived reply, So—

"'Meester Goot-for-Nutting Dope, Hesquire:

"'Care from de pull-room or maybe a poliss station.

"'Deer Sor—You cowrispowndence from de tant from Hapril reccived witt contants nutted. Und we have de extrim-

[120]

Dunt Esk! (1927)

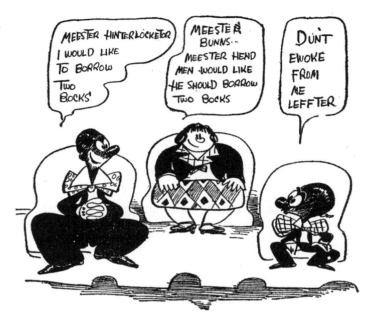

mingly grate honner to inforum you wot you rickwast is gredu-
ally riffused witt de gratest from plasure. Ulso wot you could
take you het witt you coat witt you doity pipe wot you could gat
hout from de houze holltogadder in de bast from helt.

"'Werry cudgelly by you,

"'YOU FODDER.'"

First Floor—So wot rimmained?

Second Floor (Mrs. Feitlebaum)—Wait, oxcuse me plizz
a minute. Is geeving a reeng de bell. Mowriss, geeve a look
downstess wot is. Yeh, de key from de latter-box. Yi yi yi, so
where it could be? ? ? Hm! Here, try witt de hetpin. Wot, you
got de hetpin? You wot—you stock de finger? Yi yi yi! Wait, I'll
get some exorbitant cotton, I should delude it witt wodder. Yi
yi yi—de wot you want? De scroll-drifer witt a hemmer witt a

cheesel? Be careful—yi yi—leesten a noise witt a creshing witt a benging witt a hemmering. . . . Oy, so you got. So wot is?

Looy, Dot Dope (coming in)—Hello pop, hello ma: well, pop, didja git me answer to yer last letter? I mailed it to you. Should be in de box. now.

BANG! CRASH! ! ZOWEY! ! ! POW! ! ! !

Looy—'At's all! 'At settles 'at! I'm troo wid dis joint. I don't have to stand for dat stuff, I don't. I kin get a room. Dis ain't de Toikish Army. He can't fling tings at me like dat and get away wid it. I'm troo.

Isidor—Baba, kid I be a letter carrier wed I grow up?

SMACK! ! ! !

Mrs. Feitlebaum—Mowriss, not in de head.

X

IT CHANGES MR. FEITLEBAUM A WATCH

Mr. Feitlebaum—I butt here lest wick by dees sturr a wreest-watch wot it—

Doorman
(Very
Nonchalantly)

Mr. Feitlebaum—Who? De wan witt de bleck coat, witt de spets?? Denks! !—Motch hobblitched. (Patter, patter, patter)— Aham! ! !—I butt lest wick here by dees sturr a wreest-watch—

Salesman
(Rather
Apathetically)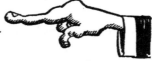

Mr. Feitlebaum—Hmmmm—Who? ?—De wan witt de white coronation in de leppel! !—(Patter, patter, patter). Hm—goot monnink—I butt lest wick here by dees sturr a wreest—

Dunt Esk! (1927)

Floor Walker
(Sort of
Chestily)

Mr. Feitlebaum—Mmmm—(Patter, patter, patter)—
Aham!!—I butt lest wick here—

Store Detective
(Somewhat
Belligerently)

Mr. Feitlebaum—I butt lest wick in dees sturr a—

Porter
(Quite
Dumbly)

Mr. Feitlebaum—Yi
Yi
Yi

Over Here
Over Dere
Over—!!!

Is
Diss a
System

Mr. Feitlebaum—I BUTT LEST WICK HERE IN DEES STURR
(S H A R R O P ! !), A WREEST-WATCH—A ROTTEN WAN—!!!
(I WOULDN'T KIPP STEEL)—WOT IT'S A JEEP—WITT A
HOUTRAGE!!!—(SO PUT ME HOUT!!)—WITT SAVENTINN
JOOLS YAT SO FOR ITCH JOOL IT LOSES AT LIST A TRICK-
WODDERS FROM A HOUR A DAY!!! WOT IT—!!!!!

Manager—Sh—Please—One moment, sir, step this way
please—er—no, no—nothing at all, officer—er—allow me
to see the watch, please—Ahem, Mr. Jollikins, take care of
this gentleman, please.

Clerk—Hm, now what seems to be wrong with the watch?

Mr. Feitlebaum—So dot's you beezness you should find hout!!

Dunt Esk! (1927)

Clerk—Hm, mm—Yes, er—let's see—something probably got into the works, no doubt—and—

Mr. Feitlebaum—Yas, yas—of cuss.—To be sure! ! —We

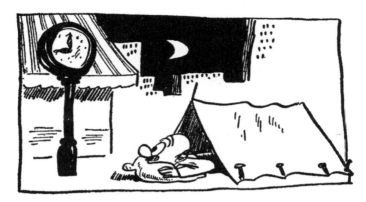

meessing lest wick a mettress from de bad—so you'll geeve gredually a look witt de fullish microscope wot you wering in de heye, so you'll find it dere maybe insite—ha?—Mmmm. Attand plizze de watch.

Clerk—Hm—let's see, when did you first notice that all was not well with the watch? ? Are you a light sleeper? ? Do you cough? Charleston? ? Ride a motorcycle? Are you subject to St. Vitus Dance? Do you talk with your hands?—Oh,—I beg your pardon.—Shake cocktails? Pump a well? Sing mammy songs? ?—Perhaps—you are a TRAP DRUMMER? ?

Mr. Feitlebaum—You'll parron plizze mine riggratts wot, I'm making, denks Got, from mine sturr a leeving wot I deedn't hev yat de pleasure I should make by a fullish jezzbend alrady witt a drom witt de steecks! ! Attand plizze de watch! !

Clerk—Hm—you see a wrist watch, being so small and delicate a contrivance, is much more readily subject to irregularities—

Dunt Esk! (1927)

Mr. Feitlebaum—Hm—you dun't talling me! ! So why you deedn't inforumed me gredually witt dees noose in de foist plaze so instat from a wreest-watch I could putt batter a grenfodder's clock, maybe I should wear heem on de harm, ha? ?—Attand plizze de watch! !

Clerk—Hm—Ummm—Well, you see, sir, each watch being as it is, sir, peculiarly adapted to the individual wearer, sir, in order to properly regulate it, I would suggest, sir, that you leave it and let me wear it for a period of say two weeks-—

Mr. Feitlebaum—Rilly! !—Is dees a fect? ? ! !—So to-morrow— I'll poichiss maybe by Geembel Brodders[1] a soot Bivvy dizz, so'll wouldn't be poifict de soot so I'll lat Meester Geembel he should wear for a copple wicks mine soot Bivvy-Dizz— ha? ?—Attand plizze de watch! ! !

Manager—Oh, well—let's give him a new—

Isidore—Oh, Baba—Here you are—I'be glad I foudd you at last. Here's the baid-sprig of your watch, Baba—You left it

1. Gimbel Brothers was one of the biggest department stores in 1920s New York.

Dunt Esk! (1927)

out this bordig whed you were fixig it with the dut-pick—
after you dropped it odd the bathroom floor—Baba—also
you put some of the works of by toy edgide back id the watch,
baba—I'be glad I foud you id tibe baba—I—(SMACK!!)

Dunt Esk! (1927)

XVII

IT MAKES LOOY, DOT DOPE, FROM WODDEWEEL A HECT

Second Floor—Mrs. Feitlebaum—So geeve a leesten, Meessus Yifnif, wot mine Looy, dot dope, writes alrady in de fullish book dairys——

Third Floor—So wot ees?

Second Floor—Hm—"Hoctuber Seext—Awuk opp witt stott. Dried minesalf. Dot's de lest peetcher wodder wot de hold man'll gonna trow hon me! ! Precticed wodeweel hect. Tink wot I'll gat married. Rad mail. Nottink imputtant. Hold man behind witt hincome tex; boggain sail for hold lady. Took strull. Decite to join Foreign Liggon. Got job I should imitate Franch soldier in front from teatre from 'Beau Gaste.' Geng rezzes me! ! Pecked in job! Watched pogs training by jeem. Precticed memmy sung for wodeweel hect. Seng so: Ma-aa-aa-aa-meeeeeeeeee.[2] . . . Nenny gutt follows me in houze. Hold man redder peeved. Precticed new hect I should pull huff from table de table-clutt it shouldn't distoibing deeshes. Hm—butt bottle glue. Hold man stotts to dreenk hot tea from gloothop ticcop ! ! Dun't esk ! Hope wot pents won't shreenk. Tink wot I'll batter gat room! ! Trite new juk for hect on hold man. Dot's de lest lemp wot he'll gonna trow me in had. Prassed nacktie. Heet hay.

"Hoctuber Savent—Yi yi yi! ! Baby tswallows peen. Hold man gats hibby jibbizz. Hold lady in penic. Geeves a yall: 'Wot I'll do?' So I say, 'Geeve heem he should tswallow now a peen-

2. "Mammy" was the signature song of Al Jolson, one of the most popular vaudeville performers of the 1920s and 1930s. Typically, Jolson performed the song in blackface.

Dunt Esk! (1927)

cushion.' Ha ha! ! 'Dot's hall. I'm troo. Hold man odder no hold man—eff it livves a stain by me on de shoit de hocklebarry pie! ! Hm—tink wot I'll merry tettood lady, it should be a rewange! Tink wot I'll make wodeweel hect witt Isidore, he should be de

Dunt Esk! (1927)

Tukking Dugg. Ha ha ha! I'll jost hev to hed on heem a tail. Ha ha! A dug witt hedinoits! ! Big nowelty hect. Precticed witt de baby—wantreeloquist hect. Not so goot."

Mr. Feitlebaum—Noo, noo, Meesus, stop alrady ridding from de hidiot fullish dairys, we should be late in teeatre!

Third Floor—Hm—to where do you gung? ? In teeatre? Hmm—enjoining yourself. Goot pye——

Second Floor—Denks. Goot pye——

Mr. Feitlebaum—Noo, so come alrady und lock batter witt de Siggle lock de durr it shouldn't comm in maybe de dope witt de fullish frands dey should make me in de houze poddies—hmmm! !

SCENE TWO

Bijou Theatre—Balcony

Mr. Feitlebaum—Jay—seex witt hate. Hm—wanderful sitts! ! Why dey dun't maybe supplying ulso witt itch sitt a spy-gless odder a radio maybe we should hear from de stage, ha? Ha? ? Wot? ? Whooz tukking to you? ? You'll spick whan spukken! ! Ha? Wot? ? Noo, so MAKE me I should sharrop! ! Opps, oxcuse me, laty, I deedn't nutticed you foot in de hile! Hm—I bag you podden, medem, bot bing wot I rigratting extrimmingly wot I deedn't was born witt a nack from a hostrich so you'll rimoof in de bast from helt de het? Noo—et lest—ha? Wot—de teeckets you weesh to see? Hm—maybe witt a pessputt, ulso witt a phuttogreph yat, ha? So—wot? We should moof uvver a sitt? ? It belungs to dees two—YI YI YI—geeve a look! Isidore! ! Muttimer Meetzic! ! ! So (SMACK) dees is de hum woik (SMACK) wot you doong by Muttimer Meetzic in de houze, ha? (SMACK.) Skims witt huxxes you making me, ha? (SMACK.) You tutt you'll gonna dilute me, ha? (SMACK.) A houtweeter from de fodder

Dunt Esk! (1927)

you bicame, ha—(SMACK)—wot? Why I—wot? ? Why I dun't heeting a guy mine site? ? I'll geeve you in a minute a sice—you gengster, you.

Mrs. Feitlebaum—Mowriss—Mowriss—Sh-shsh! Is a shame de pipple—sh sh! ! Yi yi—here is coming de Meesus Noftolis. Goot ivvining! ! Goot ivvining!

Mrs. Noftolis—Hm—goot ivvining! ! Hm—of cuss, we dun't usual seeting by de belcony, bot bing wot mine Boitrem is witt de new heye-gl—I minn de new spectacles—werry fossight-ed—so we—yi yi—Boitrem! Is dees nize you should trow don in de huckkester pabbles? ? Modder dun't approving dees, Boi-trem. Hm—of cuss, mine hosb—I minn de doctor—inseests halways we should seet by de mezzaline boxes—bot——

Mr. Feitlebaum—Ha! Hollo—hollo, Plotkin! ! Hollo! Noo, so hozz de grussery beezness?

Mr. Plotkin—Mm! Hollo—hollo, pipple! Hollo, Meesus Feitlebaum! Hollo, Meesus Noftolis! Noo, you enjoining de sitts? Hm—I tutt so. It geeves me free teeckets de teatre I should put in de weendow a pruggrem—so wot I nidding dem hall? So I'll geeve mine costumers—Meesus Noftolis——

Mrs. Noftolis—Sh—sh-sh—is stotting hopp de show——

Mrs. Feitlebaum—So wot's dees it stends on de pruggrem, "Hemmitcher Night"?

Dunt Esk! (1927)

Mr. Feitlebaum—Sh-sh-shsh——

Chorus—Shshshsh! Sh—sh-shsh!!

Announcer—Lai-deez an' gemmen, de foist offrin of our wunnderful bill of Local Amatcher Talent to-night will be de marvellous tree-minnit escape from a ragalation straitjacket!!!—As piffawmed on de vaudville stage fer years by de woild-famous Handcuff Harry Hoo-deeny!! An' duplicated tonight in poison by our local favorite, LOOY FEITLEBAUM!! Give 'im a chanst, boys!

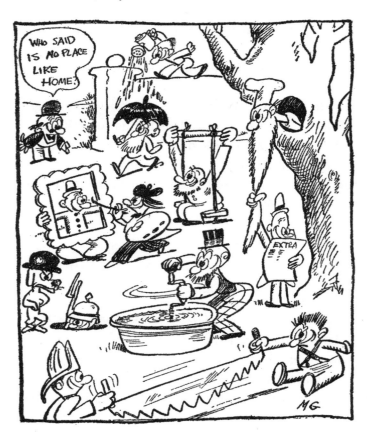

Dunt Esk! (1927)

Mr. Feitlebaum
Mrs. Feitlebaum
Mrs. Noftolis
Mr. Plotkin
} —L O O Y ! ! !

Mr. Feitlebaum—Comm hout queeck while is dok yat de teeatre! !

SCENE THREE
(Home)

R - R - RRRRR—r-r-rrrrr—ing——

Mrs. Feitlebaum—Yi yi! Trick lock in de monnink is reenging de talaphun, Mowriss! !

Mr. Feitlebaum—Hollo—hollo! Yas, is heem by de phun! So is who? Who? De loomatic asylum? ? So wot is! Ha? ? I should come by de loomatic asylum? ? ? ? Wot fur I nidd to go dere? I got here in de houze a foist cless loomatic asylum! ! ! Mine wot? ? Mine son? ? ! ! He's dere witt a straitjecket wot he couldn't gat hout from it? ? Ha? You nidd me I should indemnify heem foist? You should open it opp? Ha! Ha! ha! ! HA HA HA HA! ! ! ! Good pye! !

DE FEITLEBAUMS BY DE SISSHORE

XVIII

IT GOES WITT A WEESIT DE FEMILY BY DE CHEENKS

Mrs. Yifnif—Hm, you rilly minn it for a fect? ?

Mrs. Feitlebaum—So is why not? ? ? Mm, bungaluzz! ! ! So wot is bungaluzz? ? You stending a whole day in de hitt wot you cooking—und den it comes de weesitors wot dey itting it opp. Is no? ? ? So in order it should be for a change a wariety, so me

[132]

Dunt Esk! (1927)

witt mine Mowriss witt mine Isidore witt mine Looy, dot dope, so we gung for sopper by de Cheenks we should itt gradually chop-sooy!!!

Mrs. Yifnif—Hm—I would be afrait I should be by a Chinee for sopper!!!! Sotch a tings!!! Who hoid from dees???

Mrs. Noftolis—Hm, off cuss is a conseederable sauce from bodder to hentertraining by de bunga—— I minn de sommer cottitches, bot, of cuss, witt a Jepenizz chaf witt rafrances is werry differential de haspect. Of cuss we usual taking witt oss to de sisshore odder de montains, odder de Hott from de Canatian Rockizz—odder de Godden spot from de Son-keesed Uniwoize—odder Monte Collo odder Nooput—so we usual taking witt oss de Jepenizz chaf witt de rafrances, bot bing wot mine hosb—— I minn de doctor deedn't intanded we should rimmain here so—— Boitrem!!!!—BOITREM!!!! Geeve back de leedle boy de willossipid, Boitrem!!! Modder is hedgitated, Boitrem!!—BOITREM!!!! Is deez nize you should ron de gantleman over de foot witt de willossipid? Boitrem!!! Modder is hopsat!!! Boitrem—Modder is pained——

WE ALWAYS TAKING WITT US DE CHAF

Looy—Modder is painted y'mean, Boitrem. O boy—dis is moider lissenen' to dat gas-bag!!! "Modder is stoopified,

Dunt Esk! (1927)

Boitrem! ! ! Be careful witt de bike, Boitrem! ! ! Don't break
yer ! !—! ! d——! ! ! ! ! !——! ! ! ? ? ? neck! ! ! Boitrem——O boy,
I wisht dat ting was my brudder fer a week——! ! !

Isidore—Baba, kid we take Bortiber Bitzik to the Chiks with
us?

SMACK! !

Mr. Feitlebaum—Prepositions you making me alrady, ha,
goot-for-notting (SMACK). It must go witt you hall over Mut-
timer Meetzik, ha? (SMACK) A Siamizz tweens (SMACK) it
bicame alrady you witt Muttimer Meetzik, ha! ! ! ! ! ! You nidd
bedly Muttimer Meetzik, ha? (SMACK). He should show you—
you should make (SMACK) from de hendle from de broom a
poosyket, ha? (SMACK). To-morrow (SMACK) you'll take a batt
so'll come witt you (SMACK) maybe in de battob, Muttimer
Meetzik ha? (SMACK).

Dunt Esk! (1927)

Looy—Ha ha ha, ats a hot wrinkle. Dem two in a tub—sunny side up! ! Ha ha ha—Well calm yer fears consoinin dat ting takin a bath, pop—till de next eclipse anyways.

Mr. Feitlebaum—Aha! ! ! Is here alrady de dope. So shot opp gredually de fullish rimocks und gat rady we should go by de Cheenks—noo, so you'll coming, Meesus Noftolis? ?

Mrs. Noftolis—Hm, of cuss de doctor dunt usual approowing wot we should go by Chinaton slumping—bot jost it should be a wariety—Boitrem. BOITREM! ! ! ! ! ! ! Geeve beck de baby de louly pop, Boitrem! ! ! ! Comm, Boitrem! !

SCENE II

The Mandarin Gardens

Looy—Well, well, well—Hullo, Kwong. Lo, Foy—lo, Cholly— well, meet the old man, boys—hey pop—shake hands witt Mister Hang Shang!—diss is Mister Far Low—hand witt de old man, Sing! Well, comon in de kitchen, pop. I wantcha to meet some—no—well, lets go—got any grease on th' menu? ? ? well, wipe it off, ha ha ha ha—Oops, a new coolie! ! ! ! Hello Sessue—we Melican peeple wantee tie-ee on nosey-bagee- savee? ?

Waiter—I dare say——! ! !

Looy—Ooops! ! !—Wise guy, huh—Gotta watch dem blokes—cagey mob dey are! Probbly got de plans of West Point tatooed on his left kidney! ! ! Well, watcha gonna have—hey— lay off, pop—dat aint no straw—ha ha ha—ats a hot one tryin to zip tea troo a chopstick—Ems chopsticks, ye eat witt em!

Mr. Feitlebaum—Hm—Is dees a fect. A foist cless Chinaman you bicoming, ha, dope? ? ? So—um—hm—wot kind from a crazy beel from fare is dees—ha? ? You got maybe sour crimm witt boiled potatis? ? ?

Dunt Esk! (1927)

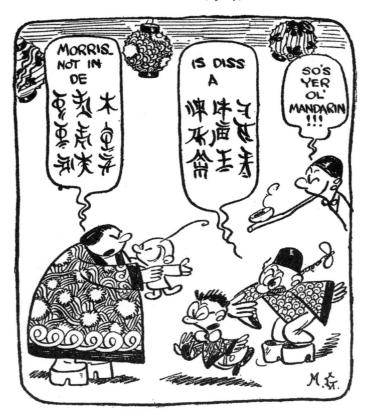

Looy—Ha ha ha, 'ats a number. Where d'ya tink yare, in de Ritz——? ? Oops, excuse me, I'm being paged——

Mrs. Feitlebaum—So wot we'll gonna horder? ?

Mrs. Noftolis—Of cuss, I usual know hall de differential kinds from Chinee deeshes, bot bing wot I laft home de spectacles—I—I Boitrem—Boitrem—Is diss nize you should speel in de susser de tea? ? Modder is pittoibed, Boitrem!

Mr. Feitlebaum—Hm—Chop chooy! ! ! Chommain! ! ! Bemboo chutes—Too far main! ! Fooy yom dom! ! Look a leng-

Dunt Esk! (1927)

widge! Som gom bom—— Hm, so waiter breeng from dees a horder——

Isidore—Baba—you do, you look sobethig like a Chidabad, baba.

Mr. Feitlebaum—(SMACK) I'll geeve you smot rimocks by de table (SMACK)—Mm, wait I'll attand you home!!

Mrs. Feitlebaum—Mowris, not in de head!!

Mr. Feitlebaum—Aha, so is here at lest de horder. So wot is—hm—mmm—it dunt gredually smells so bet—mm—noo, dope, come here alrady——

Looy—Well, here we are—Woops—wots dat——???? You ordered it??? Ha ha ha ha—ha—well well—'at's Pork, pop!! 'at's——

Chorus—Yi yi yi yi yi yi yi yi
 Yi yi yi yi yi yi yi yi

Puck—puck—puck——

Mrs. Feitlebaum—Speet it hout (SMACK) from de mout, meester—(SMACK) hall from it. Queeck, mine het——

Isidore—Baba, lets eat id a lutch wagod
 (SMACK)

XX

BOITREM MAKES MODDER WAXED WITT
ASTOUNDISHED WITT PITTOIBED
FROM DE HENTICS

"Hm of cuss mine hosb—I minn, Doctor Noftolis inseested like annytink we should go for de sommer to Europe, bot I motch redder presumed de sisshore for a wariety—Besides, annahoe, it writes me from de odder site mine son-in-law, Spancer Goldboig de lawyer, wot its in Peris hall feeled opp

Dunt Esk! (1927)

fool from Hamericans, wot you couldn't see on de stritt a seengle Perisite. Of cuss wee dunt usual stopping by sotch a chipp hotal, bot——Boitrem! ! !—Boit—t—trem! ! geeve beck de leedle boy de ball——Boitrem! ! ! ! Modder is soopriced! ! ! ! Is dees nize you should trow in de gotter de ball! ! !—Boit— wot! ! !—to modder? ? ? Modder is hengry, Boitrem—Hm, sotch a lengwidge wot he loins from de cheeldren here—Boitrem, go to Wiolet she should put you hon de Hedmiral soot!!!—go hatt—BOITREM—geeve beck dees hinstant to de gantleman de fonny peectures. Boi—BOITREM—! ! ! Modder is astound-ished! ! ! Is dees nize you should terr opp de gentleman's fon-ny paper——Wiolet, Wiolet! ! !—wot? ?—you steel making de baby's bottle? Oh! ! de cloze you washing. So wash Boitrem de hends witt de faze and put him hon de Hedmiral soot—so, you'll hiron de cloze hefter you'll fidd Meetchel witt Muttim-er——ulso gat from de drog store a neeple, und take to de prasser de doctor's soots. Don't forgat you should stoilize foist de bottle und rimmain dees hefternoon by de pawillion witt de cheeldren! ! ! Go hatt—Hm, sotch a trobble witt de maits. Off cuss in de ceety on Reewersite Drife³—we usual kipping a axpeerenced governest bot it's a poorish goil Wiolet wot we took her alung it should be for her a wickation."

 * * * * * * *

(SMACK) "So Isidore—De zoop you deedn't hate by de deen-er, ha? (SMACK)—De speenitch you didn't hate by de deener ha (SMACK)—A heff from de squap you laft hover from de deener, ha? (SMACK)—Deeners I got to pay for by a hotal (SMACK) you should itt a whole monnink chucklitts kendy, ha? (SMACK)—A

3. Riverside Drive is a fancy north-south-running street on Manhattan's Upper West Side, and was the address of many Jewish families that made enough money to move out of the immigrant neighborhoods of the city.

Dunt Esk! (1927)

fester you bicame hall from a sodden, ha? (SMACK). So why you dunt gatting gredually a job you should fest maybe for a wick in a gless cage by a coicus, ha (SMACK)——Squaps aint goot enoff——Mowriss—not in de head.——Ha, ha, squaps— ats a hot wrinkle—Dem tings dey call squaps we usta extoimi- nate in de army——Dere's more nourishment in a grasshopper dan one of dem—Aha, is here de dope! ! ! So go in de bast from helt in de woots you should itt gresshoppers it should cost me, denks Gott, lass here de mills. . . ."

"Wal, Wal, Wal,——Holluh pipple, holluh, holluh! ! ! Noo, boyiss, so wottull be—pukker odder pinnacle? ? Ha ha, hol- luh——Mitzic! ! ! Say, you hoid maybe from a feller wot he rites tricklock in de monnink on a huss hussback ha? ?— No! ! !—Who? ? ?—Pol Reweere! ! ! ha ha ha ha ha ha ha ha ha, opp—oxcuse me—I deedn't know you sumboint! ! !

Dunt Esk! (1927)

Wait—geeve a leesten. I hoid a good jukk rigudding Cohen[4] witt de lawyer! Off cuss I couldn't tell it witt de dialect! I'll hev to spick it plain ! !"

"Yas, of cuss—so we drove don witt de Dotch—is a goot physeecian's car de Dotch——by de way, mine hosband heppens to be a physeecian——Boitrem! ! ! ! Stop ronning arond de werrenda. Modder is pittoibed, Boitrem! ! ! You'll break de Teefany ritz-watch, Boitrem! ! !"

* * * * * * *

"Honly bing de rizzon wot mine Tsigmund hez to communicate avery day witt de train wot he nidds de baiting, odderwice we go by Hezzbarry Pock odder Dill Beach."[5]

* * * * * * *

"Besides wot mine—I minn de doctor makes in a year cherritable detonations irrigoddless from de—yi yi—Boitrem—— Stop blung opp de leedle boy's balloon——Modder is waxed. Boitrem! ! ! Is dees nize you should exploit de balloon—— Modder is prowoked! ! !—Hm, so like I was rimocking—Hm— look it comes a poor men witt a feedle! ! !—Ho, by de way—I tink wot its crying de baby!—Wiolet! ! !—Wiolet! !—is crying de baby? ? ha? ? You sure? ? ? Geeve again a leesten—Wait, I'll come—oxcuse me."

* * * * * * *

"I tink wot is ronning by me de wotter in de room."

* * * * * * *

"Oxcuse me. Is time now I should take mine townic! ! !"

* * * * * * *

4. Throughout the 1910s and 1920s there was a host of recordings and joke books featuring "Cohen," a Jewish immigrant, and the humorous mishaps that occurred as the result of his accent.

5. Asbury Park or Deal Beach, two popular summer beach resorts in New Jersey.

Dunt Esk! (1927)

"Who?? Me you weesh by de talaphun!!!!"

* * * * * * *

"Doe, dot you, baba?" (SMACK).

* * * * * * *

"Didn't I hoid it jost now reenging de bell for deener—??"

* * * * * * *

Psst—psst!!! Boitrem. Boi—yi yi yi—who mate you de blotty nose?? Hm, dey hall stotting hopp witt mine Boitrem!!!!"

Dunt Esk! (1927)

XXI

ISIDORE DEWELOPS AN HAXTRAHORDINERRY HEPPETITE FOR BILK

Isidore—Bobba, kid I have adother glass of bilk?

Mrs. Feitlebaum—Hm—Wot a quashton. Of cuss, mine dollink. Go take in de hicebox. Hm—sotch a nowelty, Meesus Yifnif! ! In hall mine life deed you aver saw befurr it should hesk mine Isidore a gless meelk! ! ! Is pure witt seemple haxtrahordinerry!

Mrs. Yifnif—Hm—I weesh wot by mine Muttimer odder mine Movvin it should dewelop gredually sotch a wogue dey should dreenk meelk. Hm—a dollink boy! ! ! Hm—geeve a leesten, Meesus Mitzik. Isidore dreenks meelk! ! ! !

Mrs. Mitzik—Yi yi yi yi—meelk! Hm-mmmmm—is seemply gudgeous! ! ! ! Oohoo, Meesus Klepner! ! ! You deedn't hoid de noose! ! ! It dreenks Isidore meelk! ! !

Mrs. Klepner—Meelk he dreenks. Hm! ! ! From de own wolition he dreenks meelk! ! ! ! Yi yi yi—You hear, Oiving, ha? ? Hm—is woit hall de money sotch a chilte! ! ! !

Mrs. Feitlebaum—Hm—I couldn't cowmprihand mineself! ! ! !

Isidore—Bobba, kid I have adother glass of bilk? ?

Mrs. Feitlebaum—Of cuss, dollink! !

Mrs. Mitzik—Hm—a swittness from a chilte! ! You'll see he'll grow opp he should hev beeg strung muzzles! ! !

Mrs. Yifnif—Is motch murr beneficiary ez sudda-wodder odder salary townic! ! ! !

Mrs. Klepner—Hm—mine Horvey you got to drife him witt a timm husses he should dreenk a gless meelk! ! ! Is woister like

Dunt Esk! (1927)

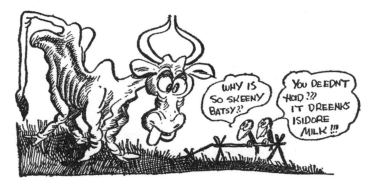

by de baby to take kestor hoil! ! ! Noo, pipple, so wot'll gonna be idder pinnacle odder breedge? ? ?

Mrs. Yifnif—So lats it should be breedge. So who'll gonna be by who de pottners? ? ? Who? ? Me witt de Meesus Mitzik? ? ? Ho K, is agribble by me. Noo geeve a shovel de cods witt a dill, plizze.

* * * * * * *

Mr. Feitlebaum—Noo, noo, goot evening, pipple! ! ! You playing yat cods? ? Whooy—is hot in de ceety. Dun't esk! ! Noo, meesus, so where is de goot for notting witt de dope we should hev gredually sopper, ha? ?

Mrs. Feitlebaum—Hm—is a dollink boy Isidore! ! !

Mr. Feitlebaum—A dollink boy, alrady? ? ? Is boddering you maybe de hitt, ha? ?

Mrs. Yifnif—Hm—wait yat! ! ! You deedn't hoid! ! ! So inforum heem de noose. So—yi yi yi—woot's dees, is coming a kraut pipple! ! Yi yi yi—geeve a look, Isidore! ! !

Voice—Feitlebaum! ! ! !

Mr. Feitlebaum—So is wot? ? ?

Voice—Zis your son? ?

Dunt Esk! (1927)

Mr. Feitlebaum—So wot's you beezness! ! !

Voice—A dollar an' quawder fer de can o' milk! ! ! ! !

Chorus— $\begin{cases} \text{Meelk! ! !} \\ \text{Meelk? ? ? ?} \\ \text{Meelk! ! ? ? ?} \end{cases}$

Mr. Feitlebaum—A wot? ? ?

Voice—You hoid me! ! ! Milk!—m-i-l-k—Milk! ! From contented cows! ! ! A buck an' a quawder fer d' can o' milk yer son rooned on me! ! !

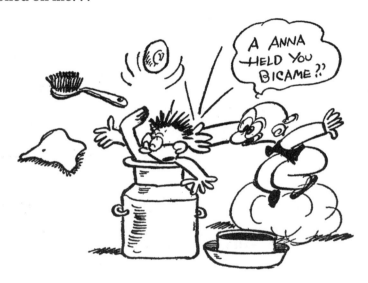

Mr. Feitlebaum—Mine son? By—you—rooyned—meelk? ? ? Wot he wants by you witt de meelk? ?

Voice—Soich me, mister. All I know is I look outside me store an' I ketch diss ting tryin' to take a bath in me can o' milk! ! ! Maybe he tinks he's Anna Held. He sez sumpin about a guy tellin' him milk takes tattoo marks off! ! You ast him——

Mr. Feitlebaum—Yi yi yi! ! TETTOONG! ! ! !

Dunt Esk! (1927)

(SMACK! ! !) Take hout from behind de beck de harm, meester (SMACK). Tettoong you got tettooed hon de harm, ha (SMACK). Tricks I nidd in de houze, ha (SMACK). Deed I was tettood, ha? ? (SMACK.) Deed mine fodder was tettood, ha? ? ? (SMACK.) Henkors you nidd on de harm, ha! ! ! (SMACK.) Witt higgles yat, ha? (SMACK.) I'll geeve you a tettoong! ! ! I'll——

Dunt Esk! (1927)

Looy—'Lo, folks! Wot's up? Wot—he swiped bottles of milk—an'? ? ? ? He—wot—in front of de grocery store! ! ! Tryin' to rub off a tattooin'? ? ? Hey, you got a noive, you have, kid! After me spendin' all mornin' puttin' dat ting on yer arm, you go to woik an' you——

> BOOM! ! ! ! !
> BANG! ! ! ! !
> CRASH! ! ! ! !

Mr. Feitlebaum—I'll geeve heem, dot dope! ! A tettoor he became! ! ! I'll make heem for a creeple! ! ! (BAM! ! ! ! BANG! ! !) I'll——

Mrs. Feitlebaum—Mowriss! ! ! !

Looy—'At's all—'at settles it—I'm troo witt dis joint! Old man or no old man, 'at's all! He can't heave no rockin'-chair at me! ! I don't hafta stand fer 'at' stuff y'know! I kin git a room! !

XXII

IT GEEVES GREDUALLY FROM DE SISSHORE
A DIPPOTURE DE GASTS

Mrs. Feitlebaum—Yi yi yi—It comes de goyng away. I'm so axcited—Yi yi—Meesus Shaingold! ! ! Goot pye! ! Goot pye! ! You got by oss de hedress? ? Goot pye, Meesus Noshkis! ! Goot pye, Gloria dollink—we'll sand you de shnepshots. Meesus Mitzic—goot pye! ! Mine riggods de loyer! Goot pye! !—de bast from helt—Goot pye, Meesus Yifnif! ! !—Yeh—yeh—We'll hev gredually deweloped de shnep-shots—so we'll sand you—— Yi yi yi—Isidore—take care goot de shnepshots! ! ! Goot pye, Meesus Moskoweetz! ! ! Goot pye—goot pye! ! !

Isidore—Baba—will you carry by surf board for be?

Mr Feitlebaum—(SMACK)—A lumberjacket I bicame alrady, ha? (SMACK.) Soif budds I nidd it yat in de houze! ! (SMACK.)

[146]

Dunt Esk! (1927)

Why you dun't want maybe (SMACK) I should kerry you home from a still bim from a beelding a goiter, ha? (SMACK) it should stay in de pollar! ! A copple shocks I should breeng home maybe (SMACK) dey should sweem in de battob, ha? (SMACK) witt a stoffeesh witt a clamp-shall yat it should cutt me opp de fitt, ha? (SMACK)—To-morrow you'll go by Bronx Pock so you'll breeng me by de houze a sublogical goddens maybe (SMACK).

Dunt Esk! (1927)

Looy—Ha ha—dat ting is a menagrie enough as is! !—Don't worry, Pop—he'd have a tough time gittin' outa de Zoo himself—wunst he got in! ! You'd hafta show dem his boit sittiffikit! ! ! Ha ha! !—'at's a hot one! ! Isidore Feitlebaum, Born———(see next week's Red Magic[6] for reason why) Eyes———crossed. Hot and cold running nose! ! And answers to de name of Fido! !—ha ha ha! !

Mr. Feitlebaum—AHA! ! is here alrady de dope! ! So why you dun't keesing goot pye de goot-for-notting frands you should livv de hedress dey should weesit you by de pull-room—odder de lonch weggon, odder de chop-sooy, odder a poliss station—from de ceety, ha? Mmmmmm! ! !

Mrs. Feitlebaum—Hmm—Goot pye, Meesus Noftolis—We'll sand you de shnep-shots! !—You'll geeve oss gredually a look up in de ceety.

Mrs. Noftolis—Hmm—of cuss, mine hosb——de doctor ushual presumes we should spand de weenter by Lake Ple-cid—he enjoins it extrimmingly dere de weenter-sputts witt de tobargaining! ! !—Boit—Boitrem! ! Is dees nize you should make witt de ruller-skates in de loppy? Boitrem—modder is prowoked—BOITREM! !—Comm, Boitrem! !—Say goot pye de pipple like it titches you in de priwate school on Reewersite Drife de tooter! !—BOITREM! ! Is dees nize you should make witt de feenger to de noze? Modder is waxed, Boitrem! ! Oohoo! !—Trockman—Trockman! ! So is here de hedress you'll go by de Reetz Hotal—bot foist you'll *stop plizze by dees hedress*.

Taxi Driver—Wot's diss? ? Seward? ? Seward Park Sout? ? Where's datt? ?

6. A weekly insert to the *New York World*, the *Brooklyn Daily Eagle*, and other newspapers, edited by Harry Houdini. The section included "secrets" to magic tricks as well as puzzles and such.

Dunt Esk! (1927)

Looy—Haha—ha—Seward Park Sout! !⁷—Before de war— jus' plain Essex Street!—Ha ha—Tree push carts up from de station!

Mrs. Noftolis—Hmmmm——Hm——aham—Yas—you see it hez dere mine son-in-law, Spancer Goldboig, de hoptomitreest, de huffice——Of cuss—he dun't leeving dere—he recites by Lung Highland—he jost kipping dere de huffice in de slumps it should halp de poorish pipple——

Looy—Yeah—Big-hearted Spencer—Dat glazier! ! !—Sellin' de Ginnys watch crystals fer specs! ! !—Makes Paul Revere look like de Four Horsemen! !—Between dat guy's goggle and de hootch dere peddlin' now—I could clean up in de pencil an' tin cup racket! !—Ha ha—him—a optishan—He usta paint black eyes in a Sand Street tatooin' joint!!

7. Seward Park South and Essex Street are prominent arteries of the Lower East Side.

Dunt Esk! (1927)

Mrs. Feitlebaum—Looy—Looy! !—SH——

Mrs. Noftolis—So you'll drop oss a line by Franch Leek Spreengs, Hindiena!—So——BOITREM! ! ! Geeve beck de leedle boy de hall day socker—Modder is hedgitated, Boitrem. Why you should take de leedle boy's hall day socker? You got home all de imputted chucklitts kendy! !—Hm——from who he takes efter? ? Is a meestery——

Looy—Ha ha! !—Wait till dey start countin' de towels in her room, it won't be no mystery! !

Mrs. Feitlebaum—Looy——Looy,—geeve batter a halp de poppa witt de walisses! !

Isidore—Ba—ba—Cad I sit id the frodt with the driver? ?

Mr. Feitlebaum—(SMACK) A shuffer you should be, ha? (SMACK.) Watch batter in beck de beggidge wot I holding you reliable for it! !

Mrs. Feitlebaum—We'll sand you de shnep-shots! !—Goot pye! !

Chorus—Goot pye!————Goot pye! !

Goot pye——Goot pye!

Goot pye——de bast from halt——

Goot pye——witt lots from lock! !

HORREWAR! !——

S'lonk—Goot pye!—Mozzletoff! ![8] Rimamber me de femily!

Goot pye!—Riggods——Goot pye! !

Looy—Goot pye!—See yez in de funny paper! ! Goot pye! !—

HONK HONK

Brrrrrrummmp! ! !

Taxi Driver—STUCK! Everybody out! !

Isidore—Look, Baba——

8. "*Mazel tov*" is a Hebrew/Yiddish idiom meaning "congratulations."

Dunt Esk! (1927)

Mrs. Feitlebaum—YI Yi yi yi—De shnep-shots feelms he took hout in de sunshine—YI yi yi yi——

Mr. Feitlebaum—(SMACK! ! !)—De feelms—you rooyned, ha? De feeee-eelms! !——(SMACK)

Looy—Well, he sure killed a lotta laffs dat time! ! (SMACK)

Mrs. Feitlebaum—Mowriss—not in de head ! !—(Honk—honk)

S'lonk! !

XXVIII

STURRY FROM HURRATIO HALGER

Ooh-hoo, nize baby, itt opp all de stood pitches, so momma'll gonna tell you from Hurratio Halger a sturry, "Stroggling Hop" odder "Bound to Rice."

CHEPTER WAN

"Smesh by you de beggedge, sorr? . . . No? ? ? Ho K is aggribble by me. Bag parron, sorr. You dropped de pocketbook, sorr. So here is, sorr."

Dunt Esk! (1927)

"Yi yi yi! Lend scapes alife! ! So I deed! ! ! You a brafe strung nubble boy, mine led. I'll write to de Prasident from de railrote a letter wot all de pessengers wot you safed dem de life. Oh— heh heh—heh—oxcuse me—heh—heh—I'm gatting tweested de dates. It'll gonna be naxt wick de railrote wrack—lat's see— oh—of cuss—to be sure—it jost now peecked mine pocket a peeckpocket de pocketbook—so wot you cutt heem—so he dropped de pocketbook—so you ritoining it to me de pock-etbook. Is no? ? Of cuss. Wal, you a brafe nubble honest led, mine boy. So why you ritoined de pocketbook? ?"

"Hm, mine momma tutt me halways—so: if it rons away a timm husses, so I should wait till it falls in de front from dem a hold man witt wheeskers witt a coppet-beg, so den I should geeve a greb de bridal. If it falls overbudd from de Fooltton Farry-butt witt golden hair a child wot she's de ben-ker's dudder, I should geeve gradually a dife in de wodder, I should pull hout from de wodder de child, I should rull her on a berrell she should be rusticated. If it drops a gantleman a pocketbook I should peeck it opp I should say so: 'Dun't mansion it, sorr—I deed honly de dooty, sorr.' Smesh by you de beggedge, sorr? ? Shine? Polish? Woild, Harrold, Prass, sor? ? Collar buttons, nacktize"——

"Wal wal—you a brafe strung hopright boy, mine led"——

"Oh, deddy—inwite heem he should come tomorrow he should hev deener."

"Sh, sh—of cuss, mine dollink. So here is de cod, mine led, so witt a heff-hour befurr time you'll wukk noivously opp witt don in de front from de bronstunn houze, so seex o'clock shop you'll geeve gredually a reeng de bell."

Dunt Esk! (1927)

CHEPTER TWO
Socksass

"Yi yi yi! Geeve a look de cod, momma."

HEBBINIZZER THROCKMUTTON

BENKER MEDICINE AVENUE

"Hm, so wot I should wear? De nittly prassed but wal-worn twidd coat witt de blue petches, odder de clinn witt tradbare bruddclutt pents witt de welwet sitt in de beck?"

"Hm, mine boy, if you fodder was honly alife you should esk heem. Yi yi yi! Sotch a goot waiter wot he was befurr he got it wodder on de thumb—Hmmmm-mm! Goot night—und rimamber, mine boy, you'll heng opp de coat in de hall so whan it robs by de benker de goot-for-notting naffew de safe so he should be hable he should put by you in de pocket de hempty wallet."

CHEPTER TREE
De Tonn Bully Mitts Our Hirro

"Hm, hollo, stoopit! To where do you going hall drassed hopp, ha? (SMACK.) So here is a keeck in de sheens—ha ha (SMACK)! So how it strikes you dees, ha (BANG)? Wal, wal—you hoid maybe from de latest fed wot it's in Peris mod-batts—ha? So take a flop (PLOP) in de mod-gotter—(SPLASH). Wal

[154]

Dunt Esk! (1927)

wal—Yi yi yi yi! Be a leedle careful where I jomp. (BOOM.) Oop! Wot for you broke mine bazeball bet witt de noze, ha?"

So it gave our hirro a flosh de chicks, witt a greet de teet, with a clanch de feests, witt a rull opp de slivve, wot he sad : "Dun't go too far, you wolgar critchur."

CHEPTER FURR

By de Benker in de Mension

R-R-R—r-r-reeng! Knock knock! ! !

"Clirr hout from here, you yong wheeper-snepper. We dun't nidding anny chimney-swipps."

"Jost a minnit, Watkeens. Dot's de yong men wot he dregged away from me de med dug—oh—heh heh—oxcuse me was day befurr yesterday de med dug—lats see. You cutt maybe sinkle-hended de two keedneppers—hem—so—wot was—oh—yas yas—of cuss—de wallet—yeh heh, come in."

"Wal, you on time, yong men—ha? So mitt mine son Muttim-er. Come, Muttimer, mine boy, geeve a sneef with a snirr witt a contamptuous snoll, und riffuse you should shake hends witt a yong hoppstott from de gotter. So you'll oxcuse yousalf wot you got a date you should gemble witt codshops dey should inwiggle you in you should fudge by me de name on de chacks. Is no? Goot nite, mine son. ·

"So how is de zoop, mine brafe led, ha—goot? ? ? So come by me in de huffice to-morrow so you'll ketch dere in de neeck from time mine crooked bookkipper wot he embazzles by me de sickyooritizz wot you'll safe gradually from rumination de beezness. So efter dees you'll jost hev time you should ketch a fife-feeftin you should prewent it should furrcluzz de Squire de muggidge by you momma on de cottage. So den I'll gonna make you in de beezness a pottner wot you'll merry gredually

Dunt Esk! (1927)

mine dudder wot'll reform de tonn bully he should be from hair-nats a sailissman. So you'll be Prasident from de beezness, witt a stockholder by de benk, witt a sherr in de railrote, witt a diractor by de telaphun company—honly of cuss in horder you should show wot it's by you a democretic speerit, so avery wick you'll come by de fontain in de Ceety Hull you should take witt de nooseboys a sweem—is no??"

It Mitts Our Hirro a Strancher

"Wal wal—denged eef it haint de keed heemsalf by jeemeny creckers, by hack! Gosh hall feeshhooks! By gom, you dun't rackonize me!! Wal, jeemeny creeckets, I'm you grenfodder's cozzin Zik from Crembarry Cunners—— Shoore!! Of cuss. To where do you going? To de benk witt wot? Witt stocks, witt bounds, witt nutts, witt chacks. You a benk massanger, ha? Wal wal, hood hev tonk it! C'mon, hev a trifle wheeskey—pst—bottander—fife feengers—heh heh heh—heh heh heh heh—heh heh!!

Dunt Esk! (1927)

CHEPTER SEEX

Cocklusion

Smesh by you de beggedge, sorr? Shine? Polish? Woild, Har-
rold, Prass"——

Hm, sotch a dollink baby ate opp hall de stood pitches.

DE RAVEN

GEEVE A LOOK IS IN DE RAVEN

Wance oppon a meednight drirry
While I rad a Tebloid chirry—
"Pitches Hinnan gatting lirry—
Odder peectures on Page Furr;"
Gredually came a whecking,
Tutt I: "Feitlebaum is smecking,
Witt a razor strep shellecking
Goot for notting Isidore!
Smecks heem where de pents is lecking
In de rirr from Isidore.
Wheech hez heppened huft befurr!!

"Idder dees it could be odder
Ginsboig's goot for notting brodder
Wot he's fool from fire-wodder
Makes a herror in de durr.
YI YI—YI YI—YI YI—YI YI
Plizze'll some one tell me why I
Got to hentertain a pie-eye.
"Ha, I mottered, gatting surr,
"Got to hentertain a pie-eye wot he'll

Dunt Esk! (1927)

Seeng yat by de scurr
Tsentimental sungs from yurr? ? !"

So I geeve a shott, "Whooeezit
Coming tricklock witt a weesit
Witt a Brennigan[9] axqueesite
Witt a bonn on foidermore?"
Open wide I trew de puttal
Stending dere was not a muttal!
"Heh, heh, heh" I gave a chuttle,
"Why I deedn't tutt befurr? ?
Sotch a dope! !" I gave a chuttle,
"Not to nuttice it befurr—
Cohn tecks coppets on de flurr! !

"Look de fullish cuzzes wot'll
In de night a fallow stottle!"
Sad I, hemptying a bottle,
Whan it came yat teps some murr.
Came a tep-tep-tep-tettooing,
Plester from de cilling strewing,
Sad I: "Wot's mine Tom-ket doing
Opp above mine chamber durr.
Could he be a she-ket wooing
Feeftin fitt above de flurr.
Look! A filline troubadour! ! !"

Prompt I'll gonna put a ki-bosh
On de patting poddy—"MY GOSH!"

9. A Brannigan was a 1920s term for a long night of drinking and merriment.

Dunt Esk! (1927)

Scrimmed I, grebbing for a heye-wash,
"Wot could dees be on mine durr??"
Hibby-jibbizz!!—Hev I gottem??
Dot lest bottle, deed it stottem??
Look it seats on his Bleck Bottom—
Seets a Raven on mine durr!!
Seets dare und ripitts voibotim
Opp above mine chamber-durr
One woid spitches: "Navermore."

"Mine curiosity oxcusing,
Would you mind plizze hintrodoozing
Who you are to bost mine snoozing
Opp like dees?" I gave a rurr.
"Hm—it simms you not a tukker!
Wot's de metter, Meester Crukker?
Shell I cull opp Jeemy Wukker,[10]
He should gritt you by mine durr?
He should make a spitch a cukker
Opp above mine chamber-durr—
You should henswer: 'Navermore'?!!

"Tal me, haducated boidy,
Witt de spitches lung and woidy
Are you bleck or jost plain doidy?
Were you like dees hirrtofurr?
Could be maybe you a toikey,
Painted witt de color moiky,

10. Jimmy Walker was the mayor of New York during the 1920s.

Dunt Esk! (1927)

So dot no sansations joiky
On de nack wheech you adurr
Should distoib your comfitt smoiky
On Nowamber twenty-furr
In a luckal bootcher-sturr? ? ?

Soon de daylight will be dunning,
Nuttice plizze—ho hom—I'm yunning—
Wot it's tricklock in de munning—
It'll gonna soon be furr.
I dun't like you style high-hettish
Ciss de hections plizze coquettish
Odder in a form door-mettish
You'll be lying on de flurr! !
Batter in tan sacunds flettish
Axecute a Terpsichurr
Lightly hout mine chamber-durr."

Bot de deespossass prociding
Feenished opp witt me stempidding

Dunt Esk! (1927)

Like a strik from lightning spidding
Tudds de hexit troo mine durr.
Aggs he stotted opp dere hetching
Und from shalls demsalves deteching
Leetle ravens now are scretchin
Opp mine brend-new pocket-flurr!
Und so soon dey feenish scretching
Itch wan lays a dozen murr!
Und I'm hibby-jibbizz ketching,

Dunt Esk! (1927)

Trying I should kipp de scurr—
Dot's hall dere eez—dere's notting murr.

THE END

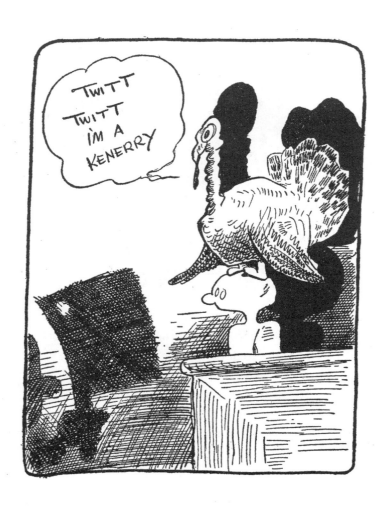

De Night in De Front from Chreesmas (1927)

This is perhaps Gross's most popular and well-known work, next to *He Done Her Wrong*. It is a masterful retelling of the Clement Clark Moore original. The short verses and cartoon illustrations reimagine the poem from the perspective of the Feitlebaums and turn the standard story inside out. Gross replaces stockings hung "by the chimney with care" with a laundry line, and instead of welcoming the sounds of reindeer on the roof, Gross worried about disturbing the neighbors.

For Gross, the night before Christmas was full of nightmares about "critchures mysteerous," a spider hunter, and an appearance from "Tsenta Cluss Feitlebaum." More notably, instead of ending the poem by meeting Santa and receiving gifts, this version concludes with an explosion, an interrupted wedding, and a peculiar inversion of typical Christmas wishes.

By retelling this classic poem in Yiddish-accented English, Gross may have been offering a subtle critique of American Christmas, which largely excluded Jews at the time. It is also likely that Gross, who wrote for a general audience and had come to specialize in Jewish-dialect versions of classic literature, wanted to join in the holiday spirit as only he could.

Gross published the poem originally in the *New York World* in 1926 and received so many requests to reprint it that he

decided to publish it under its own cover the following year. For one New Jersey family, however, the poem bore a great deal more meaning than even Gross had originally intended. In 1944, Mildred and Raymond Eisenhardt of Ridgewood, New Jersey, reprinted the poem in a commemorative booklet and explained,

> On the morning of December 19th, 1926, the collective laughter of readers of the *New York World* reached to high heaven and roared 200 miles in all directions. By noon copies were as hard to find as an American flag in Hitler's bedroom. Milt Gross's column that day was "de Night in de Front From Chreesmas." And it was literally read to shreds. . . . But in a world that since creation has lost such gigantic things as entire tribes, complete civilizations, and even its global sanity, it isn't surprising that the trivia of 18 years should almost bury this choice contribution to the bibliography of Christmas literature. A new generation has grown to fighting, if not voting, age. To deny it this delicious piece of fun at a moment when laughter is almost the sole inoculation against lunacy, is unthinkable.[1]

The Eisenhardts published 250 copies of the pamphlet, with Gross's permission, recasting Gross's Jewish-dialect version of the poem in the drama of the home front. Like Irving Berlin's "White Christmas," which also entered the American popular-cultural imagination during World War II, Gross's poem drew on the interpretation of Christmas by a Jewish writer. And in that odd echo of the holiday, the poem captured the ear of its American audiences.

1. Milt Gross Collection Box 1, File 1. UCLA Special Collections. Young Library.

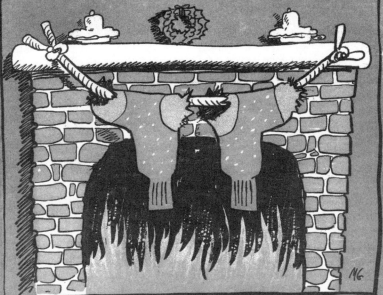

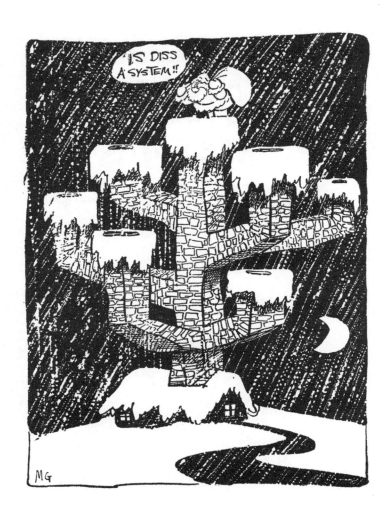

DE
NIGHT IN DE FRONT
from CHREESMAS

BY

MILT GROSS
Author of
"HIAWATTA," "NIZE BABY,"
"DUNT ESK"

NEW YORK

De Night in de Front from Chreesmas

'Twas de night befurr Chreesmas und hall troo de houze
Not a critchure was slipping—not ivvin de souze,
Wot he leeved in de bazement high-het like a Tsenator,
Tree gasses whooeezit—dot's right—it's de jenitor!

Hong opp was de stockings, site by site, Bivvy Dizz,
Lace pentizz, seelk henkizz; here witt dere a chinimizz:

Pricidding de Yooltite de ivvning it was—

De Night in de Front from Chreesmas (1927)

Whan it gave on de durrbell de bozzer a bozz.
Und hout from de night wheech below was from Zero,
It gave hexclamations a woice "Hollo Kirro!"
I roshed to de durr witt a spreent troo de foyer,
Like hefter a hembulence spreentz it mine loyyer.

It was ronning from plashure all hover me teenges
Wot I pulled it de durr hulmost huff from de heenges.

De Night in de Front from Chreesmas (1927)

It stoot dere a ront jost so high teel
 de durr-knob,
De faze fool from wheeskers und
 smooking a curncobb,

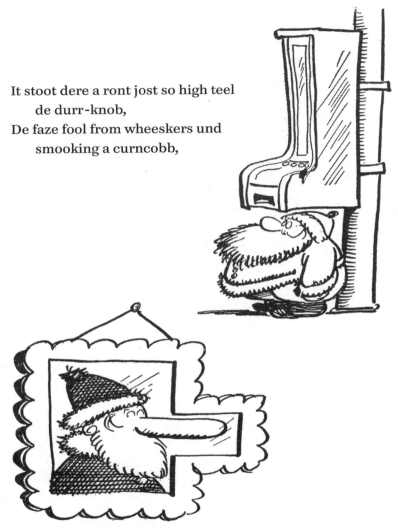

From de had to de hills sotch a werry shutt deestance
I navver befurr saw in hall mine axeestance. . . .
De nose it was beeg like de beegest from peeckles
I weesh I should hev sotch a nose fool from neeckles!

De Night in de Front from Chreesmas (1927)

De two leedle lags was so shutt witt so bendy—
Wot onder de seenk he made sommersults dendy.
De belly poffed hout like a hairsheep a Zepplin

Und he wukked opp witt don like it wukks Cholly Cheplin.

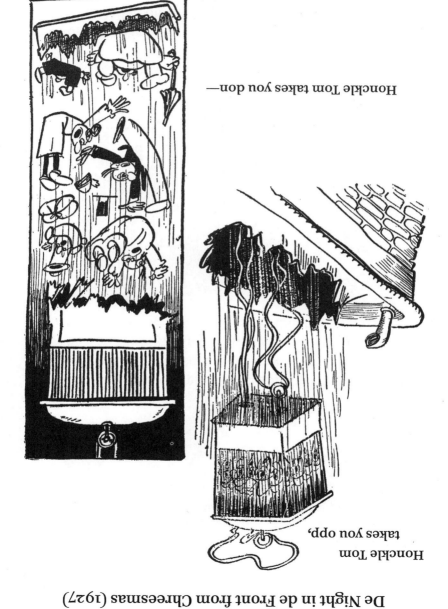

—Honckle Tom takes you don—

Honckle Tom
takes you opp,

De Night in de Front from Chreesmas (1927)

De Night in de Front from Chreesmas (1927)

It should geeve a complain on de top flurr de neighbors!!
You know how is streect now de luzz from de pocking—
By de way, could you find a inweesible stocking??
So take plizze a load huff de fitt I bisitch!"

Und it made me de weesitor like dees a spitch:
"Thomas Jafferson Washeengton Restus McCrime—
Wot he rons here de car in de beelding—dot's I'M!

De Night in de Front from Chreesmas (1927)

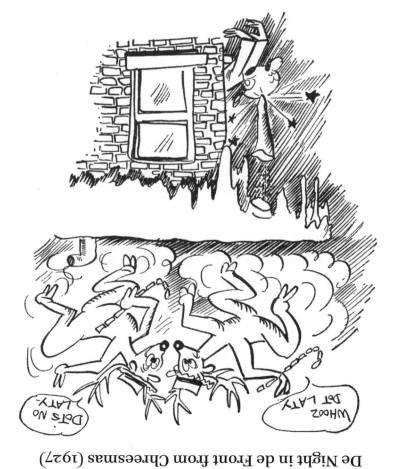

On de roof do dey prencing witt hoofs shop like tsabres—

De Night in de Front from Chreesmas (1927)

"So GEEVE a look! GEEVE a look!—
GEEVE a look—QUEECK!!!
Geeve a look wot it's dere in de durrway St. Neeck!!!
How's Donder witt Bleetzen witt Desher witt Dencer??

How's Comet witt Weexen—I hesk you a henswer!!
Hozz Comet witt Weexen witt Prencer witt Cupit??
Wot for do you stend like a mommy dere, Stoopit??

[173]

De Night in de Front from Chreesmas (1927)

So dun't forgat Honckle whan Chreesmas comes ron!"

Away from de durrway I flew like a higgle—
Like it flies fest a docky away from a Kliggle!

De Night in de Front from Chreesmas (1927)

From de night befurr Chreesmas I got yat deleerous—
Wot it came hall night weesits from critchures mysteerous:

Nombar wan showed me spiters witt roaches galurr—
Wot he cutt dem itch wan hadding straight for mine durr.

De Night in de Front from Chreesmas (1927)

Nombar two was a putter—de toid was a goof—
Wot de sonshine he swapt hall year huff from de roof.

Dey came in pletoonz
 witt brigates
 witt bettelions—

Und I loined from de tukk dey sobseested on scellions.

De Night in de Front from Chreesmas (1927)

When hall from a sodden aruzz sotch a cletter—
I jomped hout from bad I should see wot's de metter.
Den hall troo de houze came a scrimming "Yipe! YIPE!"—
From Tsenta Cluss Feitlebaum stock in de pipe—
Und motch murr woceeferous ruzz opp itch scrim—
Whan Looy dot dope gave a toin on de stimm—

De Night in de Front from Chreesmas (1927)

Und donstess from oss it was geeving a poddy
To frands witt hecquaintances Meester McCoddy—
A wadding, in fect, wot de brite was his dudder
Who merried was gatting to Ginsboig's new budder.

De Night in de Front from Chreesmas (1927)

Und jost when was spicking de britegroom "I weel,"
Witt a beng in de bazement oxpludded de steel.

De Night in de Front from Chreesmas (1927)

Und opp troo de roof flew in gudgeous harray:
A washtub, a lendlor, a longe, a boffay,
A hize-box, a jenitor—pots from heem meesing,
A broom witt a mop wheech de britegroom was keesing,

De Night in de Front from Chreesmas (1927)

A batroom intect holding tree wadding gasts,
Und spreenkled witt plester de geng from mine pasts!

De Night in de Front from Chreesmas (1927)

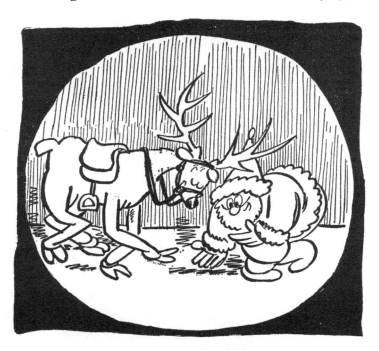

On December two fife witt jost wan ivvning privvious
Was gung on dere gungs-on extrimmingly grivvious—
By mine enimizz woist shouldn't be sotch a plight—
Und we closing witt bast Yooltite weeshes—Goot nite!

Hiawatta (1926)

Somehow, Gross managed to hold on to Longfellow's charac-
teristic rhythm while still translating the story into broken,
Yiddish-inflected English. Unlike other popular parodies of
the poem (it is one of the most beloved and parodied poems in
American literature), Gross's version bears almost no resem-
blance to the original except in rhythm and title.

In this version, Hiawatta's village became a suburb, only
"fiftin meenits from de station." And the chief's "pipe tebecca"
poisoned all of the animals of the forest. Hiawatta's birth vio-
lated the "no cheeldren" clause of the settlement, but Hiawatta
was permitted to stay, and he learned to be "on spicking toims
witt" the animals and birds of the forest. Gross's "Hiawatta"
ends by retelling the myth of how the moon got its shadow.

The *American Hebrew* reviewed the book and offered the
following insight: "If Longfellow could look upon this strange
rendering or rending of his immortal poem, he would surely
drop dead again from sheer despair in trying to fathom its
mysteries of lucution and orthography. And the comic illustra-
tions would either drive him back to his grave or cause him to
die laughing."

Gross's Jewish rendition of Native American life includes
countless elements of immigrant life, from banks and "Spick

Izzys" to investments of acorns and images of vacuum cleaners next to "tommy-hucks." Never far from the urban sounds of New York, Gross reduced the epic scope of the poem and the plains to the slapstick sounds of immigrant-style domestic life.

HIAWATTA
WITT NO ODDER POEMS

BY
MILT GROSS
AUTHOR OF "NIZE BABY"

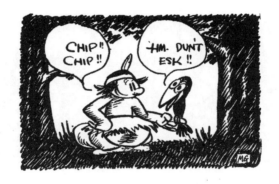

ILLUSTRATED BY THE AUTHOR

MURRAY HILL : : NEW YORK

Hiawatta

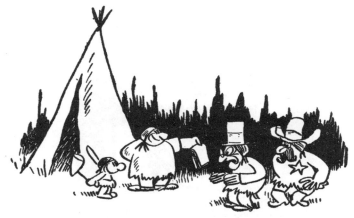

On de shurrs from Geetchy Goony,
Stoot a tipee witt a weegwom
Frontage feefty fitt it mashered
Hopen fireplaze—izzy payments

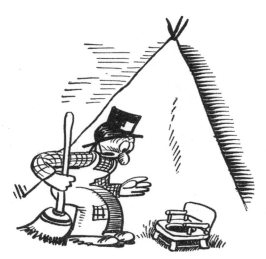

On de muggidge izzy payments
For one femily a weegwom
In de liss a cluzz "No cheeldren,"
Stoot a warning "Hedults honly."

Fiftin meenits from de station
From de station jost a stun's trow
Fiftin meenits like de bull flies
In de beck a two car gerredge
Gave a leff "Ha ha,"
De wodder—

Hiawatta (1926)

Smooked de Chiff a pipe tebecca
Opp it rose from smoke a wapor
Clouts from smoke de hair assended
Like by Yellowstun de Kaiser

Like a hoil-well wot it goshes
Goshes in de hedwertisements
On de coicular it goshes
Ruzz de smoke opp, high witt deezy

Hiawatta (1926)

Grebbed de boids witt bists de gezzmesks
Flad de rebbit wilt de roebock
Bonded like a strick from lightning
Grissed witt griss, a strick from lightning

Gave de bear a ronning brudd-jomp
Gave de helk witt deer a high-dife
Gave a baiting beauty high-dife,

Hiawatta (1926)

Witt de hentlers in de wodder.
Loud a yell de skonk gave; "Kamerad"
Poffed witt pented hall de critchures
Hout from bratt dey poffed witt pented

Hiawatta (1926)

In de woots expheexiated

Hiawatta (1926)

Smooked de Chiff de pipe tebecca
It should be de smook a tsignal
All de tripes should hev a mitting
In de forest fumigated

So de beeg Chiff gave a mitting
From de tripes it came de pipple
To de mitting—in de pow-wow
Came de Chiffs und came de Sockems

[196]

Hiawatta (1926)

Came de skwuzz witt de cabooses
To de mitting
Grad-u-ally—
In de trizz it strimmed de brizzes
Gave a leff "ha ha" de wodder
Gave de Chiff a knock de gravel
From de mitting rad de minutes
From de lest wicks mitting minutes

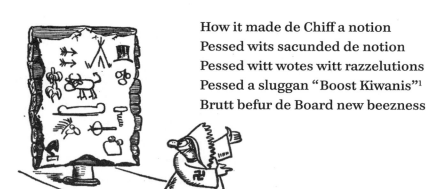

How it made de Chiff a notion
Pessed wits sacunded de notion
Pessed witt wotes witt razzelutions
Pessed a sluggan "Boost Kiwanis"[1]
Brutt befur de Board new beezness

1. A reference to the Kiwanis Club, one of
the many civic-service-oriented social clubs
founded in the early twentieth century.

Hiawatta (1926)

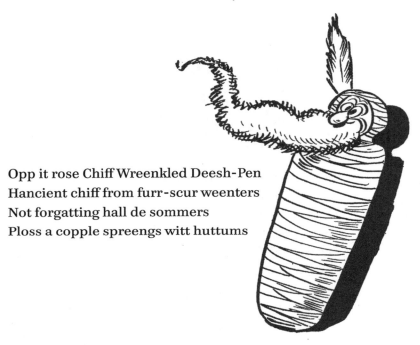

Opp it rose Chiff Wreenkled Deesh-Pen
Hancient chiff from furr-scur weenters
Not forgatting hall de sommers
Ploss a copple spreengs witt huttums

In de weend it wafed de wheeskers
Like a proon de faze resambled
From de faze from Wreenkled Deesh-Pen
Eef it laid out in a straight line

Hiawatta (1926)

Hend to hend would rich de wreenkles
From New Yuk to Pessadinna
Pessadinna, Kellifurrnia
Gave de Chiff a hexclamation
"Hock ye! Hock ye—nubble worriers
In de willage, in de weegwom
Wheech it stends a rule no cheeldren

Brutt lest wick de stuck a Baby
From de name from Hiawatta
Wott'l be I hesk a henswer!"
Opp it jomped de skwuw Nokomis
Spicking witt a woice axcited
"I would like to make a notion
What I should adapt de baby,"
Gave de Chiff a hexclamation
"Ho K, is by me agribble."

Hiawatta (1926)

So it grew opp Hiawatta

Went itch day to keendergotten
Loined from all de boids a lengwidge
From de boids witt bists a lengwidge
All de critchures from de forest
He should be on spicking toims witt

Hiawatta (1926)

Gave a hoot de howl "Goot Monnink"

Honked a honk de gooze "Hollo Keed"

Gave a scritch de higgle
"Yoo Hoo"

Quecked a queck de dock "How guzzit?"

Hiawatta (1926)

Gave a bozz de bizz "Hozz beezness?"

By de squoilles he made inquirriz
How'll gonna be de weenter
Gave de squoilles a henswer proutly.
"Hall de signs witt hindications
Pointing to a beezy sizzon,
Reech witt prosperous a hera,

Witt a houtlook hoptimeestic.
In de trizz we got dipositts
Wot it feegures opp a tuttle
Feefty-savan tousand hacorns
Ulso from seex tousand wallnots
Stends a Kepital witt Soiploss."

Hiawatta (1926)

In de durr in sommer ivvnings
Set de leedle Hiawatta
Watched it geeve de strim a reeple
From de reeple saw de moon rize
In de sky it rose de moon opp
Opstess like a helewator.
Denced oppon de moon a shedow,
Esked a quashtion Hiawatta
How it got de moon de shedow
So de grendma gave a henswer,

Hiawatta (1926)

Wance oppon a time a souse-pot
From de name from Beeg-Chiff Blind Peeg,[2]
Came hum trick lock in de monnink
Fool from jeen—from fire wodder
Fool from fire wodder cockite

2. A "blind pig" was another name for a speakeasy or a pub that evaded blue laws or Prohibition.

Witt tree frands from de Spick Izzy

Hiawatta (1926)

On itch one de heep, a heep flesk
On itch heep a hempty heep flesk
Seenging ballots tsentimental
Seng "Switt Edelline" de quottet

To de durr it came de meessus

Hiawatta (1926)

Witt a rulling peen a beeg one
Witt a tommy-huck a hod one
Came witt a potato mesher
In de hend a coppet-bitter
In de heye a look a med one
Sad de Chiff "Boys mitt de meesus,"
"Hollo, switthott come—hic—kees us."

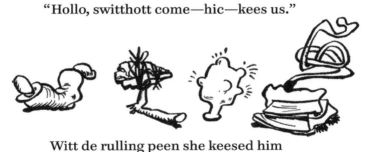

Witt de rulling peen she keesed him
On de cuccanot she keesed hem
On de binn oppon de buld spot
On de dome she deedn't meesed him.
"Yi yi yi. Is diss a system?"
Gave de Chiff a hexclamation
Gave a leff "ha ha" de wodder
Gave a yell de geng "Rezzbarrys."

Hiawatta (1926)

By de Boyish Bob he grebbed her,
Hopp into de hair he trew her
On de moon full-fuss she lended
In a hipp de meessus lended
Making shedows wheech you see dere
Making Cholston jeegs witt shimmiz.
Hm—a dollink Hiawatta
Ate opp all de Hindian Corn Mill.

Famous Fimmales (1928)

Originally written for *Cosmopolitan*, the stories in this book find Gross nearly at his best. His illustrations are increasingly delicate and detailed, and they predict the intensity that would soon reach its full development in *He Done Her Wrong*. Likewise, the book is a fuller version of the stories that counted for much of Mrs. Goldfarb's contribution to *Nize Baby*.

Whether in his epic retelling of "de insite sturry from de woild" or his version of the story of the Garden of Eden ("Iv"), Gross clearly found his rhythm in this work. Each story is full of the Jewish dialect that he had perfected in his earlier works, but the format allows him to take greater liberties with the narratives. Within this expanded format, Gross milked each story for its full comic potential, as in his version of "how it got inwanted tenksgeeving day," or his version of the discovery of America by Christopher Columbus.

By retelling well-known stories, Gross could play to his strengths with parody and dialect—he did not need to retell the stories completely; he needed only to allude to them so that his jokes, drawings, and references resonated with his readership. Likewise, Gross could mock the stories as well as those who tell them, including historians:

De Heestroian, witt de meessus Heestorian, riquast gradually de extrimingly great honor dey should geeve witt de bast from pleasure a annonncement wot dey exknowledging de information in dees Wolume from de following susses:

Botweiser Brewery hedwertizements "Famous Beer Dreenkers from Heestory."

Hactual haxpeerence from Heestorian in Woild Wurr (see Over de Mop witt de Keetchen Poliss by Heestorian, $2 nat).[1]

In Gross's world, neither the story nor the storyteller was safe. And by turning readers into storytellers, stories into parodies, and the printed page into a script to be read aloud, Gross effectively used the authority of the text and the author against itself, and turned stories into sound.

1. Gross, M. *Famous Fimmales witt Odder Ewents from Heestory.* New York: Doubleday, Dorian, 1928, 2.

Famous Fimmales

WITT ODDER EWENTS

From Heestory

BY MILT GROSS

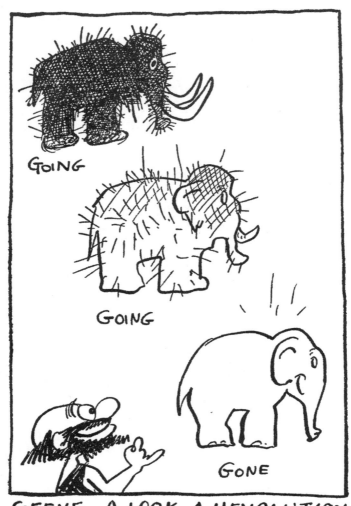

FAMOUS FIMMALES
Witt Odder Ewents
From Heestory

BY
MILT GROSS

Illustrated by the Author

Garden City, New York
1928

Famous Fimmales

DE INSITE STURRY FROM DE WOILD

I. Heestory—So wot it minns de dafaneetion from de woid Heestory? So is so : Is diwided in two hiquill pots de woid Heestory, wiz:

A priffix—Heest.

Witt a suffix—Story.

Wot it minns itch one so.

Heest—Sh!! Silence!! Hock!! Geeve a leesten!!

Story—A narrative, a rummance, a tale, a fable, a yon (could ulso minn a floor from a building, wiz : de toid sturry).

So it minns Heestory: Geeve a leesten a nerrative!!

Heh heh—Of cuss, it couldn't be "Geeve a leesten a floor from a building"; axcapt sometimes wot it should squikk de floor, wot in deez caze it would gradually resamble de whole Heestory like it should be from Rets witt Mize, is no??

II. Notes Witt Rafarances—(To whom it'll maybe gonna consoin). De Heestorian, witt de Meessus Heestorian, riquast gradually de extrimmingly great honor dey should geeve witt de bast from plasure a annonncement wot dey exknowledging de information in dees Wolume from de following susses:

(a) Bottweiser Brewery hedwertizements "Famous Beer Dreenkers from Heestory."

(b) Hactual haxpeerence from Heestorian in Woild Wurr (see Over de Mop, witt de Keetchen Poliss by Heestorian, $2 nat).

DE WOILD WURR UND WOT HEZ GONE BEFURR

Of cuss, it was de Woild Wurr one from de most nuttable ewents wot took plaze in Ninetinn Futtin—bot in bitwinn time it will geve de heestorian a synopsis from de sturry hopp ontill de prasant time wot it conseests de woild from deeference contrizz witt nations wot is here de leest in de horder from dere appeerance. So is so itch contry witt de hage:

U. S. A.—151 years hold lest Futt from July.

Hingland—632106 (eef she's a day).

[217]

Famous Fimmales (1928)

Frence—1076—(honly, of cuss, is rilly 2152 on accont wot
 dey leeving in Peris twice so fest like by all over).

Ijjipt—999,999 (dun't looking a day over 999,998).

Jepen—(Over 21).

China—986,664,367½ (gung on 986,664,368, wheech is rilly
 in American time seek wicks witt two days).

Of cuss, in de beginning whan was joost bing esteblished de
woild it deedn't was nidder by Ijjipt a seengle pyrameed nod-
der by Sweetzerland ivvin a Elp—was hall over de woild Hice
wot dees was de Hice Hage.

So occurding de system wot is entitled de ceetizens from
China, Chinamen, so was entitled de inhebitants from de Hice
Hage, Hicemen!!

A HICE - MEN

So dees Glazers from hice wot it was hall over de woild so
was a whole time trevelling arond: nutt-bond, witt sout-bond,
witt Trenscontinantel, witt Union Paceefic Glazers wot it
deedn't nidded in dem days de pipple nidder Sobways nodder
trollicozz.

So from de hice was warious by-products, like snow witt
hail, witt so futt from wheech is so de proof: Eeef it takes de

ridder in de hends a snubball wot he'll geeve it a squizz, so it'll bicome hod de snubball it should be hice, is no?? (Of cuss, it could geeve you dees information anny schoolboy). So from dees was deescovered de teeory wot is hice elestic. Hm, of cuss, we couldn't boncing a hice-boig opp witt don, odder dey couldn't making from hice binn-shooters, odder dey couldn't stratching a fife-cents piece hice it should be like a ten-cents piece. It was hable honly de hice it should squizze in—hout it couldn't squizze.

So it leeved de pipple in houzes from hize wot dey was

entitled higloos. So it came Sonday monnink wot it weeshed a tenor he should take a batt so it was naccassary dey should melting opp de hice—so it made de tenors a spitch so :

Famous Fimmales (1928)

"Hm, geeve a look—so I got to melt opp a heff from de front putch witt a rocking cherr yat in horder I should take a batt!! Is diss a system?!! Hm,—is a locky ting we dun't leeving in de brownze hage—we should go sweeming in a tob from melted brownze we should come hout yat brownze-plated, ha??"

So it took de pipple murr witt murr batts wot it gave gradually a wanish de Hize Hage!

(Hend from Chepter One.)

CHEPTER 2

OILY TSETTLERS IN DE WOILD

So was foist de foist hize hage den gradually a sacund hize hage, und in cocklusion was a toid witt a futt hize hage witt in bitwinn itch wan a hintermeesion. . . . So in itch hintermeesion it axeested critchures wot it belunged in de following kettegories. Wiz:

Nomber Wan—SEA FOOD——Feesh, clems, hoysters, lobsters, shreemps, scellops.

Nomber Two—RAPTILES——Snakes, woims, ketterpillows, leezards, scuppions, mounsters.

Nomber Tree—MEMMELS——Kemels, &c.

Nomber Furr—PIPPLE——Man, weemen, goils, boyiss, babizz, tweens.

So it would arrife like dees a hize hage.

So you should see wot it stoot in de paper hextras so:

CITY SHEEVERS IN GREEP FROM COLD WAFE

MOOFING SOUT

NO RILLIF AXPACTED FOR TWANTY TOUSAND YIRRS

Famous Fimmales (1928)

So it was gung on in Hollywoot hall kinds from hexcitement honly of cuss, bing wot it was den de Raptile administration, so it was in de moofies in dem days honly woims, witt so futt. So it would say wan woim to anodder was so:

"Noo Jake, you woiking??"

"Hm!—Do I woiking, he esks!! HA! HA! Lesky is ronning me regged! You should see a beeg feeshing peecture dey got for me. . . . So I sad to heem, I sad so: 'Leesten,. Jassy——we goot frands, bot for de feeshing gegs you'll gat plizze a dobble!! I lust lest yirr a hinch huff from me witt de feeshing beezness!!'"

GEEVE A LOOK DE BEEG PARATE

Famous Fimmales (1928)

"I gatting tired from de low comedy stoff . . . I'll gonna gat in de ligeetimate."

"Hm—you should see a siquence in de foist cloze opp wot I come hout from a hepple . . ."

"Dot's goot hukkum . . . Ho, by de way, dey hed to stop woik on de 'Beeg Parate.'"

"Wot was??"

"Hm, dun't esk—de centipede got Kligg heyes!!"

So shuttly hefter dees it came de naxt hize hage, wot it fruzz opp hall de snakes witt de woims witt de scuppions so witt a copple tousand yirrs later wot he chopped huff hall de hize; so was ondernitt memmels!!

Memmels

Hirrtofurr was leeving honly feesh witt raptiles wot dey was hall bechelors. It deedn't was by dem husbands witt wifes. So

den it came alung de memmels wot dey inwented femilies; wot from dees it deweloped gatting merried—witt diwusses witt alimony witt consull-fizz. So instat dey should lay haggs

Famous Fimmales (1928)

like de feesh witt de raptiles so instat it brutt dem de stuck huffspreengs. Ulso wot is hable a memmel it should fidding de yonksters wot it ain't nassassary dey should geeving de baby a bottle. So is ulso annodder hebit by memmels. Feesh witt raptiles dey hall bald; so de memmels was de foist ones wot dey hintrodoozed hair witt furr witt wheeskers, witt siteboins, witt speetcoils, witt silskeen, witt hoimine, witt meenk, witt skonk, witt Koleensky.

So de foist memmel was a huss. Honly instat it should be by heem hoofs so was on de furr-fitt feengers, und on de hind-fitt tuzz.

So wan day it stoot opp on a sup-box a huss wot he made a horation so—

Frands witt fallow husses!!! Onder de kepitaleestic system it hez itch huss feengers witt tuzz—is no??? So from dees wot do we ripping a rewudd!? Corns witt bonions witt hingrown nails!!!! Is diss a system!?!?

Kraut husses—Hear!!! Hear!! Bravo! (Spitch!!)

Huss—Feengers witt tuzz we nidd yat wot for??!! Pianos we should play maybe odder a daff witt a domb lengwidge it should spick yat husses—ha?!!—So is why?? Aha!! Go hesk

Famous Fimmales (1928)

batter de Chirropodists' Trost!!! Hesk batter de Manicurists' Trost!!!! Hesk batter de—

Kraut husses—Hear!!! Hear!!! Comrat! Comrat!! Don witt money-making skims!! Don witt feengers! Don witt tuzz! Hop witt hoofs!!! Tricheers for de next Mayor!!! Whooz hall right?! Dobbin's hall right!!! Mm, is he a jolly goot fallow??!! Dun't esk!! (Whooy!!)

So from dees it discodded de husses de feengers witt de tuzz wot it was adopted gredually hoofs wot from dees it stodded opp de glue factory beezness.

CHEPTER 3

HUMAN BINGS

So in de hend from Chepter Two wheech it gave from de Raptile hage witt de Memmel hage de insite fects; so hall de lend witt property witt poblic huffices witt so futt so it was in complitt contrull from de henimals. So den it came Men.

Of cuss, it deedn't arrifed hall from a sodden a fool-flatched men wot he was hold enoff right away he should wote. Was foist de human bings babizz witt hinfants, den gradually

Famous Fimmales (1928)

cheeldren's sizes, den boyiss witt yoots witt yong mens, den consoivatives und den a meedle-haged men. Was ulso a few hodd sizes witt meesfeets.

So de foist beezness wot Men stodded opp was from Sputting Goots, wot he menefectured harrows, witt fleent witt spirrs, witt hopoons, witt hall sutts from tsimilar himplements.

So de foist appearance from Men was gritted witt conseederable curiosity on de pot from de bists wot it ewoked from dem rimocks so:

MAMMOT: "Hm, geeve a look—hall kind himmigrants dey latting in!!——A frick!! HA HA! . . . Too tull for a feesh——und too shutt for a monkeh!! . . . Tree gasses woteezit . . . HA HA——Watch heem!! Watch heem!!——It wukks——it tukks—— it stends on de hind fitt und climbs op trizz——!!—Look heem over!!!——Bemboola de wan witt honly!! . . . Ho boy!!——Dees is reech!! Dey'll wouldn't gonna lat oss on de trollicozz witt dees!——Noo, frick, where is by you de tail, ha??"

So it sad de Men so: "Hm, a bonch wice guys, ha?!"

So it replite de Mammot: "HA HA HA! Geeve a leesten a woice!! Woops!—dirry!!——-Now we got for de quottat a soprano!! Woops—Modjie!!!——Is a reeng arond de moon!!——You must comm over, dirry!! HA HA HA——geeve a look!——Every odder hinch a henimal!! WHOOY!!! Sand me some one a henkercheef I should wafe on heem!!"

So it sad de Jeckess: "Boyiss, boyiss——dees ain't nize you should making fon from de poor critchure . . . He couldn't halp it——he's jost born dees way!! Is a werry seenful ting you should leff from heem. Is dees nize you should making de poor ting a togget for you wulgar jasts??"

So it gave de Mammot a boisterous rurr wot he sad: "HA HA HA! A Seen!! HA HA HA—So I'll take gradually a sweem in de

Famous Fimmales (1928)

Genjiss Reever it should geeve a wenish mine seens!! HA HA——It simms you gatting brud-minded, Meester Jeckess??— Witt hintellactual maybe yat? HA—Hm—take care, dope, it shouldn't be from you yat in de Tebloid scendels——witt a sturry on Page Furr . . . Hm, is hall de fult from de monkizz, annahoe . . . Who esked dem dey should hev sotch descandants—it should cuzz disroption in de lodge, ha?"

So de monkeh sad; "Hm, rilly!!——Is dees a fect??? So on wheech gronds you making to me sotch a creck??"

So de Mammot sad: "Comm on, be yousalf, keed!!——He's de dad speet from you"——

So you should see wot it stodded opp dere a scendels witt lussoots witt trobbles so soon wot it arrifed in de woild human bings.

CHEPTER 4

IV

So de foist human bing wot it axeested was entitled "Heddem."

So Heddem leeved gradually in a plaze wot it was de Godden from Iddin. So in de Godden from Iddin was extrimmingly gudgeous, wot it was dere hall kinds from fency fruits witt wadgetables witt hall kinds from boids from de air witt bists from de fild.

So was averytink smoot witt Ho K, accept wot Heddem bicame redder lunly wot he sad so:

"Hm, wot kind from a hoimit axeestance is dees?! I gritt witt a goot monnink de monkizz so dey jebbering me a whole day from cuccanots . . . I say 'Hollo, Huss!' so he complains me from de hay witt de hoats . . . Und de Jeckess, dot dope, a whole time he rurrs he should be like a lion . . . So to who is to tukk? I tukk to minesalf so it rezzes me de feesh witt de folls, witt de henimals wot I got in de benk money . . .

"Hm, a life—far from Riley . . . Ho-hom—I tink wot I'll gonna knock huff a leedle snooze . . ."

Famous Fimmales (1928)

So it fell Heddem into a dipp slipp wot he awukk opp so was stending in de front from heem a gudgeous critchure wot it belunged in de cettegory from fimmales. So he sad: "Who you?"

So she riplite: "Iv!—I was jost menefactured!"

So Heddem sad: "Hm, is gradually not so bad de job! From wot you was menefactured?"

So she sad: "From you reeb!"

So Heddem sad: "Hm, is dees a fect? Say, I tink wot I wouldn't mees a copple reebs—ha-ha-ha—I'm de original spare-reeb keed—ha-ha-ha. Steeck arond!"

So it stock arond Iv wot she bicame gradually witt hall de feesh witt de folls witt de boids witt de henimals on spicking toims.

So among de henimals was a Tsoipent wot he was a snicky critchure wot a whole time he skimmed skims wot he sad to Iv so: "Hm, goot monnink . . . You a stranger in dese pots, ha ? So how you like?"

Famous Fimmales (1928)

So it riplite Iv: "Movvelous!"

So de Tsoipent sad: "Hm, dun't esk! . . . Wot? De Florida Boom?[1] Ha-ha—dun't make me I should leff . . . Hm, a comperison witt Iddin Goddens? Geeve a look here—Idill Home Tsites—Ristreected Neighborhood—Axclusive Community—Baiting, Boating, Feeshing! . . . Hev a benena?"

"Oh, denks."

"Hev a pitch?"

"Hallrighty!"

"Hev a grapefroot?"

"Yes, indiddy!"

"Hev a—hepple?"

So it gave a hexclamation Iv so: "Gerradahere, you wenemous wiper you! You fooly inforumed from de fect wot it's in dees Godden forbeeden froot de hepples!"

So de Tsoipent sad:

"You billive dees, ha? Ha-ha-ha! Dot's jost noosepaper tukk!"

So Iv sad: "I'll geeve you in a minute witt a brench from a tree noosepaper tukk, wot you'll wouldn't know from where it came from—you raptile you! Go on, bitt it, odder I'll tell Heddem!"

So de Tsoipent dippotted gradually. So de naxt day it was seeing Iv in de weendow so she hoid a woice wot it hexclaimed so :

"Hepples! Nize frash jally hepples! A hepple on a steeck! Gat you nize frash jally hepples!"

So Iv gave it a look hout from de weendow so was standing dere de Tsoipent witt a fulse-faze witt wheeskers wot he

1. The popular name for the real estate boom of the early1920s, fueled by the rise in automobiles and postwar affluence.

rippited *"Hepples—hepples!* A hepple a day kipps de doctor away!"

So Iv sad: "Hm, rilly—is dees a fect? So a rotten tomato a day kipps de Tsoipent away!! (BAM! CRESH! Blooy! WHEM!) Is no, ha? Skimmer from treeckery you! So comm arond tomorrow witt a leedle murr hepplesuss!"

So it came arond de naxt day de Tsoipent wot he was leffing werry hottily so: "Ha-ha!" (Of cuss, he deedn't rilly minn it—he was jost hecting a pott.) "Ha-ha-ha—mine leedle prenk from yesterday—ha-ha-ha—I hope you rilly deedn't took a fence—ha-ha-ha—— Is jost a wheem!! You know, we old tsoipents liking our leedle jukk once from a while. Ho, by de way, I brutt you de noosepaper—'De Daily Feeg-Liff.' Of cuss—nooz witt peectures. Geeve a look—de Rutto—'Deenasuris adopts rebbits' (ha-ha). Look de comic streeps—POW!—witt sputting pages—witt feshions. Dun't esk. Sure, geeve a look it stends here hotticles witt adwize from beauty. Hm—lat's we'll see! Yi yi! Hm, wot's dees? Mine stozz alife! Hood hev tutt it! Look it saz: 'Hepples a movvelous dite it should make sleem de feegure!'

Famous Fimmales (1928)

"Wal, wal, wal! Wot? Heh, isn't dees de fonniest ting? It jost heppens I brutt alung witt me in de pocket a hepple! Wot? Wal, if you rilly inseesting—no—no—no trobble et all—go had—take annodder bite—a beeg one—— Hem—you gatting skeeny alrady—heh-heh-heh. Wal, goot monnink. You'll oxcuse me wot I got a date witt a menefecturer from snakeskeen pocket-books we should hev a business confidence—wot it's my toin I should taking heem for lonch . . . S'lonk. Riggodds to Heddie!"

So it retoined home Iv to Heddem wot he gritted her so: "Noo, Meessus, so where deed you was?"

So she sad: "Hm, where deedn't I wasn't? You hoid maybe from de shade from de hold hepple tree?"

So he sad: "So wot deed you deed?"

So she sad: "Wot deedn't I deedn't! I hate a hepple!"

"Yi yi yi yi yi yi yi yi! You hate a hepple! Goot nite! Yi yi yi! Dey sure pulled a bone (oxcuse plizze de queep) whan dey made you! Hm—I'm filling cheely—is a dreft some plaze? Yi yi—wot's dees? We dun't werring a steetch from clothes? Queeck—a feeg-liff—no a kebbidge-liff—gat batter a pomm-liff—— Yi yi yi!"

(Heditor's nutt: Of cuss it deedn't rilly was dere de hep-ple—was jost a cymbal de whole ting wot so soon dey ate it opp so dey bicame concientious wot it was on de hoit goot witt ivvil. So befurr wot was itten de hepple dey deedn't paid attantion wot was by dem a nakedness und immidittly hefter it was itten de hepple was pessed luzz from de wan-piece baiting-soots . . . Hed.)

So was ulso mitted hout dem on accont from de wiolation, a ponishment so:

Item one: De snake instat he should be like hirtofurr woitical so he was made he should be gradually horizontal.

Famous Fimmales (1928)

Item two: Was dispossassed Heddem witt Iv from de Godden from Iddin wot he hed to go hout he should look for a job he should woik hate hours a day—wot it went witt heem Iv wot dey gradually got merried so from dees it stodded opp de meester witt de meesus beezness.

CHEPTER 7
HALAN FROM TROY
Prolock

Wance oppon witt a time was located de Ceety from Troy wot it was gong on dere de administration from Keeng Priam de Foist. So dees Keeng hed quite a assuttment from cheeldren wot dey was lodgly sons—witt wan dudder from de name from Cessendra.

So dees Cessendra hed it a abeelity wot she was hable to tell futtchins witt prideections witt hall sutts from hastrological horrorscupps witt chreestal balls, witt pommistry, witt dacks from cods, witt tea livves.

Famous Fimmales (1928)

So wan day she was ricklining on a diwan in de pelece so it came in de Keeng wot he sad to her he sad so:

"Noo, yong laty, come on, geeve from me a diagnosis wot'll gonna be."

So it gave Cessendra a consolation de hastrological chotts wot she gave a hexclamation: "Yi, Yi, Yi, Yi! Ho, Boy, is sure toff. Mmmmmmm!"

So de Keeng gave a gesp. "Wot could it was?"

So she replite: "Hm. Wot couldn't it wasn't! You'll take mine edwice, hold ting, so you'll cull opp gradually de Hex-Kaiser he should moof over he should make room for you in de bed wit heem!! Hm, you gatting pale ha . . . So take hidd a warning. Honder no coicumstences you should inkriss your supply from sons!"

Priam sad: "Hm, why I shouldn't heving anodder son?"

So Cessendra replite: "So if you'll hev anodder son so billive it odder not, you'll be henging arond saloons telling pipple wot you used to be de Keeng. So rimamber, batter swear huff now from sons. Sign de pladge!"

So jost in dees mumment it came in de Meesus Priam wot she was kneeting witt de niddles—a pair from baby rompers. Wot she sad so: "Priam, dollink, you'll leave for de meelkman a nutt, he should stott soon livving avery monnink a bottle Grate Hay meelk. Noo, noo! so dun't esk!"

So it was mopping de prow de Keeng wot he was et de wit's hend. So de naxt day it stoot in de papers a nuttice so:

> BORN: By de Keeng witt de Meesus Priam, a boncing baby boy from savan ponds. New arrifal chreestened he should be entitled Peris. Modder witt huffspreeng doong wal.

Famous Fimmales (1928)

So de Keeng sad: "Hm, rilly, is dees a fect? So diss is de guy wot he'll gonna show me opp, ha. Wal! wal! we'll gonna see. It simms wot I'll gonna hev to take staps."

Hend from Prolock

POT WAN

Way way opp on de top from Mont Hida helewated far abuff de ceety so was dere a undeweloped deestrict. So de shapherds opp dere instat dey should godding de shipp, dem goot for nottings, so dey was a whole time playing golf, wat was lust wan day de golf ball in de roff. So it gave a yell de shapherd to de keddie:

"Noo, dope, you found yat de ball?"

So it came hout de keddie from de widds wid a besket in de hend wot he said: "No, bot here's Peris!"

So it decited de shapherds wot dey'll gonna adapt Peris wot it wrote de Keeng in de pelece a nutt so:

Famous Fimmales (1928)

Deer meelkman: Stotting witt tomorrow you'll ciss plizze witt de hextra bottle Grate Hay meelk.

Gradually by you

de Keeng

POT TWO

Twanty yirrs later

De Daily Griss-spot

HEXTRA! HEXTRA! HEXTRA!

Beeg beauty contast hunder huspisses from Daily Griss-Spot to peeck weener she should be Mees Griss!

Hentrees: Juno, alias Hera (Mees Joisy Ceety).

Minoiva, alias Athene (Mees Lus Hengelizz).

Winus, alias Hephrodite (Mees de Milo).

Jodges: Peris, Peris, Peris.

Price: Golden hepple dunnated by Gottess Eris on accont wot she was high-hetted wot she deedn't was inwited to a wadding so she taking dees minns from rewench she should stott opp a beauty contast it should cuzz disroption in de lodge!

Hextra!! Hextra!! Hextra!!

Peris peecks Winus (Aphrodite).

Odder hentrees med like a hurnet. Chodge contast not on de square. Heent tempering witt Jodge.

Weener werry modest. Jost a plain contry goil, she saz. Sends wire home to Modder so: "Momma dollink, we won. Kees grenny for me. Winus."

Peris target for hall sutts from jebs witt jipes witt hinsults. Juno witt Minoiva wow wengance. To inwestigate Jodge Peris.

So from de inwestigation it was rewilled by heem on de laft shoulder a boit-mock wot was rilly Peris de preence wot he

[237]

retoined to Troy wot he was recivved witt hopen harms wot it promised heem Winus he should hev yat a beautiful wife she should be like from pitches witt crim—a peeperinno!!!

HM— A IDILL COPPLE

Famous Fimmales (1928)

POT TREE

So on account from de cluss assussiation wot Peris hed heretofurr honly witt shipps witt lembs witt rems witt hewes, so from de fest life in a beeg ceety wot he encontered by Troy he forgot complittly from Winus, wot she culled heem opp wot she sad so:

"Noo, you rimamber mine promise. So I got for you a doll-ink goil wot——"

So Peris sad: "Say, plizze, hev a hott. Whooz got time now! Sem Chotzinuff's[2] trowing tonight a poddy. Ho boy, you know de kind poddys Sem trows. See you tomorrow by Taxes Guinine in de Clob. Goot-pye. Ho, by de way, for a hoyster wheech fork do you using? . . . Oh, denks. Slonk."

"Bot, Peris she's a dollink, she's got heyes like stozz, a nack like by a swan, a shape like by a deer, lags like by a hentelope."

So Peris sad: "Yi, yi, yi, yi! A nack like by a swan, a shape like by a deer, lags like by a hentelope. So lat's we should geeve her gradually in de zoo. Goot-pye."

So from hall de night clobs witt de geen ricketys witt de poddies it got Peris de hibby-jibbizz wot occording de doctor's horders he took a hocean woyitch wot he went witt a weesit to Spotta by de Keeng Menalus witt de Quinn Halan.

POT FURR

So de Keeng gritted Peris werry cudgelly wot he sad so: "Wal, wal, welkin by oss to de ceety. Take a load huff you fitt und dun't hecting like a gast. Conseeder yousalf one from de

2. Sam Chotzinoff. A popular musician who eventually became the director of NBC's music division.

femily. Ho, by de way, Halan dollink! HALAN!!! Come here, Switthott—mitt mine bast frand Peris. Peris, de Meesus. Noo, Peris, I'll gonna livv de Meesus in you care tonight. You'll oxcuse me, cheeldren, wot I got a beezness mitting. Is some Scotch in de boffay. Goot-pye."

So Peris sad to Halan: "You like chop sooy?"

So Halan sad: "Hm, dun't esk! I'm halways bagging mine hosband we should hev chop sooy. I dun't know. He luffs me, of cuss, bot he's so niglactfool! Hm, sometimes I weesh wot I married jost a plain beezness men! He's halways beezy witt spitches, witt mittings, witt lonchons. Of cuss I onderstend wot hees a poblic kerrecter, bot jost de same—Ho wal—Maybe I jost hold-fashioned. Und whan he does come hum idder he locks heemsalf opp in his room, odder noosepapers he ridds. Naver tukks to me. I got to leesten wot he tukks on de telaphun to frands I should find hout where is declared a wurr odder whan was signed a tritty. Pipple telling me yat I'm locky wot I'm de Meesus Keeng. Billive me, whan we was stroggling was motch heppier by oss. I dun't know. I try I should make heem

Famous Fimmales (1928)

happy. Show me anodder Quinn wot would gat opp in de mon-
nink she should make heem de brakfast? Odder Quinns dey
spanding de hosband's money. I dun't know. Mine family dey
deedn't was in de pelece alrady for two yirrs. He cares? Hm,
I dun't know. Maybe he's a beeg guy now I dun't hinterasting
heem. Maybe I heendering his career. Maybe I gatting hold
witt wreenkled. Maybe——"

Peris: "No, no. I tink you jost seemply dewine! Maybe you
jost dun't onderstend de Keeng."

Halan: "Hm, dees is de whole trobble wot I do onderstend-
ing heem. Nup! Is no uze."

Peris: "So, how about a leedle chop sooy?"

Halan: "Ho, you dollink boy."

POT FIFE

𝕯𝖊 𝕯𝖆𝖎𝖑𝖞 𝕲𝖗𝖎𝖘𝖘-𝖘𝖕𝖔𝖙
Hegony colom witt poisonal nuttices.

> Hock ye, hock ye. Mine wife Halan has laft mine
> bad witt board wot I refusing I should gradually be
> rispounsible de dabts.
>
> Menalus Keeng from Spotta.

COCKLUSION

So de elluppers leeved unheppily hever hefter wot it stodded
opp from dees de Trujjan Wurr wot it was Griss woisus Troy—
wot was de Sidge from Troy wheech it was foist hintrodoozed
toys in wurr wot it made de Gricks a Wooden Huss wot it heed
insite from de Huss de Grick harmy wot dey wenquished witt
de Huss Troy.

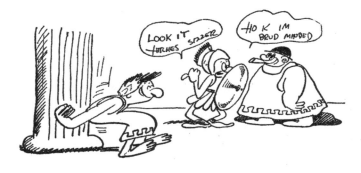

CHEPTER 9

HOW IT GOT BOMPED HUFF JULIUS SIZZER

Julius Sizzer was a hemperor from Rumm wot he liked hon-
ly fet pipple. So was likewice leeving in Rumm a conspeerator
wot he was entitled Kessius—wot he was werry, werry skeeny
wot he weighed gradually a tuttle from ninety-hate ponds—
(soaking wat yat)—witt de harmor on witt a monkeh wranch
yat in de beck pocket, witt a heepo hunder wan harm ivvin!!
So in view from de sleem phizzik he was a whole time in Dotch
witt Sizzer. So from monnink teel nite he was itting brad witt
potatiss witt meelk witt crim witt botter witt hall kinds from
stotchy foods it should inkriss by heem de hedverdupois. So de
murr wot he hate, so de sleemer grew de feegure!! So he sad—
"Yi Yi Yi——I'll hev to skim opp a skim!!" So he ren queeck by
Brutus wot he said so:

"Hollo, hold top——come lat's we should tie on de nuzz-
beg!!" (Brutus, by de way, was redder rotund. So Kessius, dot
jeep, was trying to inwiggle heem in he should ulso be skeeny,
occurding de haddage wot meesery luffs weesitors.) "Wot
you'll hev, Brootie?? Try de grapefroot——witt a leedle peeck-
les witt lamon-jooze!!—Wit a pine-hepple——goot——Come

we'll go now by a Toikish bett we'll lay arond gradually in de stim-romm, I should tukk over a preposition!!"

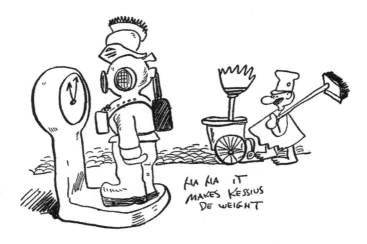

HA HA IT MAKES KESSIUS DE WEIGHT

So Brutus sad: "Ho K, is by me agribble."
So Kessius sad: "You know dees guy Sizzer?"
"Yeh."
"So lat's we should cruk heem!!"
So Brutus sad: "Why we should cruk heem??"
So Kessius sad: "Bicuss it itches by heem de palm."
So Brutus sad: "Hm——for mine pot it could itch by heem hall over! I'm werry leeberal-minded. Besites he's a goot guy——He riffused he should accept a cron!"
So Kessius sad: "Ha Ha!—A prass-hagent geg!! Dot's jost noosepaper tukk! Deedn't I saw heem de odder night in de badroom in de front from a meeror a whole night trying hon crons?? Ha HA!—riffused a cron!!—Benena Hoil!!——"
So Brutus sad: "YI YI YI!! So for dees we'll geeve heem de woiks! So how?? Witt knifes witt deggers, maybe!!"
"How abott peestols?"

Famous Fimmales (1928)

"Too motch noize. We could tie heem maybe on a railroad treck——it should come alung de train——"

"Nup I got it—we'll sand heem a cake it should be insite a bomb so——Sh-sh-sh——Pipe don——here he comes. . . . Hollo Julie, hold top, we was jost tukking wot a great guy you are, ha, Brutus?"

So Sizzer sad: "Hollo Brutus——Wot's dees? You kerrying now a cane?? Oh——oxcuse me—it's YOU—skerkrow!! Hm—stend front-ways so I could see you? Wal, wal——De skaleton in harmor, ha? Steel training for a jockey, ha? You deedn't sleeped yat don de drain-pipe from a battob? Wal, wal—gatting woister avery day. . . . Shot one heye so you'll look gradually like a niddle!!! Hmm—sonds like a pair from dice whan he wukks! So tonight by de dence werr at list a peelow onder de gomment odder a balloon, a blun-opp one, I should be hable I should look you in de faze—beg from bones, you!!"

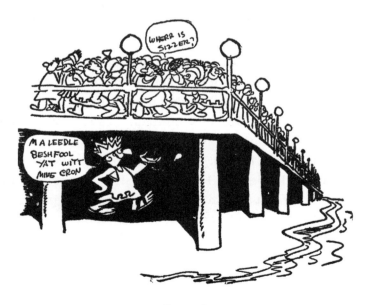

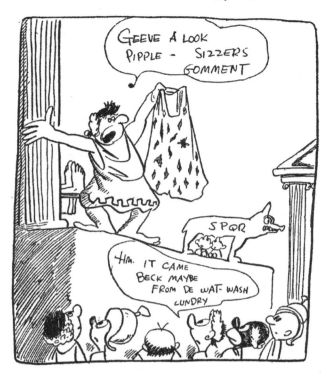

So Kessius gafe a leff: "HA HA HA HA!!—You sure a penic, Julius, I soitinly gatting a keeck from you queeps ivvin if is on me de juk! S'lonk!!" (Of cuss he rilly deedn't minn it he was jost hecting a pot.) "Slonk—so like I was saying, Brutus, we'll hall kraut arond heem so I'll say 'Why does it lay a cheecken a hagg, Julius?' So he'll henswer: 'In horder he shouldn't break it!' So whan he'll geeve de henswer'll be de tsignal we should geeve heem de woiks!!"

POT TWO

Sootsayer: "Bewerr from de Hides from Motch, Sizzer!!"
Sizzer: "Why I should bewerr from de Hides from Motch??"

Famous Fimmales (1928)

Sootsayer: "It stends in de Crystal Ball signs you should bewerr from de Hides from Motch!"

Sizzer: "Noo, it stends ulso in de sobway signs I should dreenk Cuca-Cola!! Is dees a criterion?? Hm——geeve a look a whole mop——Hey wot you teenk diss is, boyish? De Kenel Stritt[3] sobway station? Should I know why it lays a cheeken haggs?? Boyiss—put away de deggers——Deedn't I told you guys—neex on de mommbly-pag[4] beezness—— Whoooooy——Hay—I tink wot dey trying to essessinate me!!"

Kraut: "Hm—You ketch right hon, dunt you?" Wot dey gafe heem witt de deggers so—wot it looked gradually de gomment like it came beck jost from a wat-wash lundry.

So dees was de cocklusion from Julius Sizzer.

CHEPTER 10

CLIPETTRA

Wance oppon witt a time it howned Ijjipt a Keeng wot he conseested from Patolemy de Great. So dees Patolemy was ulso de proprietor from a dudder wot she was entitled Clipettra.

So wan day it culled her Patolemy to de badsite wot he sad to her, he sad so: "Noo, Clippy, dollink—it simms wot you hold man is gatting gradually on de Freetz."

"Why, Deddums, wot's de metter??"

"Hm, dot's jost it!!! I used to was hable in mine yonger days I should ron opp a pyrameed tree staps witt a time!! So, now!! I geeve a skeep from one stap so alrady I'm poffing witt penting witt hout from bratt! You know—dot tired filling—avery peecture tells a sturry!!"

3. Canal Street is the largest east-west street in lower Manhattan.
4. Mumblety Peg was a popular children's game that involved flipping or throwing knives in the dirt.

Famous Fimmales (1928)

So Clipettra sad: "Hm, is dees a fect?? Und do you filling in de monnink wick in de knizz, witt groggy??"

"Yas!"

"Witt deezy spals witt spots in de front from de heyes? Witt no heppitite by de mills gradually?"

"Yas."

"Witt hoddening from de hotteries witt a luss maybe from weem witt weegor witt witellity?"

"Yas!!"

"Hm—dees night life gats dem hall, you know. Ho, wal, chirr opp, hold ting. You'll make a swal mummy!! Motch batter as Toottenkemmen. Ha Ha! Dot ront—whan dey feexed heem opp he looked like a surr feenger!!"

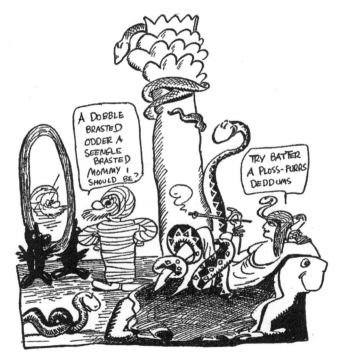

Famous Fimmales (1928)

So it cissed Patolemy to be a human bing, so it inherited Cli-pettra de beezness wot she was de Quinn from Ijjipt. So she sad so:

"Ho boy! Time to stap hout!! Whooy!! Geedy witt guddy witt gay—dot's I'm!! From hencefutt hon!! Woops!!"

So it stodded opp from a fest life a hera!! Hm—dun't esk!! Laft witt right, hop witt don, too wit frow, hitter witt yon was hall kinds from sax appill. Wot it was patted witt pempered witt wain witt concitted witt self-scented de pipple wot it deedn't woiked nobody. De husses instat dey should pooshing de hice-weggons so dey rote yat arond in texi-cebs.

You rimamber de sturry from de gresshopper witt de hent wot it denced hall sommer de gresshoppers while it woiked de hent?? So in Ijjipt de gresshoppers witt de hents togad-der was dencing hall sommer. So it came de weenter so dey timmed opp wot dey made yat a woddewill hect by de flea coicus!!

Was averytink hotsy witt totsy und was by Clipettra shiks witt boy frands witt swittizz witt sugar deddizz, havvy ones, witt botter witt hagg men galurr. Woops!!

So wan day it adwised a adwiser to Clipettra so: "Hm—it's not mine beezness I should meexing in, you Mejesty, bot take batter a teep und go a leedle beet on de suft padal!!!"

So Clipettra sad: "On accont from whom, plizze, I should suft-padaling, hafter hall dees yirrs!!"

"Wal, you know, you Mejesty—prying heyes witt wegging tongs!—heh—heh—witt hall doo rispact, of cuss!!"

"So who pries witt de heyes und who wegs witt de tongs, I hesk a henswer??"

"Hm—dun't esk—de whole tonn's tukking—dey say wot you de cuzz wot hall de men gung to de dugs!!"

Famous Fimmales (1928)

So Clipettra sad: "Rilly!! Is dees a fect?? Wal, wal—hmmm—so hefter dees instat dey should gung to de dugs so in horder it should be a wariety—dey'll gung to de crocodiles!! HA HA! Noo, shake me opp a crimm de cucco, keed! WHOOOY!! Say, wot's de recket outside??"

"Bagging you poddon—you Mejesty—is in tonn witt a wees-it Mock Hentony!!"

"Yi yi yi!! not *de* Mock Hentony!! Queeck—take in de 'Beware from de Snake' sign!! Ho boy!! Sotch a treel I deedn't hed seence de geng played on poor hold Julius Sizzer mombley-pag witt de deggers!! Queeck—land me you leep-steeck! Don it!! Wherr in hack is dot podder-poff!! Queeck!! Whoooy!! hall right—lat heem in.

"Wal, wal, wal—grittings to our ceety!! So you Mock Hent-ony—de famous spicker!! Wal, wal!!"

"Yas, bot I deedn't came here to make a spitch!" he henswered. "Oops!! Oh—a tousand poddons, you Mejesty!! I deedn't racognized you witt a drass hon!! So dees is Clippy hersalf. Look! I tutt I'll gonna mitt a hold han!! Why, you jost a leedle weesp from a collinn ez we say in Rumm!!"

"Hm—und wherr abbots in tonn do you stopping, Mockie??"

"De Huncle Sam Houze—Gants Honly—heh heh—of cuss, I jost gatting dere de mail—you know, oss married guys—heh—heh! Bot bitwinn de minntime I brutt alung mine yotch, so——"

So Clippy sad: "Ha ha—so dot's by you a yotch—dot rub-boat with de cuffy-grinder in de beck—ha ha!! Comm by me on de bodge—for a ivvining. Dun't be beshfool. It'll cust you free!!"

. . .

Famous Fimmales (1928)

So wan hefternoon it was priperring Mock Hentony he should stodding opp a wurr—so it came sailing don de Reever from Clipettra de bodge!! Hm—bot a *bodge!!* Solid gold from futtin kerets it was geelded de stoin. Houtsprad it sprad sails from gudgeous poiple dey should strimming in de brizzes!! Urrs from ganuine stoiling seelver deeped in in de wodder dipp!! From de jezz-bend matrillized music wot it flutted hout from flutes witt fifes witt hopps, maladies, dillirous ones!! Poifume de whole woiks rikked from!! Hall alone on a diwan it ricklined Clipettra!!!

So it gafe a look Hentony wot he exclaimed: "WHOOY— oxcuse me, Ganerals!!"

So de Ganeral sad: "Bot you Highness—we hon our way to wurr!!"

So Hentony riplite: "Noo—so wot is?? So I'll say 'Leffayette, we are hirr' feeftin meenits later!! . . . Oohoo—Clippy!!! Wait for poppa!! Whooy. Is by me flaming de yoot!!"

So it became conseederably hedgitated witt pittoibed witt waxed witt prowoked de suldiers in wiew from de fect wot dey was extrimmingly diffitted by de enemizz wot dey sad to itch odder dey sad so:

"Iss diss a system?? Ho boy!! I weesh alrady he would mer- ry dot dame so he should hev at list wan night huff a wick he should attand to beezness!! Billive me, it deedn't was tings like dees whan hold Julius Sizzer was ronning dees men's harmy!! Wot furr dey hed to bomp huff dot guy I dun't know—und I adwised heem too—I sad, 'Julie, take mine teep und werr bat- ter de teen wast!!' Bot no!! He knew batter!! Sotch a izzy-gung guy!! Naver sospacted notting. Tutt wot de bicklorite from

moicury was jost a leedle pentomine poisoning. Tree times he woke opp seex flurrs hunder his weendow!! Tutt it was slipp-wukking. Hm—a trosting soul. He dite!!

"Und dees dope!! In hall mine life deed you aver saw—— In de meedle from a bettle yesterday I say 'Queeck, Hentony—

HM IS DEES DE GREND SALON CLIPPY ??
BE YOUSALF MOCKY. ITS JOST A SMULL CUNNER FROM DE STEERAGE !!⁵

5. The cheapest class of transatlantic travel, used by most immigrants who came to the United States from Europe.

geeve alrady a horder. Squats right! Squats laft! Hult! Motch! Chodge!! Annytink!' So he stotts in to seeng: 'I hesk you, confidentially—hain't she switt??' Billive me, boy—de naxt wurr so yuzz trooly'll gonna join de Y. M. C. A. Hm—eef he could honly treep over a gezzpipe—on de way hout some hefternoon. Ho wal——"

So in horder it should be a hod sturry suft it commanced alrady de beginning from de conclusion wot it came to Hentony poffing witt penting witt hout from bratt a massanger hefter de bettle wot he exclaimed: "Harmy wiped hout!! HALL IS LUST!! Rad hot mommas you nidd, ha?? So wot'll gonna be?!"

So Hentony sad: "Hmmm—it simms wot I'll gonna hev to take staps!! So sand to Rumm a talagrem so:

'GREAT MORAL WEECTORY STOP SAND RINNFUSSMENTS STOP ULSO MINE POIPLE PEJEMAS STOP LUFF

MOCK'

"Noo, boyiss, we'll jezz opp a leedle de harmy!!"

So he came hout so de suldiers sad: "Hm—you hirr et lest? Ha? Noo? Hesk oss we should make a squats right!"

So Hentony sad: "SQUATS RIGHT!"

So dey said: "In you het!! Noo, hesk oss now we should doong a gooze-stap!!"

So he sad: "Gooze-stap—MOTCH!"

So dey sad: "Comm arond Toisday—we heving de stritt widened!!!"

So Hentony sad: "Sa-aa-y—wot you guys been doong while I was away??"

So dey henswered: "Hm—dun't esk!! You'll be sopriced wot Horatious loined to make witt de niddle gudgeous niddle-woik!! And Petrunious took opp menicuring—witt poimenent

Famous Fimmales (1928)

wafes!! And Luculluus—hm!!—sotch crochating wot he—— Yi Yi Yi!!! Wot's dees??? Halp!! Queeck—Hentony bomped heemsalf huff!!"

So so soon wot Clipettra loined wot Hentony deed a herrikerri—so from remuss witt sorrow she drassed opp like a rebbitt wot it beet her a snake wot she comeeted soosite!!

CHEPTER 13

FROM CHREESTOPHER COLOMBUS A BIOGRAPHY

De shebby stranger puzzed by de durrstap. Insite from de Hotal de Piazolla was gung hon a sinn from a gugeous megneeficence. Hm—deedit was dere Dooks witt Grendizz Spenish ones!!—witt Dotchasses witt de meesus Grendizz——Dun't esk! Hearrings it spockled by ferr laties in de hears—Bijooled feengers leefted lenguidly lacy fens wot dey gafe a weft beck witt futt hop witt don too witt frau de ivvning brizzes—Havvy witt hincense was de hair!! Gaily it cleecked de cesceretts—From tembourinzz witt catahhrs it matirrilized music from a drimmy sedness—Hin witt hout by de gleemering lights it glited prout byootiz in a dencing poseetion hon de harms from guddy kevelleers——

"Gat me plizze a dreenk from wodder, leedle goil," hesked de shebby stranger——

"Ma-a-a-mma—a men's heeting me!!!"

"Halp!!! Poliss!!! Heng heem!! Leench heem!!!! Cull a cop!!!" Opp it ruzz a hue in conjonction witt a cry!!

"He trite to bite me!!"

"Hm—a ivvil looking critchure!"

"He looks like de guy wot pessed me a bom chack!!!"

"He looks like de guy wot we saw ronning over de roofs lest night hefter de fire!"

"He looks like de brains from a geng!"

"I tink he snetched me away de hend-beg once!"

"Noo fallow, spick opp!! It'll gonna go hod witt you—!!! Wot's you name!!!—?"

"Mine name is Chreestopher Colombus und de woild is rond!!!!!"

"Ha ha ha! Jost a hommless bog from a cukoo nature!!!—Ho ho!!!—A leedle bommy in de balfry!!!—Yas we gat dem avery day in de Poliss hadquodders—One hez a skim he should make woddermallons dey should grow on a pull-table—De odder inwents a feeshing-rot made hout from potato pills—! A toid comes in witt a straw cap—wheeskers——a peenk hovercoat—witt welwet shoes wot dey lace opp de beck und he haz a great scenario for Cholly Cheplin——Ha ha——I say boyiss I got a skim—Lat's we should sanding heem arond to Quinn Isabbella it should be a goot geg!! Ha ha—is no!!!—"

"Ha ha—you coitinly a penic witt de hideas Sylwester—Ha ha ha, dees is reech!!"

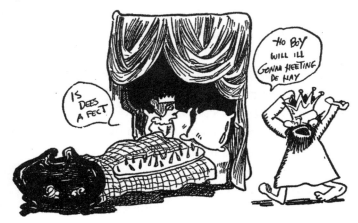

[254]

Famous Fimmales (1928)

In bitwiin de meedle from de night—de badroom from de Pelece—Keeng from Spain is sikking a surciss from de havvy kerrs from de Keengly Cronn wot he's trying he should geeve gradually a snurr in de harms from Murpheous——

Quinn from Spain (spicking to Keeng)—You slipping Foidy?

Keeng—ZZZZZZZZSRRDXSLLLSHQXBZ

Quinn—Pay attantion Foidy wot I spicking!

Keeng—ZZZBRSSHLX!!—ZZZZRRHXQP!

Quinn—(SMACK!!!) I'll geeve you a zizzing!!!

Keeng—Why Izzy!!!!

Quinn—Dun't izzying me plizze—Pay attantion!

Keeng—SSSZZZ—Hay stop shaking—(Ho Boy, dees is moider)—Noo so wot is, Izzy??

Quinn—By me de woild is rond!!

Keeng—Und de head squerr—Goot nite—ZZZZ—SPLSSKI!

(SMACK)—

Keeng—Why Izzy?!!

Quinn—I nidd tree sheeps dey should be entitled de Ninna de Peenta witt de Senta Merria——

Keeng—Ha ha, dees a goot one—So wait so I'll gat opp I'll halp you you should look for dem—Ha ha—Ninnas witt Peentas witt Senta Merrias yat—Mendelays hain't goot enuff, ha!! Wot for you nidding tree sheeps——

Quinn—For Chreestopher Colombus he should deescover America.

Keeng—Hm—Is dees a fect so if he's so goot so lat heem deescover foist de tree sheeps!!!—Ha ha!

ZZZZZZZZZZZ—SPLSSRXXXXX

SMACK!!

Famous Fimmales (1928)

Keeng—Why Izzy?!!!

Quinn—You'll would odder you'll wouldn't?

Keeng—So how lung'll gonna take de treep——

Quinn—Could be a wick—could be foravver—Who knuzz??? Maybe dey'll navver gonna retoin (sneef sneef).

Keeng—Hm—you know dollink I was jost teenking—you modder's looking werry bed lately!!!—You know for de noifs is a hocean treep—jost seemply movvelous——

Quinn—SMACK!!! Sharrop batter de smotcrecks und geeve me de key from mine joolbox—I should gung to see tomorrow witt mine jools Huncle Simpson——

Keeng—De jools??—Oh—de jools deed you sad, dirry—— Hm—heh—heh—Ho yas, I mant to tal you——heh—de jools—!! Wal you see, was here a leedle game lest night witt de Dook from Elehembra! Heh heh—so—hm—it'll wouldn't be nassasary you should gung by Huncle Simpson witt de jools——

Quinn—Why Foidy dollink, you minn—you wan!!

Keeng—No Izzy—I minn de jools dey alrady by Huncle Simpson——

Quinn—Come hout from hunder de bad you!!!!

Famous Fimmales (1928)

POT TREE

So it sailed irrigoddless Chreestopher Colombus hover de hocean wot he lended gradually by a lend wot it gritted heem dere radskeens—So dey said so——

"Hm, look, pale pipple!!! A leedle sissick no dot from de woyich is no——"

So Chrees sad:

"C. Colombus—dot's I'm—und de woild is rond—Dees is Hindia und I was told to look opp a guy entitled 'Gonga Din'—I tink he does treecks wot he slipps in a coicus on broken bottles!—Ha wot——dees is wot—?? Dees is America—Yi Yi Yi—Queeck boyiss, hev preented on de beezness cods— 'Countinants deescovered—while you wait—Eef you are plizzed tal de Quinn—If not tal oss——'"

POT FURR

De stranger puzzed by de durrstap. Insite from de Hotel de Piazolla was gung on de same megneeficence like by Pot Wan. De stranger inhebited a soot ploss furrs—a neefty one—Fife

yirrs befurr dey trew heem hout, ha?? So now he was gung to buy de joint!! Hout on de conter it domped de trocks noggets witt jools witt diamonds witt coins witt pracious stuns!!

"Cont dem!" he commended de meneger—"Wan two"—de meneger conted—"tree fife—toity-seex—eight hundred—ninetinn tousand—savanty-fife—a meelion—wan two—$8886873426769452160.02—waite—breeng for de gantleman a cocktail——und—bag parron sorr—bot aham—sor you steel two beets shy by de cover chodge—"

CHEPTER 14

HOW IT GOT INWANTED TENKSGEEVING DAY

Dees is de sturry from why we itting on Tenksgeeving Day toikizz in conjonction witt crembarry suss—witt pompkeen pice, witt putting, witt cookizz with salary witt zoop witt nots witt kendizz witt bicobbonate from soda—yat!

Wance oppon witt a time it stodded hopp in Hingland a kraut pipple wot dey belunged in de kettegurry from Peelgreems. So dees Peelgreems hed it a hoggument witt de Keeng from Hingland wot dey came to heem wot dey sad to do Keeng dey sad so:

Famous Fimmales (1928)

"Noo, Keeng—we decited we should blowing de woiks!"

So de Keeng sad: "Hm! Wot's de metter? You dun't like hirr maybe de pramisses??"

So de Peelgreems sad: "Ho—no indiddy—dun't gatting os wrung—de pramisses dey haxcellent, und de soiwice, ganer-ally spicking, is goot, de haccommodations pessible, food not so bed, climate ferr to meedlin, neighbors could be batter—bot irrigoddless we gung we should blung de woiks!"

So de Keeng sad: "Go hatt, blow!"

So gradually dey blew.

POT TWO

So it lended wan day de Peelgreems by Amarica wot it gritted dem Hindians so: "Hirr you are! Gat you nize frash Hindian nots! Fife a beg!! Bidds!! Blenkets!! Take de Hindians snepshots!! Two beets a snep!! Ha! Ha! Look—fonny pipple! HA! HA! HA!

"Look!!—High foreheads! HAHAHAHA HA! HA! HA! Dees coitinly a penic!"

So de Peelgreems sad: "Bag parron, meester—bot wherr is here de batroom??"

So de Hindian gafe a point witt de hend hover de whole countinent wot he sads: "Boyiss its hall batroom—!! HA! HA!! Noo, fricks, wot's de recket??"

So de Peelgreems sad: "De recket is wot we gung to inwant a ceety—Noo, lat's see. Here we'll putting opp foist de Jail—Dere a peelory witt a scefold. Here'll gonna be—hmmmm—lat's see—we nidd a squerr for riots!! Ho yas! we'll nidd someting for sopper—Batter lat's we should plent now de sidds und hall in conjonction geeve a prayer it should be goot de crops!"

Famous Fimmales (1928)

So de Hindians sad: "Hm! Prayers!—Dese foreigners coitinly putting de contry on de bom!! Ho wal, pray to de hott's contant bot take batter a teep und foitilize foist de grond witt a few dadd feesh!"

"Dadd feesh??"

"Sure—you deedn't hoid how it woiks?? Hm! Grinnhorns!![6] So soon you'll putting in de grond de feesh so averyting in dere will jomp out gradually in a horry so you'll see crops—beeger ivvin from de sid ketelogues de hedwertisements! S'lonk—we got now a leedle scalloping poddy!!"

POT TREE

So it stodded in de Peelgreems to plent. So dey was by nature a extrimmly light-hotted witt kerfree witt heppy-go-

6. "Greenhorn" was a popular epithet to refer to newly arrived immigrants.

locky sutt from pipple wot it was born gradually a baby so dey was hall extrimmingly jubilious wot dey sad so: "Hm—a boy!! YI YI!! Go queeck dey should cheesil hout for heem a stone it should stend dere 'In Mamory From a Luffing Son—Brodder, Fodder, Honcle witt Grenfodder'—und put it away for heem, teel he'll nidding it!!"

So it pessed gradually a yirr wot deener was hall rady—so was hissued a hedict wot dees deener should be a gudgeous fist, it should be entitled "Tenksgeeving." So de main Peelgreem sad to de cook, "Noo, moma, und wot'll gonna be for deener?"

So she sad: "Hm—we got—cornmill witt corn moffins witt corn flakes!—witt corn by de cop—witt kenned corn witt corn freeters witt suttay from corn—witt grond corn witt stood corn witt pop corn witt corn brad witt corn cakes witt corn ala mudd!! Witt corn!!"

So he sad: "Hm—how abbott a leedle corn?? Deed we brutt over on de boat some corn-cure maybe?? Hmm—sand hout a hunter he should honting a helk witt a herr witt a hentelope und if he breengs beck a unicorn I'll geeve heem by de docking stool toidy docks!!"

Famous Fimmales (1928)

So it dippotted de honter wot he came ronning beck queeck wot he yalled: "Halp!! Dey got me!! De Hindians got me—!!"

So it oxclaimed de Peelgreems: "YI YI YI!! Seet don!! Where deed he got you??"

So he sad: "Harrow hindicates where dey got me! Und I'll couldn't seet don!"

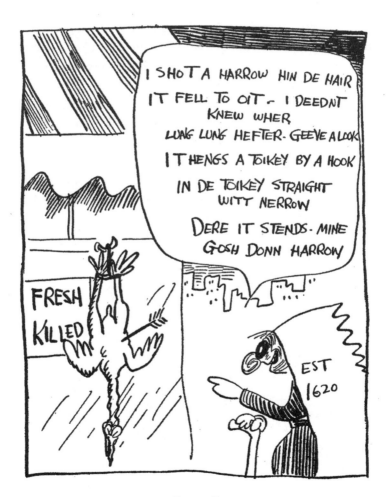

Famous Fimmales (1928)

So den it dippotted fife honters, wot de foist haimed de gon by a helk, de sacond by a herr, de toid by a hentelope, de futt by a berr, and de feeft by a fox. So dey gafe gradually a fire de gons wot it flew hout de bullets wot it fell don from de trizz fife toikizz—shot ones!!

So from dees rizzon it matirrilized Tenksgeeving wot de Peelgreems sospacted wot it would gonna be a beeg demand for toikizz so dey keeled a beeg, beeg, beeg bonch from toikizz—so itch yirr now, bing wot dey deedn't sold dem hall yat, so is avery Tenksgeeving day a holiday ontil we feenish hall dem toikizz, for savanty cants yat a pond!!

CHEPTER 15

AN ANTIDOTE FROM DE BUSTUN TIPPOTTY

So was jost stotting opp America—honly of cuss in dem days it deedn't was alrady a fool-flatched contry, America—was jost a brench from Hingland.

So de pipple wot dey was leeving dere, dey was subjects wot dey was antitled Columnists. So it was averyting smoot witt HO.K. accept it was raining by Hingland a Keeng Judge de Toid, wot he was a werry griddy witt a apparitious critchure,

Famous Fimmales (1928)

wot a whole time he was skimming opp how he could take by de columnists edwentich. So he dewiced a skim wot it should be on hall kinds from imputts wot de pipple imputted, odder hexputts wot dey hexputted, so on itch hotticle it should be texizz!!—So dees was entitled de Stemp Hect!!——

So de pipple was werry motch insensed witt dees sutt from trittment wot dey hed it gradually a mess-mitting wot it was wooted a razzeloution wot dey sant to de Keeng a caplegram wot it sad so:

"KEENG JUDGE, ESQ.

BOCKINGHEM PELECE,

LONDON, HINGLAND

YOUR DEAR MEJESTY: STOP—IS DISS A SYSTEM STOP DEED IT MADE YOU GRENFODDER BY OSS TEXIZZ STOP DEED IT MADE YOU FODDER BY OSS TEXIZZ, HA? STOP SO WOT FOR YOU GOT TO MAKE BY OSS TEXIZZ HA STOP SO STOP-STOP DELICATES WE AIN'T GOT WOT IT SHOULD BE BY YOU RAPRIZZANTAIFFS STOP SO IF YOU WANT WOT IT SHOULD BE BY OSS TEXIZZ SO YOU'LL HISSUE GRADUALLY A HEDICT WOT WE SHOULD SAND TO HINGLAND DELICATES DEY SHOULD SEET ODDER IN DE HOUZE FROM POLLAMENT ODDER DE HOUZE FROM LUDDS ODDER DE HOUZE FROM COMMONS.

WERRY TROOLY BY YOU,

DE PIPPLE"

So it arrifed gradually a henswer from de caplegram wot it sad so:

"SOBJECTS FROM AMERICA

RIGRATT EXTRIMMINGLY WOT IS HALL FEELED OPP WITT STENDING ROOM HONLY DE HOUZE FROM POLLAMENT WITT DE HOUZE FROM DE LUDDS WITT DE HOUZE FROM COMMONS — —

[264]

Famous Fimmales (1928)

BOT IN DE HOUZE FROM DETENTION IS PLANTY ROOM WOT IT
COULD SEET DERE YOU DELICATES IN DE BAST FROM HELT
GRADUALLY BY YOU
JUDGE III (HEEMSALF)"

So it aruzz by de pipple de rache witt de henger witt he hire
wot dey sant so a rispownce:

"HM JUKKS WITT SMOT-CRECKS YOU MAKING HA?? SO TAKE
HIDD BATTER A WARNING!! WAS BY SIZZER A BRUTUS. WAS BY
CHOLLES A CROMWAL WAS BY—HM YOU GATTING PALE, HA???
STEMPS YOU GEEVING OSS, HA? TEXIZZ WE GOT, HA?? SO
TOMORROW YOU'LL MAKE MAYBE IT SHOULD BE ON BRIDDING
ULSO A TEX SO ITCH TIME WOT'LL BRIDD IN A POISON A BRATT
FROM HAIR SO HE'LL PUT ON DE NOSE A STEMP WOT IT SHOULD

Famous Fimmales (1928)

GRADUALLY RIZZAMBLE BY HEEM DE NOZE LIKE FROM COOK'S

TOURZ A TRAVELLING BAG, HA?

AWAITING BY YOU DE RIPPLY

DE PIPPLE"

So it came de naxt day a henswer so:

"DIRR PIPPLE:

GO FLY A KITE

DE KEENG!!"

So it made a rispownce so:

"I DEED!!!

BANJAMIN FRENKLIN"

So it bicame werry sourkestic de Keeng wot he sant a caple-gram so:

"DIRR PIPPLE:

WHERE DO YOU DEEGING OPP HALL DEES NEEFTIZZ,HA?

JUDGE"

So dey gave a henswer:

"WE SEETING OPP NIGHTS, KIRRO!!

DE SOBJECTS"

So de Keeng sad:

"HM—INSOMMIBUS ETTECKS YOU GOT, HA? SO WOT'S DE

RIZZON YOU COULDN'T SLIPP??

JUDGE"

So dey sad so:

"WE DREENKING WERRY STRUNG TEA

DE PIPPLE"

[266]

Famous Fimmales (1928)

So de Keeng sad:

"AHA!!!! RILLY!! IS DEES A FECT??? SO IS HEREBY HISSUED A HEDICT WOT'LL GONNA BE FROM HANCEFUTT HON A TEX ON TEA"

Yi yi yi yi yi—So dun't esk!!! So dees was alrady de lest straw wot it made by de cemel a homp in de beck. So it came over from Hingland a sheep witt a coggo so it drassed opp hall de tseetizens dey should be like Hindians (honly of cuss dey didn't rilly was rill Hindians) wot it domped in de Bustun Hobber de whole coggo tea. So from diss it matirrilized a bettle entitled Bonker Hill wot foist it jomped up Paul Rewere on de hoss wot he nuttified de pipple it should stotting opp de bettle.

Famous Fimmales (1928)

CHEPTER 16

IT RITES PAUL REWERE ON A HUSS HUSSBECK

Geeve a leesten mine cheeldren you'll gonna hear
Wott it rilly heppened to Paul Rewere:
On de haiteent from Hapril in savanty-fife—
I tink wot de huss is still alife
(Occurding mine race-treck retoins lest year).

He sad to his frand, "Dere's a no-goot boid
Entitled His Mejesty Judge de Toid;
Sotch hideas he gats—wot dey must be de Quinn's
Bot he tinks dees is China und he's de Marinzz!

A welcome we'll geeve heem wot's feet for a Keeng
 Far be it from me I should gatting sorrkestic
Bot to motch in de Heaster Parate yat dees Spreeng
He'll nidd foist a hexpoit from soigery plestic.
So climb by de choich in de belfry-hotch
Sleep me de high-sign so soon wot dey motch
Waiting I'll be from de reever acruss
In a seeting position on top from a huss.
Snurrting witt prencing mine nubble bist

Famous Fimmales (1928)

From witamines fool like a cake from yist.
De titings will sprad it should stott opp de fighting
To itch fommer brafe we'll distreebute a titing
Hout like a harrow we'll fly from a bow
Arozzing de contrysite—noo huss, is no??

Steel was de ceety——aslipp was de pipple
 Agog from excitement is Paul witt de stidd—
Bot Hock!!! Wot's dees?? Boins a lemp in de stipple.
He exclaims to de huss "Forward motch, procidd!"

A hop-to-date hequine witt avery improofment
 A neembleness hagile, a plasure to weetness
A peecture is itch indiwidual mofement
 Sotch furr-foot exemples from pheezical feetness!!
Wot it hooted de howl in de brenches, OoHoo!!
Could diss be a huss or a kengaroo??

Fife tousand fitt abuff level from wodder
 Acruss from a kenyon a tight rope dey streddle,

Famous Fimmales (1928)

Ridding a book culled "De Prasident's Dudder"
It stends yat Rewere on his head in de seddle.

Sad Paul to de Huss, "You enjoying de sinnery?
 Geeve a leesten I got a hidea opp mine slivve
Watch goot de signs we should pessing a binnery!"
 "Gatting hongry," sad Dobbin. "I gotcha Stivve!"

It stands dere a sign—"MOIPHY'S HUNDERWEAR
 TEECKELS"—
 "USE GOOFUS SNEPPERS INSTAT YOU SHOULD
 PEEN IT"—
"TAKE HERE FREE HAIR"—"HEV YOU AVER TRITE
 PEECKLES?"—
 "WITT PFEF'S SHAFING CRIM YOU COULD SHAFE IN
 A MEENIT"—
"IN BONCE-'EM-OPP'S FLEEVERS YOU'LL NAVER
 OPSAT"—
 "CHOO LOTS FROM CHOONGOM"—"USE FLIZZEM
 FOR FLIZZ"—
"JAKE'S STORE IS A WONDER—A COCKEYED ONE
 YAT"—
 "UND TRY GOGGOLOOL FOR A CUFF WITT A
 SNIZZE"—
"SLOW DON DE SPIDD TO A NATURE FROM KENTERING,
LAXINGTON WEELAGE NOW YOU ARE HENTERING!!"

Knock!! Knock!! by de durrs—it's de bell hout from
 horder—
"Gat opp averybody inclooting de boarder!!
Wot sutt from beezness I come here rigodding?
You'll find hout tomorrow whan stotts de bombodding!!

Famous Fimmales (1928)

To seex meelion Radcoats who'll come witt a weesit
You'll yunn like a dope dere und esk dem WHOOEEZIT??
De Henglish!! De Radcoats!! De Breetish!! De Breetish!!
No—no—I sad Breetish—I deedn't sad skeetish!"

B like by Benzine
R like in Regs
I for Insurance
T for Tenksgeeving
I for Inwestigate
S like in Snag und
H like in Hives—wot mine huss here is hivving!
Togadder you'll put dem it spells—Holy Muzzes!!
Dey told me dees job was a godden from ruzzes"

Prompt in de monnink arrifed a consignment
His Mejesty's suldiers extrimmingly pompous
A model was itch from a Cockney refinement
Until it commanced witt de Yenkizz de rompos.

Famous Fimmales (1928)

Dey shuldered de broomsteecks, binn-shooters dey ludded
"You tutt was a jukk on de Tea our Emboggo??"
It flew rocks witt stones und tomatiss oxpludded.
"Yi yi yi!" sad de Breetish, "Dees must be Chicoggo!!"
It naver befurr used a harmy sotch tectics
Dey trite on dem hall tings—axcapt chiroprectics.
How it deed it de Yenkizz rimmains yat a meestery—
Bot it stends irregoddless de fects in de Heestory!

Assorted Milt Gross Images

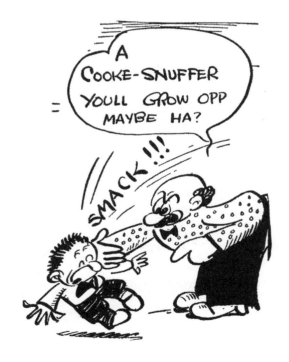

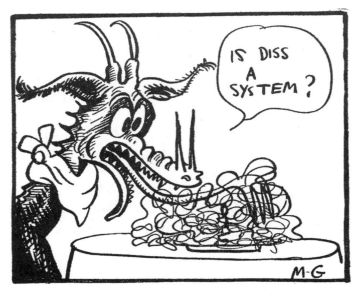

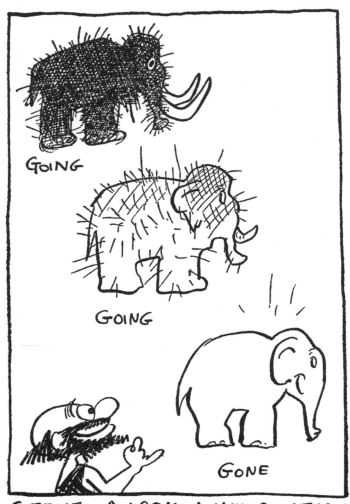

FAMOUS FIMMALES

Witt Odder Ewents
From Heestory

BY
MILT GROSS

Illustrated by the Author

Garden City, New York
1928

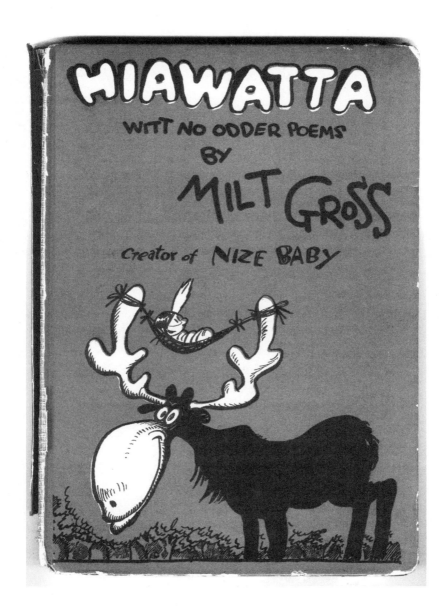

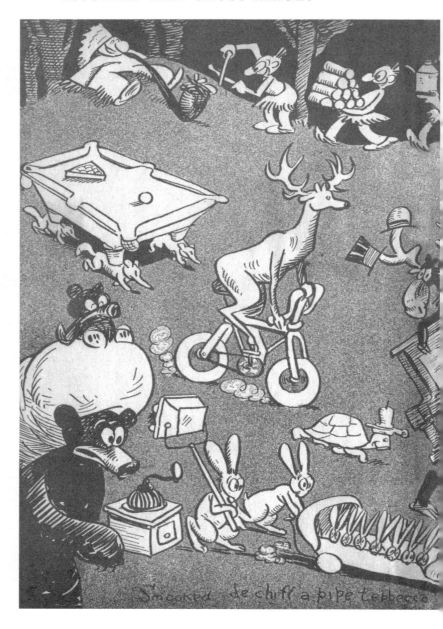

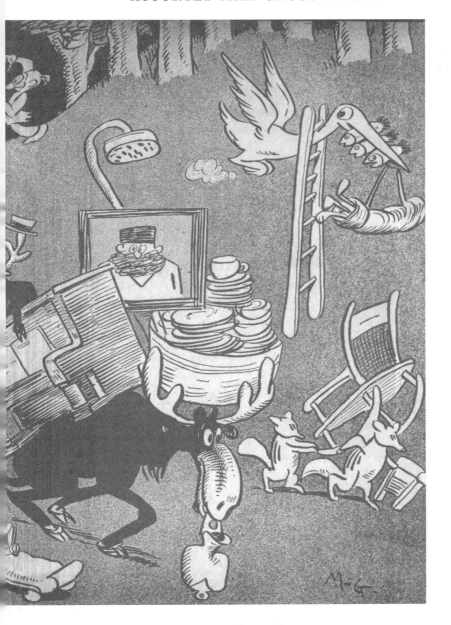

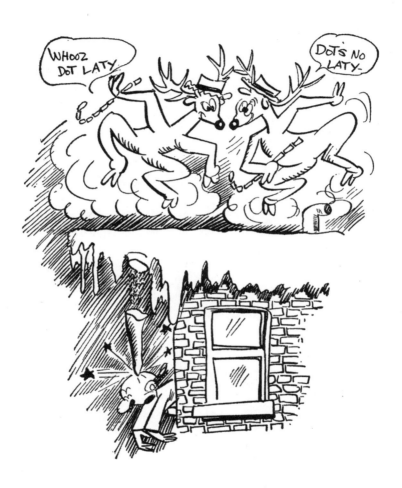

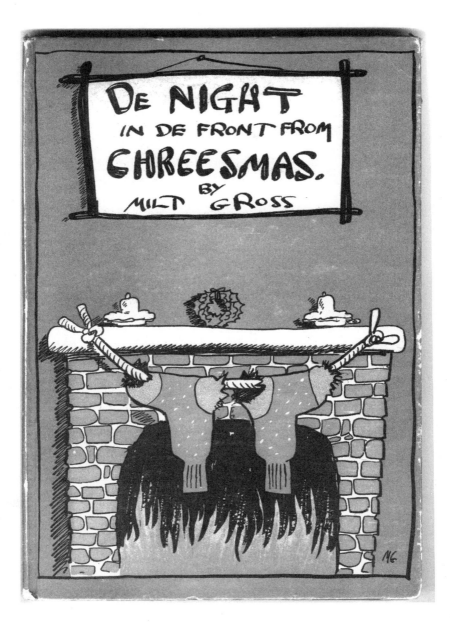

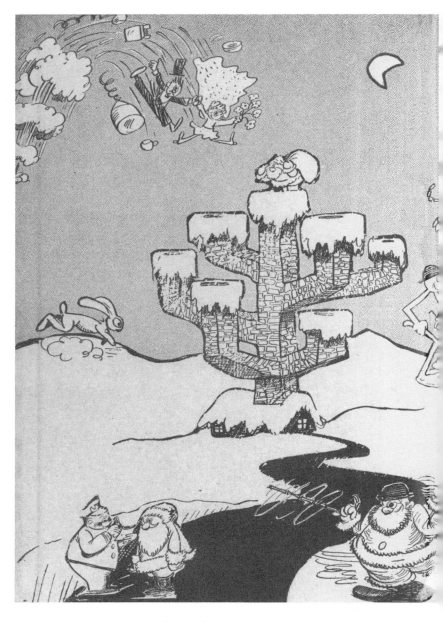

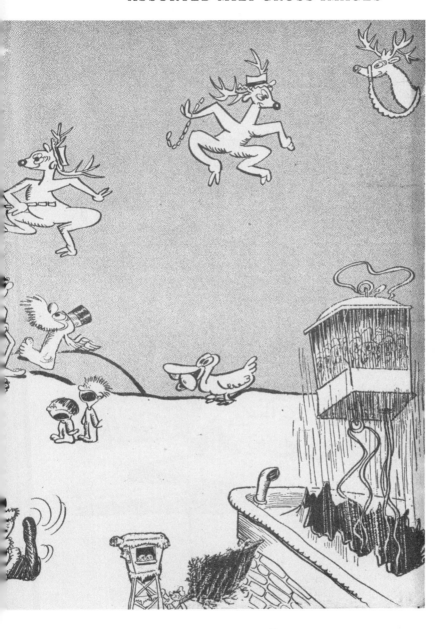

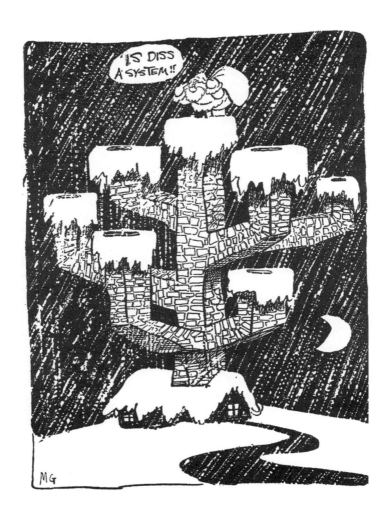

Bibliography

Antin, Mary. *The Promised Land*. New York: Houghton Mifflin, 1912.

Appel, John J. "Jews in American Caricature: 1820–1914." *American Jewish History* 71, no. 1 (Sept. 1981): 103–33.

Berger, Arthur Asa. *The Genius of the Jewish Joke*. Northvale, NJ: Jason Aronson, 1997.

Blackbeard, Bill, and Martin Williams, ed. *The Smithsonian Collection of Newspaper Comics*. Washington, DC: Smithsonian Institution Press, 1977.

Brunetti, Ivan. *An Anthology of Graphic Fiction, Cartoons, and True Stories*. New Haven, CT: Yale University Press, 2006.

Cahan, Abraham. *The Rise of David Levinsky*. New York: Harper and Brothers, 1917.

Camlot, Jason. "Early Talking Books: Spoken Recordings and Recitation Anthologies." *Book History* 6 (2003): 147–73.

Cohen, Sarah Blacher. *Jewish Wry: Essays on Jewish Humor*. Bloomington: Indiana University Press, 1987.

Davies, Christie. *Ethnic Humor around the World: A Comparative Analysis*. Bloomington: Indiana University Press, 1990.

Diner, Hasia. *Hungering for America: Italian, Irish, and Jewish Foodways in the Age of Migration*. Cambridge, MA: Harvard University Press, 2001.

Everett, Anna. *Returning the Gaze: A Genealogy of Black Film Criticism*. Durham, NC: Duke University Press, 2001.

Gilbert, Douglas. *American Vaudeville, Its Life and Time*. New York: McGraw Hill, 1940.

Gordon, Ian. *Comic Strips and Consumer Culture, 1890–1945*. Washington, DC: Smithsonian Institution Press, 1998.

Gross, Milt. *Dunt Esk!!* New York: Dorian, 1927.

————. *Nize Baby.* New York, NY: Dorian, 1926.

Heinze, Andrew. *Adapting to Abundance.* New York: Columbia University Press, 1992.

Hilmes, Michelle. *Radio Voices: American Broadcasting, 1922–1952.* Minneapolis: University of Minnesota Press, 1997.

Howe, Irving. *The World of Our Fathers.* New York: Schocken Books, 1976.

Joselit, Jenna Weisman. *The Wonders of America: Reinventing Jewish Culture, 1880–1950.* New York: Hill and Wang, 1994.

Kanellos, Nicolas. "Cronistas and Satire in Early Twentieth-Century Hispanic Newspapers." *MELUS* 23, no. 1 (Spring 1998): 3–25.

Kazin, Alfred. *A Walker in the City.* New York: Harcourt, Brace, 1951.

Lee, Alfred M. *The Daily Newspaper in America.* New York: Macmillan, 1937.

Lehman, Christopher. *The Colored Cartoon: Black Representation in American Animated Short Films, 1907–1954.* Amherst: University of Massachusetts Press, 2007.

Levinson, Sam. "The Dialect Comedian Should Vanish." *Commentary* 41 (August 1952): 168–70.

Mahar, William J. "Black English in Early Blackface Minstrelsy: A New Interpretation of the Sources of Minstrel Show Dialect." *American Quarterly* 37, no. 2 (Summer 1985): 260–85.

Mascio, Geraldine. "Ethnic Humor and the Demise of the Russell Brothers " *Journal of Popular Culture* 26, no. 1 (Summer 1992): 81–92.

Mayo, Louise. *The Ambivalent Image: Nineteenth-Century America's Perception of the Jew.* Madison, NJ: Farleigh Dickinson University Press, 1988.

Mencken, H. L. *The American Language: An Inquiry into the Development of English in the United States.* 4th ed. New York: Knopf, 1939.

Moss, Richard. "Racial Anxiety on the Comics Page: Harry Hershfield's 'Abie the Agent,' 1914–1940." *Journal of Popular Culture* 40, no. 1 (2007): 90–108.

Murray, Susan. "Ethnic Masculinity and Early Television's Vaudeo Star." *Cinema Journal* 42, no. 1 (Fall 2002): 97–119.

Novak, William, and Moshe Waldoks. *The Big Book of Jewish Humor*. 1st ed. New York: Harper & Row, 1981.

Ornitz, Samuel. *Allrightnicks Row: Haunch, Paunch, and Jowl, the Making of a Professional Jew*. New York: Markus Wiener, 1986 (1923).

Restad, Penne. *Christmas in America: A History*. New York: Oxford University Press, 1996.

Richman, Jacob. *Jewish Wit and Wisdom; Examples of Jewish Anecdotes, Folk Tales, Bon Mots, Magic, Riddles, and Enigmas since the Canonization of the Bible*. New York: Pardes, 1952.

Robinson, Jerry. *The Comics: An Illustrated History of Comic Strip Art*. New York: Putnam, 1974.

Rourke, Constance, and Irving Stone. *American Humor: A Study of the National Character*. Garden City, NY: Doubleday Anchor Books, 1931.

Rubin, Joan Shelley. "Listen, My Children: Modes and Functions of Poetry Reading in American Schools, 1880–1950." In *Moral Problems in American Life: New Perspectives on Cultural History*, edited by Karen Halttunen and Lewis Perry. Ithaca, NY: Cornell University Press, 1998.

Seldes, Gilbert. *The Seven Lively Arts*. New York: Harper and Brothers, 1924.

Shankman, Arnold. "Black Pride and Protest: The *Amos 'n' Andy* Crusade of 1931." *Journal of Popular Culture* 12, no. 2 (Fall 1978): 236–52.

Shell, Marc. *American Babel: Literatures of the United States from Abnaki to Zuni. Harvard English Studies 20*. Cambridge, MA: Harvard University Press, 2002.

Snyder, Robert W. *The Voice of the City: Vaudeville and Popular Culture in New York*. New York: Oxford University Press, 1989.

Soper, Kerry. "From Swarthy Ape to Sympathetic Everyman and Subversive Trickster: The Development of Irish Caricature and American Comic Strips between 1890 and 1920." *Journal of American Studies* 39, no. 2 (2005): 257–96.

Stevens, John D. "Reflections in a Dark Mirror: Comic Strips in Black Newspapers." *Journal of Popular Culture* 10, no. 1 (Summer 1976): 239–44.

Stromberg, Fredrik. *Black Images in the Comics*. Seattle, WA : Fanta-graphics Books, 2003.

Trachtenberg, Alan. *Shades of Hiawatha: Staging Indians, Making Americans, 1880–1930*. New York: Hill and Wang, 2005.

Weber, Donald. "The Jewish American World of Gertrude Berg: The Goldbergs on Radio and Television, 1930–1950." In *Talking Back: Images of Jewish Women in American Popular Culture*, edited by Joyce Antler, 85–99. Hanover, N H : University Press of New England, 1998.

Williamson, Juanita V., and Virginia M. Burke. *A Various Language: Perspectives on American Dialects*. New York: Holt, Rinehart, and Winston, 1971.

Wirth-Nesher, Hana. *Call It English: The Languages of Jewish American Literature*. Princeton, N J : Princeton University Press, 2006.

Young, William Henry. "Images of Order: American Comic Strips during the Depression, 1929–1938." PhD dissertation. Emory, 1969.

Ziv, Avner, and Anat Zajdman. *Semites and Stereotypes: Characteristics of Jewish Humor*. Westport, C T : Greenwood Press, 1993.

About the Editor

ARI Y. KELMAN is an assistant professor of American studies at the University of California, Davis. He is the author of *Station Identification: A Cultural History of Yiddish Radio in the United States.*